Berthe Morisot's Images of Women

Berthe Morisot's Images of Women

ANNE HIGONNET

HFA objects: pp. 141, 190

HARVARD UNIVERSITY PRESS

Cambridge, Massachusetts
London, England
1992

Publication of this book has been aided by a grant from the Florence Gould Foundation.

This book is printed on acid-free paper, and its binding materials have been chosen for strength and durability.

Library of Congress Cataloging-in-Publication Data

Higonnet, Anne, 1959–
 Berthe Morisot's images of women / Anne Higonnet.
 p. cm.
 Includes bibliographical references and index.
 ISBN 0-674-06798-3 (acid-free)
 1. Morisot, Berthe, 1841–1895—Criticism and interpretation. 2. Women in art. I. Title.
ND553.M88H53 1992
759.4—dc20 91-29966
 CIP

For Jeffrey Hart, Ethel Parmelee Higonnet,
Margaret Randolph Higonnet, Patrice Louis-René
Higonnet, and Janet King

SYMBOLS USED IN CARD CATALO

*	oversized book
**	folio
L	Reference Room
PAM	Pamphlet collection
RC	Research catalog
VF	Vertical file
p	used after call # to indicate pamphlet material.

DEPARTMENT DESIGNATIONS

ADA	American Dec. Arts
EDA	European Dec. Arts
DA/DE	Assyrian/Egyptian
DC	Classical
DI/DJ	Asiatic
DMI	Musical Instruments
DP/DPC	Prints
DPA	Paintings
DT	Textiles

Contents

Chapter One

Introduction

All my walls are lost in mirrors,
 whereupon I trace
Self to right hand, self to left hand,
 self in every place,
Self-same solitary figure, self-same
 seeking face.

Christina Rossetti,
"A Royal Princess," 1876

Berthe Morisot became a painter despite being a woman. She painted the way she did because she was a woman.

In some ways Morisot's images resemble the pictures women of her time and social situation commonly made of themselves, while in other respects her work belongs to the esthetically and conceptually elite world of fine art painting. Yet few women who made the kinds of pictures approved of as feminine became painters, and none attained the rank of "great painter," a position even Morisot is seen as only approaching.[1] Nineteenth-century European definitions of femininity and of painting combined to prevent women from becoming or being recognized as important artists. Morisot is very much the exception that proves the rule. Her work allows us to see how far a woman's expressive possibilities extended and therefore to discern all the more clearly where they ended.

Born in 1841 into a wealthy and well-connected family, Morisot enjoyed the support of her parents, sisters, friends, colleagues, husband, and child. Her unassailable social position, especially after her marriage to Eugène Manet (the painter Edouard's brother),

compensated for her participation in the radical Impressionist movement. She contributed to all but one of the Impressionist exhibitions,[2] as well as to other avant-garde exhibitions, and maintained collegial relationships not only with painters and sculptors but also with critics, poets, and politicians. Exceptionally self-disciplined, she worked steadily for more than thirty years. At her death in 1895 she left about 850 oils, pastels, and watercolors.

During Morisot's lifetime all aspects of women's visual culture were changing rapidly, so much so that we might say of her career that pictorial phylogeny summarizes ontogeny. Her individual development encapsulated widespread cultural trends affecting the entire European middle class. Her paintings evolved from the amateur work characteristic of women's pictorial production in the beginning of the century, through the commercial imagery of mid-century, and on to the new conditions of painting inaugurated in the 1860s and 1870s by the Impressionist painters. More broadly, her work reflected a middle-class ideology of domestic femininity which itself continued to change during a time of tremendous demographic and economic upheaval.

Throughout the century, but especially in its earlier decades, middle- and upper-class women represented themselves in the amateur pictures and albums they made. Amateur women artists were so numerous and their work was so extensive and consistent that we can speak of a feminine pictorial tradition. Morisot, together with her sister Edma, began painting in this tradition. It continued to determine some of the most basic aspects of Morisot's work for the rest of her career: her subject matter, her attitude toward exhibition and sales, and, most fundamentally, the relationship of her professional work to her personal life.

After about 1840, however, mass-produced prints of domestic scenes and contemporary fashions began to rival women's amateur imagery. By mid-century, their prevalence was such that no woman could ignore their impact nor entirely resist the new feminine identities they fostered. Their claim on Morisot's attention was at once

powerful and paradoxical. They represented a modernity to which Morisot committed herself in the late 1860s and 1870s. But they also stood in antithesis to the values of originality and authorship increasingly important to modern painting. Popular prints, especially fashion plates, added their trace to Morisot's work, suggesting a pattern of subjects for her, and influencing her formal style with their compositional devices as well as their spatial and psychological relationships of figures to each other and to their settings. Above all, they challenged her to react against them and seize the critical freedom painting then offered.

By the 1870s that freedom was available to a woman, though only to someone like Morisot who could grasp the implications of ongoing transformations in the painting world. Since her childhood, painting had evolved in its organization from the public, institutional, state-sponsored, and narrative toward the private, individual, capitalist, and naturalist. In France, stylistic leadership was passing from the Académie des Beaux-Arts to the avant-garde. The Impressionist movement advocated contemporary subjects, including domestic ones, treated in small portable paintings that could be executed without erudition, much equipment, or a permanent studio; the avant-garde functioned more personally than the Academy, using social connections and intimate gatherings to arrange exhibitions and sales. Each of these trends mitigated the opposition between women's social role and a professional career that had previously been virtually insuperable.

Nonetheless, even after Morisot had established herself as a painter, she continued to negotiate compromises between competing and sometimes contradictory values. Midway through her career she became a mother, which of all women's roles in the nineteenth century carried the strongest, most positive, social connotations. Maternity changed Morisot's art profoundly, altering her subject matter and encouraging her to experiment both stylistically and intellectually, in ways closely related to the endeavors of her female literary contemporaries. From 1879 on, she stretched her

ambitions in two seemingly opposite directions: professional and
personal. She aligned some of her paintings more closely than ever
before along painting's conventional standards, almost reverting to
pictorial clichés: portraits, peasant genre scenes, and nudes. Yet as
she concurrently tried to make her first self-portraits, she recog-
nized how inseparable her identity as a painter had become from
her identity as a mother. Her attempts at conventional painting car-
ried little conviction, and painting's most prestigious, most mascu-
line subject, the female nude, defeated her. With representations of
her relationship to her daughter, however, in dozens of paintings
made over the course of fifteen years, she ventured into unknown
territory, taking a subject unusual for the fine arts and interpreting
it in an unprecedented way. Not only did she suggest what it meant
to be the painter as well as the mother of a daughter, but she also
revised her relationship to her own previous paintings as well as to
paintings that had been made of her.

Morisot's circumstances and her character gave her more ex-
pressive possibilities than most women. Even in her privileged case,
though, feminine self-representation conflicted with the assump-
tions governing painting. Pictorial options easily available to
women did not necessarily lead to more valued kinds of picture
making, more analytical, convincing, lucrative, or public modes of
expression. Involvement in feminine visual culture was more likely
to hinder than to help women become artists. Amateur pictures,
domestic genre prints, and fashion plates ratified existing gender
roles and worked to exclude women from the practice of high art by
instilling amateur values, by developing pictorial markets geared to
one gender or another, and by turning women from makers into
consumers of images.

By dwelling on the exceptional case of a woman who did man-
age to move from one kind of visual production toward another, we
can see how different kinds of visual production operated in relation
to each other. Painting, for instance, however firmly in control of
visual culture, maintained its dominance by defining itself in terms

of difference from other modes of expression. A high art like painting was as much defined by the forces that isolated it as those manifest within it—as much by what it rejected, suppressed, precluded, or denied as by what it claimed to be.

This implies that at any one moment in time the way one aspect or area of visual culture functions is constantly changing, subject to the pressures of contiguity, opposition, or even encroachment of other areas. Morisot's case demonstrates how even a cultural privilege as secure as painting could be significantly altered by the right combination of factors, no matter how marginal each separate factor. Morisot found elements of subjectivity in feminine visual culture which she reconfigured into images that could meet enough of painting's requirements to bring her just within painting's boundaries. As she brought stylistic, iconographic, and conceptual aspects of feminine visual culture to painting, and as she concentrated on those aspects of painting that could accommodate what she brought, she changed painting. She and her work contributed to a new model of authorship, one more easily accessible to women (at least middle-class women) than any model had been before.

And so, finally, Morisot's case teaches us what effect an individual woman could have on the culture she was born into. Because originality and individuality in the fine arts were the conditions of intellectual success in Morisot's time, we need to take her bid for them very seriously. Her career as an Impressionist painter claimed the possibility of a woman's self-representation. What enabled Morisot to make this claim? What forms of expression were available for her to inherit or modify? What themes or issues would she choose to address? How would she try to picture women? The answers to these questions depend on a historical situation many women shared, and also on one woman's desire to change that situation.

Chapter Two

Impressionism in the Feminine Case

Often rebuked, yet always back returning
 To those first feelings that were born in me,
And leaving busy chase of wealth and learning
 For idle dreams of things which cannot be:

To-day, I will not seek the shadowy region;
 Its unsustaining vastness waxes drear;
And visions rising, legion after legion,
 Bring the unreal world too strangely near.

I'll walk, but not in old heroic traces.
 And not in paths of high morality,
And not among the half-distinguished faces,
 The clouded forms of long-past history.

I'll walk where my own nature would be leading . . .

Emily Brontë, "Stanzas," 1850

Morisot conducted an unusually successful career. The honors and recognition she received in her lifetime would have satisfactorily rewarded many a male artist's professional efforts; but for a woman to have attained even a secondary place in an art movement as influential, and eventually as beloved, as Impressionism was truly remarkable. Very few women organized their life and work into anything we could recognize as a career at all. Committed to marriage, child raising, and other family obligations, most women could not manage to sustain professional behavior or artistic production consistently over an entire adult lifetime. In Morisot's case, by contrast, we can trace from her adolescence to her death the pattern of train-

ing, initiation, alliance, commitment, emergence, fame, and retro-
spective summation we associate with the dedicated professional.[1]

Jean-Baptiste-Camille Corot, revered leader of the Barbizon
school, gave Morisot and Edma the first lessons they publicly ad-
mitted to.[2] Berthe Morisot always acknowledged her debt to him.
When in her early professional years she exhibited at the Salon con-
trolled by the Académie des Beaux-Arts she sometimes listed her-
self as Corot's student, and critics commented on the influence he
had on both Morisot sisters' style. Between about 1860 and 1863
Corot stamped the Morisots' work with the same kind of approval
he gave to a man who later became Berthe Morisot's colleague,
Camille Pissarro. Historians may disagree about whether Morisot
can also be considered a student of Edouard Manet's, but all situate
her within the history of art by establishing her lineage through
Corot. Pushing farther back, many see a resemblance to François
Boucher, encouraged by the (unsubstantiated) claim of Morisot's
collateral descendance from the rococo master.

In the early years of her career, Morisot pursued all the stan-
dard contemporary possibilities for selling pictures. Another
teacher, Oudinot, to whom Corot entrusted the Morisot sisters after
1863, encouraged Berthe to exhibit, together with Edma, from
whom she was then personally and professionally inseparable.[3] So
did their mother, who offered material as well as moral assistance;
Mme. Morisot had canvases framed and took them to dealers during
her daughters' absences from Paris.[4] The two sisters first submitted,
successfully, to the Salon in 1864 (Berthe was then twenty-three
years old and Edma twenty-five) and showed one or two pictures
each in 1865, 1866, 1867, and 1868; then Berthe exhibited alone at
the Salon in 1869, 1872, and 1873. In 1867 Berthe and Edma fol-
lowed the common practice of sending pictures to one of the pro-
vincial "Society of Friends of Art" exhibitions, in their case the Bor-
deaux exhibition, in which Berthe showed one picture and Edma
three.[5] Meanwhile the sisters put pictures on sale in the shop of the
dealer Alfred Cadart,[6] in unrecorded quantity, but several at a time

and in rotating groups.[7] Mme. Morisot wrote to Edma in July of 1867, "Your paintings were much noticed at Cadart's . . . nonetheless I have no news for you about sales and I still wonder how artists survive who rely on sales for their living."[8] Berthe also sold pictures through the dealer Alphonse Portier,[9] who still had several at her death, some of them quite early works.[10]

Before her marriage she very much wanted her pictures to be valued enough to be bought. As she wrote to Edma in the spring of 1871, for instance:

> I don't want to work anymore for the sake of working.
> I don't know if I'm fooling myself, but it seems to me that a painting like the one I gave Manet could sell and that's my only ambition.[11]

After her marriage in 1874 to Eugène Manet, Morisot continued to solicit sales, now with the help not only of her mother but also of her husband and brothers-in-law Edouard and Gustave. In 1875 Mme. Morisot wrote to her daughter about three paintings that had been in an unnamed dealer's window for two weeks, including a picture of the Parisian suburb Gennevilliers—"that painting has earned your brother-in-law's most complete admiration"— for which the dealer was asking six hundred francs.[12] Eugène wrote cheerfully about (possibly the same) pictures placed with the dealer Poussin: "He hasn't sold any, but he must have received a lot of praise, judging from the way he showed them to me . . . he seems quite won over to your painting."[13]

Morisot appreciated how much money could be made from paintings. Impressed, she reported James Tissot's prices to her mother in 1875: "He sells for three hundred thousand francs at a time. What do you think of London success?"[14] She could, on occasion, write firmly to a dealer, as she did in an undated letter: "Ask three hundred francs for that little painting of the Isle of Wight and don't let it go for less than two hundred and seventy—Have you sent my painting to Mr. Pissarro?"[15]

From the 1860s to the mid-1870s Morisot hesitated and struggled in the way we have come to expect of a young avant-garde artist. Youthful years of stylistic experimentation and marketing obstacles seem to validate the novelty and authenticity of the artist's vision. Morisot destroyed almost everything she had worked on before 1870, making it difficult to characterize her first pictures. But by 1867 at the latest, her work must have been evolving away from Corot's example and in a new direction. A letter from Mme. Morisot to Edma in 1867 tells of Manet's admiration for her painting and Berthe's, a year before he met them.[16] In an account of the 1869 Salon, Berthe exclaimed to Edma that Frédéric Bazille had captured "what we've so often sought: to place a figure in the open air";[17] she and Edma had not painted together since 1868. From these indirect clues, from letters describing tramps across the countryside with equipment or work sessions in moored boats, as well as from a few surviving works dated before 1870, we can surmise that Berthe and Edma had been working in the open air since the mid-1860s, possibly on contemporary figural subjects. Without formal training of a theoretical sort, without any grudges against the Academy, Berthe and Edma Morisot had arrived on their own at an approximation of Impressionist positions and practices.

Sometime in the early 1870s Morisot's work came to the attention of like-minded painters planning a dissident exhibition. Daring to flank the Academy's powerful Salon, Paul Cézanne, Edgar Degas, Claude Monet, Pissarro, Pierre-Auguste Renoir, Alfred Sisley, and others prepared one of the decisive events of Modernism. Degas invited Morisot to join them. In an undated letter to her mother, probably written during the winter or early spring of 1873–74, he speaks only of her reputation and of the nascent group's professional respect for her: "We think that Mlle. Berthe Morisot's name and talent are too important for us to do without."[18] Whether they knew her or only her work, the other founding members of the Société Anonyme (who came to be known as the Impressionists in the course of their exhibition) raised no recorded objections to her

participation. Neither her sex nor her skill apparently gave anyone any qualms.

Morisot herself might have had some qualms. She, unlike the other future Impressionists, had not been entirely rejected by the Salon. Letters indicate that the jury may once have turned down a submission, but not until 1874, when she had already committed herself to the Impressionist exhibition, did both her submissions for the year fail.[19] She did not need to sell paintings to live, nor was notoriety to be lightly courted by an unmarried middle-class woman. Her friend Edouard Manet, whose talent she admired immensely, not only refused to join the Impressionists but actively campaigned against her participation, as we know because in his letter Degas pleaded his case in opposition to Manet's. Taken together, these factors suggest that Morisot helped found the Impressionist movement out of disinterested artistic conviction.

At the time of the Impressionist exhibitions Morisot was without question one of the movement's key members. During the twelve years of the exhibitions and the dozens of reviews and essays (or "histories") that accompanied the exhibitions, six names recur most frequently and most prominently: Degas, Monet, Morisot, Pissarro, Renoir, and Sisley. Already in 1874 Emile Cardon sifted out the more conventional painters and proceeded: "So there remain Messrs. Degas, Cézanne, Monet, Sisley, Pissarro, Mlle. Berthe Morisot etc. etc. Mr. Manet's disciples the pioneers of future painting, the most convinced representatives, and the most authoritative members of the School of the Impression."[20] That same year Ernest d'Hervilly, among others of a similar opinion, placed Morisot on the list of "the primary members of the cooperative society that has affirmed itself so valiantly," as well as on the list of "names signed at the bottom of really remarkable works."[21]

Three years later another critic, Marc de Montifaud, implied that those who followed art developments knew Morisot's work well when he referred to Corot's influence and added, "on the subject of that candor, that sincerity, a lot has been said about Mlle.

Berthe Morisot."[22] Apparently a small but select group of collectors, connoisseurs, critics, and fellow artists fully appreciated her painting in the 1870s. At the infamous 1875 Drouot auction of Impressionist paintings, Morisot's picture then called *Interior* (probably Pl. I) fetched the highest of generally low bids, outpricing pictures by Monet, Renoir, and Sisley. Of the twelve pictures Morisot sold, two were bought by a painter, Duez; three were bought by the art critics Chesneau and Houssaye; two by Ernest Hoschedé, Impressionist patron and friend of Monet's; one by Henri Rouart, a painter and close friend of Degas's; and two by Morisot's brother-in-law Gustave Manet. A painter as commercially successful himself as Alfred Stevens esteemed Morisot's work highly enough not only to buy her *Lilacs at Maurecourt* (Fig. 56) from the dealer Paul Durand-Ruel, but also to include it as a painting within his 1880 painting *The Painter's Salon* (Fig. 57).

Matrimony and later maternity provided Morisot with a social, emotional, and financial stability that encouraged her to expand her professional role. Together, Morisot and Eugène Manet took an active organizational part in the last Impressionist exhibitions. In 1882 and in 1886 the time and money they contributed to the exhibitions' organization, as well as Morisot's reputation, entitled them to influential artistic opinions. Colleagues sought their advice on questions such as whether Georges Seurat's stylistically innovative *Sunday Afternoon on the Grande Jatte* should be accepted, and Pissarro's correspondence makes it clear that she and her husband did not always feel obliged to agree with each other.[23] By the 1886 exhibition (which did, in the end, include Seurat's painting, as Morisot had counseled), the Impressionists had secured their place in the art world and were on the way to becoming the new "Old Masters."

After the Impressionist exhibitions ended, Morisot did not exhibit as much in group shows, but when she did, she made contacts farther afield. She tried the more popular forum of Georges Petit's Exposition Internationale in 1887, and sent a few works abroad, first to the fourth Exposition des XX that same year in Brussels,

again to Brussels in 1894 for the Première Exposition of the XX's successor, the Libre Esthétique, then to New York in 1886 and 1888 for exhibitions of Impressionism under Durand-Ruel's auspices, and finally to Antwerp and to London in 1893 for the Association pour l'Art's Seconde Exposition Annuelle and the New English Art Club, respectively.

At the same time as her work became better known and more widely appreciated, Morisot began to occupy a prominent personal position in Parisian intellectual circles. The evenings she hosted at her home and the time she spent visiting studios, or attending readings and concerts, strengthened ties to old friends, including Degas, Monet, Pierre Puvis de Chavannes, and Renoir, to younger painters such as Maurice Denis, and to artists in other fields, among them the sculptors Bartholomé and Auguste Rodin, Emmanuel Chabrier the composer, and writers Henri de Régnier and Stéphane Mallarmé, especially, whom she placed as high among poets as she placed Edouard Manet among painters. Morisot and Mallarmé respected and trusted each other, enough to withstand the occasional jab. She invited him to read his eulogy to Villiers de l'Isle-Adam in her home in 1890, but at another moment could chide him: "I'd like to add my admiration to the public's, despite your being so disdainful of women."[24] After her death, he wrote the essay for her retrospective catalogue and called her "the friendly Medusa."

After the birth of her daughter in 1878 Morisot worked more prolifically than ever. Many more pictures survive from her late years than from her early ones. Because Morisot died unexpectedly at the age of fifty-four, oils, pastels, and watercolors from the 1890s she might have otherwise discarded remained in her estate, and some of these cannot be considered finished pictures, though they are listed in her catalogue raisonné; Morisot had certainly edited her earlier work. Her own selections, however, had spared more work from the 1880s than from the 1870s and 1860s. Moreover, despite the many small sketches of her last years, the average size of her paintings rises slightly over the course of her career. In the 1880s

and 1890s she also executed several exceptionally (for her) large and significant canvases.

She designed two of these pictures as decorative panels for her living room: a copy of Boucher's *Venus Asks Vulcan for Weapons,* which she made in 1884 and which measured 114 by 138 centimeters, and her 1885 *The Goose,* which measured 165 by 85 centimeters. Although their decorative function provided an excuse for their (at least relatively) imposing scale, and although one was only a copy and the other not of an ambitious subject, Morisot nevertheless had extended herself. She had also literally placed herself, however modestly, next to Monet, who contributed another large painting for her living room, and next to Edouard Manet, whose work dominated those walls. Mallarmé described the room, which Morisot also worked in, as a "very discreet studio, whose Empire woodwork enclosed Edouard Manet's canvases."[25]

Morisot undertook the most monumental project of her entire career in 1891. She chose the subject of young women gathering fruit from a tree. The theme had been treated innumerable times before, both in painting (Fig. 2) and in popular imagery (see Fig. 21, for instance), and could thus fairly be called "classic." It was also being reinterpreted around 1890 by two artists Morisot had always measured herself against competitively: Mary Cassatt and Puvis de Chavannes.[26] Morisot may have been raising the stakes even higher by citing a painting in the Louvre by the artist then most hallowed among French masters, Nicolas Poussin. She could have adapted the passage from his *Autumn* (Fig. 2), in which a woman picks oranges while standing on a high ladder, to redo it with her daughter Julie and her niece Jeannie Gobillard picking cherries, using the same triangular motif to structure her image geometrically (Fig. 1).

More studies survive for this painting than for any other of Morisot's. Not only did she give the general theme a trial run in an 1889 painting, *Young Girl Picking Oranges,* but she continued with at least two related oil paintings, twelve drawings, two watercolors,

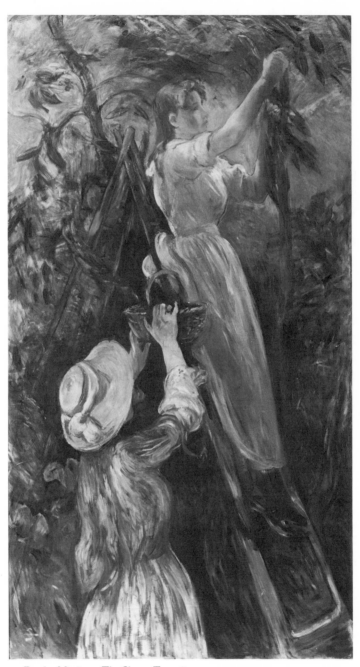

1. Berthe Morisot, *The Cherry Tree*, 1891.

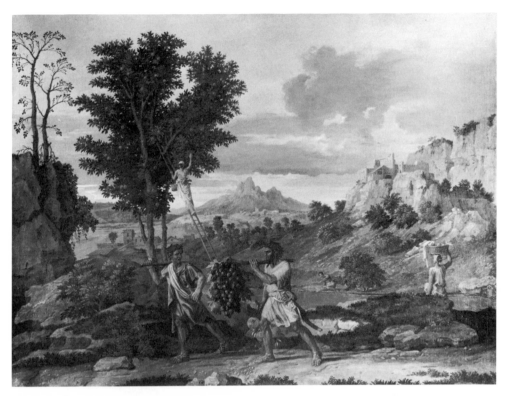

2. Nicolas Poussin, *Autumn,* 1660–1664.

and two pastels in preparation for the final version. The image seemed so important to her that she actually made two final versions, one measuring 154 by 80 centimeters with Julie and Jeannie as models, the other measuring 146.5 by 89 centimeters with professional models (Fig. 1). Renoir recognized the public intentions behind these two paintings and Morisot's attachment to them when he wrote to her in the summer of 1891 after a visit during which she had been working on *The Cherry Tree.* "I'll let you work. Above all, finish the cherry trees canvas. I'll send something to the Champ-de-Mars [an exhibition], do try to do the same. We have to exhibit. I send you all my wishes for success."[27]

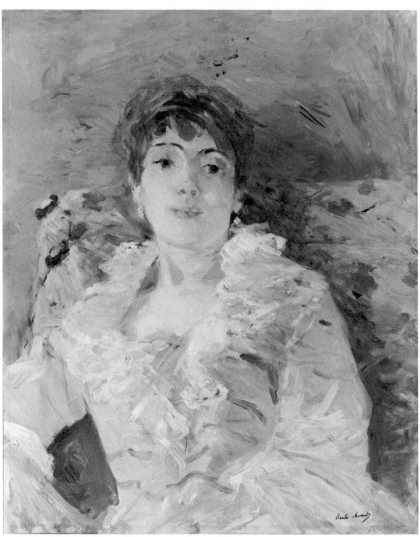

3. Berthe Morisot, *Young Woman on a Couch*, 1885.

On the whole, many more studies survive for Morisot's later paintings. This could mean only that Morisot did not save analogous preliminary work from her earlier years. But in conjunction with cautious subject matter, Morisot's newly meticulous preparatory work indicates an accommodation to current professional standards. Much of Morisot's most fluid, and facile, work dates from the late 1880s and early 1890s. In images like her 1885 *Young Woman on a Couch* (Fig. 3) she demonstrates a technical and conceptual ease that renders the paintings supremely professional. Lushly treated and authoritatively relaxed, such paintings cannot be distinguished from work on similar subjects by male colleagues. What, for instance, differentiates her 1890 *Peasant Girl among Tulips* (Fig. 4) from Renoir's 1886 *Child Carrying Flowers* (Fig. 5)? And though Morisot's and Renoir's pictures share the same confidently broad Impressionist style, what differentiates their subject from a much more stylistically conservative, more tightly crafted painting like Albert Anker's 1884 *Girl with Strawberries* (Fig. 6)? All three make the same conventional associations among girls, nature, and flowers or fruits.

A more articulate self-assertion accompanied, or perhaps supported, Morisot's integration into her profession. She expressed few opinions about painting or fellow painters before 1878, and then only to Edma. All her surviving notebooks date from the 1880s and 1890s. These notebooks contain personal material along with almost all of Morisot's recorded critical comments not only on the visual arts but also on literature and on music both classic and contemporary. In 1891 Morisot at last demanded a separate space for her work. The summer before Eugène Manet's death, he, Morisot, and Julie stayed in the village of Mézy. There, Morisot transformed the attic of a rented house into a permanent studio.[28] It was in this first studio entirely of her own that she began *The Cherry Tree*.[29] After her husband's death the following spring she moved into a new apartment and did not again choose to work in the living room, as she had in their previous home. She tore down the walls between several maids' rooms on the top floor of the building and made them her studio.[30]

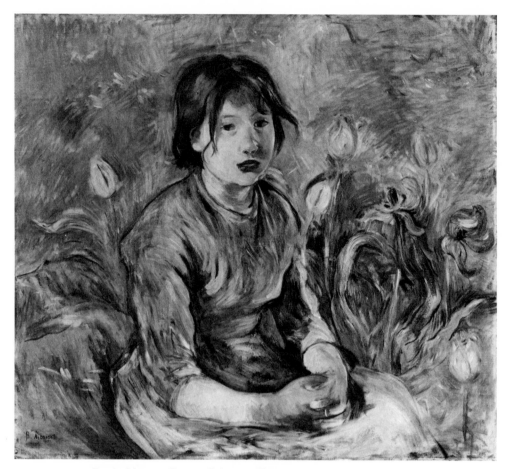

4. Berthe Morisot, *Peasant Girl among Tulips,* 1890.

On two occasions Morisot even asserted herself as a woman in a man's world. A letter from 1890 contains Morisot's first, and last, attempt to define a woman's voice. She had been reading a popular memoir by Mrs. Augustus Craven that described the sustaining power of sisterhood, and, more recently, the journal of Marie Bashkirtseff, whose painting had been academic but whose writing demanded equality for women artists. "I associate in my mind these

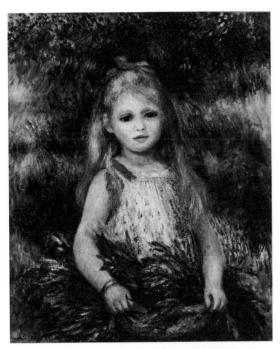

5. Pierre-Auguste Renoir, *Child Carrying Flowers,* 1886.

two women's books: *A Sister's Tale* and [Bashkirtseff's]. Really, our value lies in feelings, intentions, and a vision more delicate than those of men; and if, by chance, pretension, pedantry, and affectation don't spoil us, there is much we can do."[31] Sometime that year Morisot scrawled in a notebook: "I don't think there has ever been a man who treated a woman as an equal, and that's all I would have asked, for I know I'm worth as much as they."[32]

Morisot's efforts reaped an important reward in 1892 when the first exhibition devoted exclusively to her work was held at the Boussod and Valadon Gallery. Eugène Manet had apparently initiated negotiations for this consecration, but when he died in April, Morisot was forced to assume responsibility for her show's preparation and hang it as well. She gathered forty-three works in two

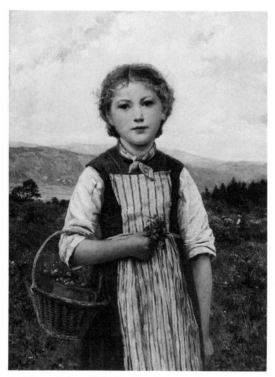

6. Albert Anker, *Girl with Strawberries,* 1884.

small rooms. Morisot, mourning her husband, did not attend the opening on May 25, but she could read the effusive preface to her catalogue by Gustave Geffroy, in addition to the generally favorable reviews that soon appeared in the press.

Not even an exclusive show could match the prestige of exhibition in the national museum of living and recently dead artists, the Luxembourg, with the possibility it carried of the ultimate honor, a place in the Louvre. Gustave Caillebotte had intended to accelerate acceptance of the Impressionists by donating their works to the Luxembourg on the condition they be exhibited. When the stipulations of his bequest were disclosed after his death in 1894,

however, it became clear that this strategy would do nothing for Morisot (or for Cassatt), whose work Caillebotte had never bought. Morisot's friends Mallarmé and the collector-historian Théodore Duret hastened to remedy the situation; they urged Henri Roujon, a disciple of Mallarmé's and then the director of the Beaux-Arts ministry, to buy Morisot's 1879 *Young Woman in Ball Dress* for the Luxembourg Museum. Rather than purchase the picture directly from Duret, Roujon agreed to bid for it openly at auction, where it fetched the quite respectable price of 4,500 francs. Underlining the public character of the accolade in his history of the Impressionist movement, Duret himself recalled Morisot's pleasure at this event and reassured his readers that Morisot was no amateur woman painter but a real professional.[33] Morisot's biographer Monique Angoulvent reported Julie Manet's memory that her mother "felt a deep satisfaction at this event that meant to her the public recognition of her merit."[34]

After Morisot's unexpected death in 1895, Degas, Monet, Renoir, and Mallarmé collaborated on a posthumous retrospective exhibition of her work. This committee, surely one of the most prestigious imaginable, installed about four hundred paintings and drawings from every period of her career in the galleries of Durand-Ruel, eminent champion of the Impressionist movement. Mallarmé summed up her achievements in a brilliant preface to the catalogue. Art critics, spokesmen for the professional art world, chimed in unanimous praise.

This somewhat triumphant account leaves out quite a lot of Morisot's story. Another sort of narrative could just as easily be constructed from the available records. At the same time as she conducted her successful career, Morisot also consistently behaved with a recalcitrance and diffidence that did not diminish as she became more professionally secure—quite the contrary. Rather than immediately dismiss her behavior as a feminine weakness, we might consider whether the two sides of Morisot's story obey some logic that unites them productively. To do that we have to pay attention

to the ways in which her work took twists and turns around the usual professional routes.

Let us go back to the beginning. Morisot's first art teacher was not Corot. She took her first lessons in 1857 along with Edma and her other sister, Yves, from a now-forgotten teacher named Geoffrey-Alphonse Chocarne (1797-?) and her next from the equally obscure Joseph-Benoît Guichard (1806–1880). (Yves soon abandoned painting in favor of sewing.) The Morisot sisters were not entering professional training but cultivating an elegant middle-class hobby. Neither Berthe nor Edma, as far as we know, ever trained in any clearly professional painting studio. Corot's vaunted influence came in extremely casual and sporadic doses, and after three years he passed the Morisots on to a less-renowned colleague. Berthe and Edma had known Corot well only because he dined in their home as their parents' personal guest.

Between this early phase and her professional emergence, at around age thirty, Morisot went through a deep crisis. In 1869 Edma felt obliged to decide between marriage and painting and chose marriage. Though she and Berthe kept up pretenses, their correspondence makes it very clear that both of them believed they had faced an inevitable choice, and that Berthe had made hers just as surely as Edma. Assailed by doubt, depression, and the political traumas of 1870 and 1871, Berthe Morisot floundered for the only time in her life. When she recovered in about 1872 she had found a new direction for her work, the representation of people like herself. Thereafter she concentrated exclusively on the depiction of middle-class women's daily lives and surroundings, a trivial subject by traditional artistic standards.

Over 500 of Morisot's 858 catalogued works depict women. Landscapes or still-lifes account for virtually all the rest. She pictured friends and family members, in the settings they and Morisot shared. Morisot knew her landscapes intimately as well. She painted only what she experienced in the most banal aspects of her daily life. Though she had famous friends and relatives she never por-

trayed them. Though she participated in critical art historical moments she did not depict them. She painted no public events of any kind, nor ceremonies of any sort.

Morisot did not always display the works she listed in the Impressionist exhibition catalogues, leaving the subjects of exhibited works in doubt. And since Durand-Ruel may have selected the pictures for the shows he organized, the best idea we can get of Morisot's exhibition priorities comes from the catalogues of the 1887 XX and Georges Petit exhibitions along with the many choices she made for her 1892 retrospective. The large majority of the pictures she decided to exhibit in these three shows represented women.

Morisot became involved in the Impressionist movement through personal connections. Bound by the conventions of bourgeois etiquette, Morisot could meet Manet, whose work she had admired for years, only when formally introduced to him by Henri Fantin-Latour in 1868. The social parallels between her family and Manet's allowed their friendship to flourish under parental auspices. She almost certainly met Degas soon after at the Manet family's receptions. Since we do not know where or when she met any of the other Impressionists, we can assume that, if she did meet them, their encounters did not seem professionally significant enough to these ambitious young men to be worth noting. She certainly did not meet her future colleagues in the Café Guerbois or the Café de la Nouvelle Athènes, since bourgeois women did not frequent cafés. If Morisot met Monet, Renoir, Pissarro, or Sisley in person before the first Impressionist exhibition in 1874, she probably met them the way she met Degas, during family evenings in her home or the Manets'. She had no part in the professional anti-academic circuit that included the cafés, the Académie Suisse, and Gleyre's studio, where the Impressionist program was debated and formulated.

Impressionism accommodated Morisot partly because of its personal character as an alliance of socially and intellectually compatible individuals. It has been argued recently, notably by Jean-Paul Bouillon, that the Impressionist exhibitions had no coherent

esthetic policy.[35] Yet in letters to each other, Degas, Monet, Morisot, Pissarro, Renoir, and Sisley, along with their slightly later colleagues Cassatt and Caillebotte, repeatedly referred to a concerted artistic movement, as Pissarro did when he wrote to his son in 1895 that Morisot "did honor to our Impressionist group."[36] Informed critics also noted the collective nature of the Impressionist endeavor. "You and your friends, Madame," wrote Camille Mauclair grandiloquently to Morisot sometime between Manet's death in 1883 and hers in 1895, "have incarnated a new grandeur of vision."[37] Along with Pissarro, Morisot had the strongest belief in a united Impressionist front, and she maintained the same unswerving policy through all the divisive squabbles of the late 1870s and early 1880s. She abstained from only one of the Impressionist exhibitions, because that year, 1879, care of her infant daughter took precedence over painting. Long after the Impressionists had begun to drift their separate ways in the late 1880s, Morisot was still seeing and writing Monet regularly, and Degas and Renoir weekly. It might even be argued that Impressionism sustained itself as long as it did in part because Morisot cultivated its network.

Throughout her life Morisot demonstrated a mixed attitude toward earning money from her painting. The fact that so much of our evidence about Berthe's and Edma's early exhibition tactics comes from their correspondence with their mother indicates that the two young women often abdicated control over the exhibition and sale of their work to her. They left town to paint, but at the same time they were avoiding the realities of selling. In 1872 just the prospect of an actual money transaction filled Berthe with "anxiety."[38] What she really wanted was "a sort of independence for myself,"[39] an independence from the child-like condition of unmarried bourgeois ladies, a freedom she gained through her marriage to Eugène Manet in 1874. After her marriage Morisot let business drift even more. Her mother wrote to her in 1875: "Your dealer complains that you won't tell him your prices; I pointed out that I had just told him you trusted him, but it bothers him and he doesn't like it."[40]

Morisot gave paintings to people she believed would care for them. She offered two to Edouard Manet. Emile and Alexandrine Zola obtained theirs through Manet. Alexandrine thanked Morisot on March 5, 1877:

> I want to give you my warmest thanks for the delightful painting you've been so kind to give me.
>
> I'm almost afraid I was a little indiscreet, but please think of the request I made Mr. Edouard Manet only as our very great desire, on the part of both my husband and myself, to have a canvas by an artist whose refined and delicate talent we've loved for so long.[41]

Even when Morisot did sell, she appears to have usually sold to family members, friends, and colleagues. Although the buyers of her work at the 1875 Drouot auction belonged to the art world, Morisot also knew them all personally, at least indirectly. Morisot's best-known picture, *The Cradle* (Pl. III), was for sale for 800 francs at the first Impressionist exhibition of 1874;[42] Durand-Ruel had sent it to an exhibition in London the year before at almost double the asking price, 1,500 francs;[43] but in the end the picture went, unsold, back to the family, into the home of Edma Morisot and her daughter, the models for the picture. At the time of Morisot's 1892 Boussod and Valadon show, she owned twenty-nine of the works she exhibited and borrowed the rest from eight collectors. Those eight all belonged to her immediate professional and social circle: Dr. de Bellio, Edouard Manet's physician, Renoir's friend the diplomat and banker Paul Bérard, the publisher Paul Gallimard, the dealers Durand-Ruel and Portier, the critics Charles Ephrussi and Michel Manzi, in addition to members of her own family. Over the years she manifested a diminishing insistence on monetary recognition of her talent (which cannot be entirely explained by her personal income, since having money has never precluded wanting more).

Nothing exemplifies Morisot's feelings about the art market better than her relationship with Durand-Ruel. Durand-Ruel promoted Impressionism not only through exhibition but also through

judicious purchasing and selling. His success, ironically, enabled cannier members of the group, namely Monet, to play off other dealers like Georges Petit and Boussod and Valadon against him, thus beginning the escalation of the Impressionists' market value. Durand-Ruel did consistently exhibit Morisot's work in group shows: in London in 1873, 1876, 1882, and 1883; in New York in 1886; in Paris in 1888. But his records show he may never have sold more than seven of Morisot's pictures. Of those seven sales, six were to her friends or to friends of friends: Hoschedé, Rouart, Stevens, and Manet's disciple George Moore.[44] Moreover Durand-Ruel took Morisot's work on consignment as often as he bought it outright. Like Portier, Durand-Ruel still had unsold Morisot paintings at her death, including pictures dated as early as the 1869 *Lorient Quay*.[45] Always civil to each other, Durand-Ruel and Morisot never became cordial. When Morisot's 1892 show took place at Boussod and Valadon, it was both because Durand-Ruel had not offered her such an accolade (though he did to Cassatt in 1891) and because Morisot would not court it. She complained to Durand-Ruel's son Charles in 1888 about the way her pictures were hung and expressed her annoyance at being condescended to, especially in contrast with Puvis de Chavannes—"Aside, Pissarro and I comment philosophically on success."[46] Durand-Ruel might have judged Morisot's work unsalable; she could have disdained his commercial dealings. In either case her work did not suit his enterprise.

Already in 1875, the year after their marriage, Eugène Manet wrote Morisot asking if she wanted him to submit her work to the Dudley Gallery, a London gallery specializing in watercolors, many of them by women. "If you'd like, I'll show it all to Edouard [Manet]. I'll order the frames."[47] The prominent part played first by Morisot's mother and then by her husband in her business negotiations signals not just her reluctance to handle money but also her desire that they mediate her contact with the professional world. In conforming to women's traditional habits of deferring to their mothers and husbands, Morisot seems to have wanted to emphasize

to her mother and husband that they still took precedence in her life.

Husband and wife exchanged particularly revealing letters at the outset of the 1882 Impressionist exhibition. Ostensibly because she was caring for their daughter, Julie, during a brief illness, Morisot waited until the very last minute to arrange for anything of hers to be included. Eugène came to the rescue, traveling from the south of France to Paris and staying with Gustave, where they plotted with Edouard on Morisot's behalf; meanwhile Eugène chose pictures, had them framed, hung them, and praised them: "Gustave claims that it's your paintings that interest the public the most. Do something for the poor public . . . Give me your prices. Edouard says you have to ask a lot." Morisot responded with interminable fussing and anxious self-deprecation, reverting from exhibition issues to her maternal concerns. When she reported trouble concentrating on her work—"they knock at my door (you can guess how much I appreciate that while I'm working)"—Eugène replied, "Turn your visitors away, establish visiting hours in the evening and close the door while you work."[48]

Morisot hardly pursued exhibition at all. Even in her apartment she relegated her paintings to private back rooms while Manet's, Monet's, Renoir's, and Degas's work occupied public spaces.[49] Although she participated in the 1887 Exposition des XX in Brussels, she declined invitations from the same group in 1886 and 1891.[50] Writing a last letter to her daughter on her deathbed, Morisot asked that Julie contribute a painting of Manet's if Degas should ever found a museum of Impressionism but said nothing about any work of her own. "In truth, there were indeed a few pieces exhibited from time to time without fuss, as if with the wish to attract no attention," summarized Arsène Alexandre in his obituary.[51] If Morisot exhibited regularly during her entire career, it was less to make a reputation for herself in order to sell or become famous than to affirm to herself and to a small group that she was a serious painter and a mind to be reckoned with.

Morisot not only declined to participate in the market, she also rejected the possible solidarity of other women. When Louise Chandler Moulton came to Paris in 1890 to look at modern painting, she asked Mallarmé which avant-garde artists to investigate. Mallarmé put Morisot on his list. Moulton supported both women and Modernism; she devoted nine pages to Marie Bashkirtseff, the fledgling academic painter whose early death and posthumously published diary had catapulted her into public prominence, and also much admired Monet, Renoir, and Degas. Of Morisot's work she reported: "There was one lovely picture [in Durand-Ruel's private gallery] by Mme. Berthe Manet, the sister-in-law of Manet . . . This one picture is the only one I have seen by Mme. Berthe Manet. She does not exhibit; and as she is at present out of town, I cannot visit her studio."[52]

Morisot made no attempt to create any public, institutional, or political context for her work, not even within the nascent organization of women artists. She never joined the Union des Femmes Peintres et Sculpteurs. No mention of her appears in either *La Femme dans la Famille et dans la Société,* a women's rights journal that ran a regular art column in 1880–81, or *La Gazette des Femmes,* a journal run by Jean Alesson, who wrote in other contexts about women's art, and whose board included Morisot's friend the sculptor Marcello, though the *Gazette* duly noted the Impressionist exhibitions, as well as the marriage and death of another woman painter in the Impressionist circle, Eva Gonzalès. Jean Dolent, in his 1877 *Le livre d'art des femmes,* mentions twenty-three women artists, among them Eva Gonzalès, but not Morisot. The year of Morisot's Boussod and Valadon exhibition, 1892, was also the year of the Exposition des Arts de la Femme at the Palais de l'Industrie; Rosa Bonheur presided honorifically over a Beaux-Arts section that included five works by Bashkirtseff and none by Morisot.[53] One critic, at least, noted Morisot's lack of interest in women's art organizations; in an 1882 column reviewing first the Impressionist exhibi-

tion and then that year's Exposition des Femmes Artistes, the Union des Femmes Peintres et Sculpteurs' showcase, Charles Bigot did not mention Morisot's presence among the Impressionists, but chided her for her absence in the women's exhibition.[54] I have been able to find only one reference to Morisot's work during her lifetime in a mainstream women's magazine: an article on women's painting which placed her foremost among her peers, by none other than her collector Hoschedé, published in an 1881 issue of *L'Art de la Mode*.[55] An obituary also appeared in *La Grande Dame* accompanied by a reproduction of her *Young Woman in Ball Dress*, recently purchased by the Luxembourg.[56]

One of Morisot's staunchest supporters, Théodore de Wyzéwa, had written in his 1891 article on her (the only monographic article on Morisot published during her lifetime): "Mme. Morisot, however, is still not famous. The public hardly knows her name."[57] Learning of Morisot's death, Pissarro wrote his son Lucien on March 6, 1895: "That poor Madame Morisot, the public barely knows her!"[58] Morisot's passage into obscurity accelerated after her death, a decline in her critical fortunes that indicates how fragile and tenuous her career had been.

The critic André Mellerio called her posthumous exhibition "almost a revelation," and continued: "For many, barring the painters of her generation, the artist was known only by a small number of works."[59] But four years later Mellerio himself would assign Morisot a secondary rank, as, reviewing the Impressionist room at the Exposition de 1900, he declared: "Four artists must be mentioned: Monet, Pissarro, Renoir, Degas."[60] Typically, when Lionello Venturi published his *Archives de l'impressionnisme* in 1939, its subtitle read: "Letters by Renoir, Monet, Pissarro, Sisley and others. Mémoirs by Paul Durand-Ruel. Documents." He included almost nothing by Morisot. John Rewald's standard textbook *History of Impressionism*, first published in 1946, indexed 24 references to Morisot in comparison with 31 to Sisley or 33 to Zola. The book included 17

reproductions of paintings by Sisley, 7 by Morisot—and 2 illustrations of Morisot as Manet's model. Rewald referred to all artists by their last name, except for "Miss Cassatt" and "Berthe Morisot." (The *History of Impressionism* has since been revised.)

Morisot's work trickled into the public domain very slowly. Louis Rouart, one of her descendants, wrote in 1941: "Almost all her works: paintings, sculptures, watercolors, pastels, drawings, color crayons, miniatures and drypoints, belong to her family."[61] Of Morisot's 417 catalogued oil paintings—and oils are what a painter's reputation usually rests on—at least 227 belonged to her daughter, Julie, until well into the second half of the twentieth century, and at least another 34 belonged to other family members.[62] When Monique Angoulvent established a preliminary catalogue of Morisot's oeuvre in 1933—a catalogue based, admittedly, on Julie Manet's knowledge of her mother's work—out of 665 catalogued works in all media, 18 were in public collections, at least 73 items belonged to family and friends, and 441 belonged to Julie Manet. Morisot's 1941 retrospective at the Paris Orangerie was assembled, with the exception of 1 pastel from the Louvre Cabinet de Dessins, entirely from works in private collections.

Public awareness of Morisot's work has been further skewed by the disproportionately large number of early paintings among those that have left her family. Dr. de Bellio, for instance, counted 4 Morisots in his superb Impressionist collection, all of them painted before 1876. Chocquet, eminent collector of Delacroix, Renoir, and Cézanne, owned 2 Morisots, also painted before 1876. Pictures like de Bellio's and Chocquet's began circulating during Morisot's lifetime, passing through several private collections and then into museums; pictures in family collections have tended to remain private until quite recently.[63]

In the hope of counteracting her marginalization, Morisot's family lent her pictures generously. Almost every year, Julie Manet sent 1 or 2 paintings to some Paris exhibition,[64] and of course all Morisot's solo exhibitions depended almost entirely on her daugh-

ter's loans. Julie Manet and her husband, Ernest Rouart, gave works by Morisot to museums in Paris and in the provincial cities of Pau, Montpellier, and Grasse. To ensure that *The Cradle* (Pl. III) would enter the Musée du Jeu de Paume, then the national museum for Impressionism, the Rouarts offered in 1930 to donate Edouard Manet's *Woman with Fans* if the museum would purchase Morisot's painting from their cousins the Forgets.[65]

Nevertheless, and despite the Rouarts' efforts, few of Morisot's paintings could be seen regularly, even in Paris. Although the Jeu de Paume owned several, often only *The Cradle* hung in public galleries.[66] More paintings by Morisot were bought in the United States than anywhere else, yet the solo exhibition drawing entirely on American collections in 1943 by the Arts Club of Chicago revealed that "more" did not mean "many" in public institutions. Of 30 works on display, 7 came from 5 museums, 10 from 7 private collectors, and 13 from 4 commercial galleries.[67] The discriminating Danish collector William Hansen bought Morisot's 1874 *Portrait of Marie Hubbard* (Fig. 59) sometime before 1918, together with, or soon followed by, her 1885 *The Red Bodice*.[68] Since Hansen planned all along to turn his private collection into a public museum, these pictures could be considered the second and third Morisot paintings—after the Luxembourg's *Young Woman in Ball Dress*—purchased for public exhibition. Yet these 3 pictures had passed into museums through private intermediaries. Only in 1929 was a Morisot painting bought by a public institution on its own initiative: *Portrait of Maria Boursier and Her Daughter* (Pl. VI) by the Brooklyn Museum.[69] Morisot's work, therefore, especially in comparison with the other Impressionists', remained difficult for the public or even art historians to know firsthand.

Is this second narrative the tale of Morisot's failures? Or is the problem our categories? Morisot's professional "failures" could be interpreted as feminine "successes," while according to the gender conventions of her time, her professional "successes" could be attacked as feminine "failures." It may be unproductive to consider a

woman's work as if she could conduct a career independently of her gender, as if she did not have to merge the professional roles of painter, reformer of art institutions, competitive producer of art, and stylistic innovator with the personal roles of daughter, sister, wife, and mother. Morisot probably groped her way forward as many women do, with conscious but small-scale daily concessions to competing claims, eking out bits of free time, perhaps not calculating what the days might add up to, but trying to make each day count.

Morisot stands out because in her case the choices, efforts, and achievements were more than individual. However diffidently or marginally or partially, she engaged in a domain of thought and production where collective values could be made or unmade. She spent her life doing work that would last and would affect other people's understanding of themselves and their place in the world. Her work took the permanent form of pictures, and it is through specific pictures—hers, other women's, and men's (of women)—that her accomplishment can be understood, by thinking about how pictures were made, circulated, or related to each other, and about how images constructed social identities and ideals. I use the words "image" (which implies a concept) and "picture" (which implies an object) to get behind the assumptions implicit in words such as "painting," "amateur," "art," and "advertisement." For Morisot's achievement came from her ability to work with those assumptions and adjust them flexibly in new ways.

The rest of this book is about such adjustments between what we can provisionally call "painting" and "feminine visual culture." Because so much more is known about Impressionist painting than about the other kinds of pictures Morisot grew up with or dealt with, the book as a whole betrays a compensatory impulse. I am not sure, though, whether any account of a woman's history could be smoothly organized along a biographical or career trajectory, pulled at an even pace along a chronological path. Nineteenth-century femininity tended to submerge individual women, and the im-

ages of its visual culture, a marginal area which remained on the periphery of a dominant patriarchal culture, concealed a deceptive undertow as likely to immobilize women as to carry them to sure ground. Morisot worked with values and meanings and practices she did not determine and could not control. Over time, she did, ultimately, attain some measure of artistic autonomy and therefore most of the book does generally move forward chronologically and concentrates increasingly on Morisot's individuality. Nevertheless, her story is not one of progress, but one of ceaseless negotiation.

Art critics since Morisot's youth have all agreed that her work represents femininity. Speaking with a vested interest in fine art, art critics could hardly be considered neutral reporters, which in this context makes them a good starting point.

Mallarmé wrote in 1876, at the beginning of his acquaintance with Morisot: "More given to render, and very succinctly, the aspect of things, but with a new charm infused by a feminine vision."[70] After twenty years of close friendship, he added: "she whose talent current praise wishes to denote Woman."[71] Félix Fénéon in 1886 praised "a feminine charm without affectation."[72] Gustave Geffroy similarly rambled in his 1892 catalogue preface and finally concluded with acclaim for "this woman who is a rare artist and who accomplishes something so rare: a painting about observed and living reality, a delicate painting, lightly brushed and vivid,—which is a feminine painting."[73] Morisot's own daughter described her mother's work, displayed at her posthumous retrospective, as "work so feminine and which maintains itself so well."[74] The art historian Madeleine Benoust added in 1936, "an exquisitely feminine creature, whose life cannot be told: she appeared, she felt, she passed."[75]

But what did all these commentators mean by "feminine"? Critics of Morisot's work go out of their way, over more than a century, to insist that this femininity does not merely mean that Morisot is a woman. Distinctions between Morisot and other women painters recur throughout criticism of her work, distinctions interpreted as Morisot's particular accomplishment. Already in 1878

Duret observed: "Mme. Morisot's painting is indeed a woman's painting, but without the dryness and the timidity with which the works by artists of her sex are generally reproached."[76] An anonymous reviewer of the 1886 Impressionist exhibition, probably George Moore, gushed: "Madame Morisot—the only woman who has ever been able to infuse a trace of her sex into her art . . . It is life seen from a different side."[77] This same idea dominated Wyzéwa's 1891 article. Only Morisot satisfied his definition of feminine painting: "There are plenty of women in the history of art: but what is altogether missing, is exactly a woman's painting, a painting that expresses the particular aspect that things must offer to feminine eyes and a feminine spirit."[78]

Apparently Morisot's professional contemporaries were convinced of what they saw. Still, we are not much closer to knowing what exactly they were seeing, or, to put it another way, why they thought they knew what they were seeing. What was a "feminine" picture in the second half of the nineteenth century? By applauding Morisot's femininity while marveling at its rarity, critics both approved of it and distanced themselves from it. Morisot had mastered the expression of femininity, but in so doing she represented values outside their ken, evading their professional definition of familiar and therefore satisfactory work. Critics could explain femininity only as a difference from what it was their business to be familiar with, or as an insufficiency, a lack. Frustrated, Joris Karl Huysmans exclaimed in 1883: "Always the same,—hasty sketches, refined in tone, charming, even, but come now!—no certainty, no whole and full work."[79]

Mallarmé approached the limits of his own perception in his opaquely phrased 1896 catalogue essay. He realized that hidden from him beneath a seductively feminine, "less peremptory," "elysianly delectable," color surface must be an "armature" "on integral conditions perhaps even hostile to passersby." But even to Mallarmé it remained unclear to what use Morisot put her "acuity" and

"mastery." Her work still seemed to him a "pane of glass," a "fasci-
nation one would like to enjoy," a "divination" that "defends itself."
If we look through the "pane of glass," behind the surface, not, as
Mallarmé warned "superficially and through presumption," we may
learn what were the "conditions" of Morisot's "integrity."[80] But to
do that, we have to leave the critics behind and venture outside their
sphere of competence, to images governed by other values.

Chapter Three

———

Amateur Pictures: Images and Practices

When art critics or friends called Morisot's work "feminine," they referred to a specific pictorial tradition.[1] They were seeing in Morisot's pictures a likeness to images they already knew. Her work echoed in many ways the amateur art made by countless women of her time as well as the generations preceding hers. These images and the practices that created them represented bourgeois European women's social values and experience. It was so obvious at the time that Morisot's pictures came out of a feminine amateur tradition that no one had to articulate the point. It was enough to say that Morisot's work was feminine for anyone to know what was implied.

By some definitions Morisot was an amateur painter all her life. She herself chose the rubric "no profession" for official documents like her wedding certificate; her family did the same for her death certificate. According to almost any criterion Morisot worked as an amateur until the age of thirty-three. According to prevailing artistic standards, amateur art was inferior and expendable, and Morisot acted on these judgments by destroying virtually all her early work. Her beginnings may have embarrassed her, but they remain her starting point.

If we reconstruct the cultural climate of Morisot's youth, virtually nothing distinguishes her from dozens if not hundreds of her peers. It is essential to understand the extent of the amateur phenomenon in order to understand Morisot's trajectory. The banality of her beginnings explains why, in a time when professional art was a masculine occupation, she should have encountered no initial obstacles to her pursuit of painting. Morisot's amateur artistic origins

also explain her later deviations from professional career paradigms. The least professionally conventional aspects of Morisot's career were for a woman the most conventional not only socially but also artistically.

Nineteenth-century women's amateur art has never been fully studied.[2] Considerable difficulties in finding, correlating, and measuring material impede a history of amateur art. By definition, amateur work was neither systematically exhibited nor preserved in institutions; nor has it been "collected" except by a few devotees. Most of my primary "research" has been conducted in family homes. Actual drawings, paintings, or albums have been scattered, and even what survives cannot always be fully identified because information about its maker and original context has been lost. A few amply documented cases provide points around which disparate material can be organized; some allowance, however, must be made for the tendency of these cases to be of women who became famous for other reasons, either for their own achievements or for those of their male relatives. In France, particularly, amateur work remains virtually unknown.[3] A wealth of indirect evidence gleaned from all kinds of texts compensates for this lack of direct sources: references to amateur work, often extensive, in novels,[4] biographies, family histories, journals, etiquette manuals, pedagogic treatises, political commentaries, and magazine stories. Visual sources also testify to the prevalence of amateur picture making: genre scenes in both high and low arts, ranging from paintings to fashion plates.

The frequency of these references indicates how many upper- and middle-class women drew or painted. Most girls in these classes learned rudimentary drawing and watercolor techniques and even occasionally oil painting skills. They were taught for several years or for several consecutive summers by someone else in their family or by hired teachers—during summers often by itinerant teachers. These lessons took place during their adolescence, usually in the company of sisters or female cousins.

Artistic proficiency counted among the feminine accomplish-

ments which could attract suitable husbands. Morisot's mother in-
tended her three daughters to cultivate such an accomplishment
when she first took them in 1857 to Chocarne for drawing lessons.
Few more professional options were then available to a respectable
middle-class mother. Cornélie Morisot could, however, have taken
her girls to the somewhat rigorous studio run by the fashionable
painter Charles Chaplin for ambitious young ladies, but she didn't.
Her letters to a very young Berthe had made it quite clear that for
women the arts should be a pleasure and a pastime, a skill exercised
primarily for their own edification: "You'll see later how glad you'll
be to give pleasure to others and some moments to yourself."[5]

Boys, too, often took art lessons, but within a diverse curricu-
lum, whereas girls might have received systematic training in little
else.[6] John Stuart Mill wrote in his 1869 *Subjection of Women,*
"Women in the educated classes are almost universally taught more
or less of some branch or other of the fine arts . . . their education,
instead of passing over this department, is in the affluent classes
mainly composed of it."[7]

Early exercise provided a technical basis for later work. Al-
though many women abandoned hobbies after the first years
of marriage, some went on painting or sketching for the rest of
their lives, among them Louise de Broglie, comtesse d'Hausson-
ville (1819–1882), better known as the subject of Jean-Auguste-
Dominique Ingres's portrait than as a dedicated amateur artist.[8]
Amateurs often devoted many hours a week to making pictures.

A rising middle-class family like Morisot's encouraged women
to cultivate artistic accomplishments, called *arts d'agrément.* While
some grand-bourgeois families left girls little free time, occupying
their days with religious, charitable, or social obligations, others
gave their daughters the leisure to develop intellectual talents. Two
recently published diaries written by Morisot's peers illustrate these
different tendencies. Caroline Brame filled her notebooks with the
religious and family concerns of her regimented schedule.[9] By con-
trast, allowed time to herself in which to read, ride, draw, or paint,
Geneviève Bréton mused about art, love, and woman's condition.[10]

The Morisot family belonged to the Bréton type, all the more so because Morisot's father, Tiburce, had had a first career in architecture and cherished the memory of a youthful trip to Italy where he had been moved by the masterpieces of the past.

Take the example of Sophie du Pont (1810–1888), born in America of French parents. Her first exposure to picture making came at the age of eleven, when two traveling artists stopped at her parents' country home. Sophie du Pont's elder sister Eleuthera began taking lessons with one of these artists, Charles Alexandre Lesuer, in nearby Philadelphia the next year. Lesuer came back to the du Pont home in subsequent summers and led several young men and women, presumably including Sophie du Pont, on informal outdoor sketching expeditions. Du Pont's uncle Charles also gave her lessons at home. Her only official schooling consisted of four months at Mrs. Grimshaw's school in Philadelphia at the age of fifteen. During this period she also took drawing lessons with Lesuer. He returned to France that year; du Pont continued to draw on her own and also scheduled regular sketching excursions with her cousin Ella. "Ella and I draw from nature every Monday and Friday,"[11] du Pont wrote in 1825. Three years later she was still assiduously drawing. "Once a week, when the weather permits, Ella comes over to draw with me, as My Aunt hoped thus to give her some encouragement. But I fear it does her very little good, as she never will draw at home, and once a week, even if she would come regularly, is too little to improve much."[12] In the decade between 1823 and 1833 du Pont produced more than two hundred surviving caricatures, drawings, and watercolors. After her marriage she stopped her artistic work completely.

Judged according to contemporary esthetic standards, amateur art peaked in France in the years between 1820 and 1850. These were the years when young women like Marguerite de Krüdener, who took lessons from artists as eminent as Ingres, rarely intended to become professionals. Krüdener (1818–1911), the daughter of a Swiss-Russian diplomat who lived in Passy from 1825 to 1837, took lessons from Ingres in Paris in 1834 and from Joseph Hornung

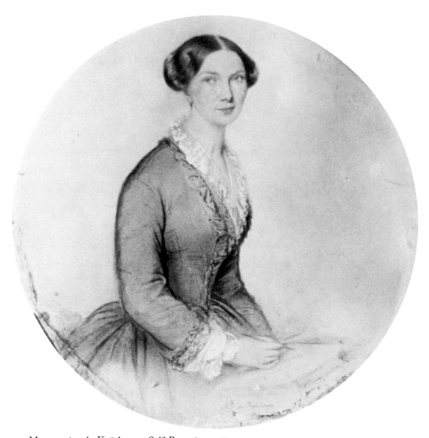

7. Marguerite de Krüdener, *Self-Portrait,* c. 1851.

(1792–1870) in Geneva in 1840.[13] The technical proficiency and artistic confidence she gained is evident in the watercolor and gouache self-portrait she made around 1851 (Fig. 7).

Many women considered their own work or other women's to be of professional quality. Over and over, novels written by women in the generation preceding Morisot's tell stories of a woman artist whose amateur skill enables her to support herself in a crisis. In 1837 Hippolyte Auger described an irreproachable heroine. "Entirely devoted to her studies, in the hours she spends in the Louvre, she never turns her eyes from her canvas and her palette . . . The

governess who chaperones her never leaves her; back home, it's still work that occupies her." Then she predicted: "Léonie will have, I believe, a remarkable talent that might procure her independence."[14] In 1835 Aloïse de Carlowitz staged a dialogue between two men looking at a self-portrait by the heroine, Francesa Léonard. Not knowing who the author is, one exclaims: "What correct draughtsmanship! what truth, what brilliance of color!" The other names the painting's author.

> —This is more than an amateur talent, murmured the Marquis.
> —And she doesn't paint to amuse herself, but to earn a living.[15]

Both Auger and Carlowitz praise a remarkable skill with professional potential that emerges from an acceptable and unsurprising amateur occupation. Only financial necessity forces amateur talent into the professional arena.

Women writers did not claim that amateur artists were actually professionals; they claimed only that the quality of the artistic work was of professional caliber. Painting, no matter how excellent, could leave its author's femininity intact, even when she was obliged to sell. As long as her heroine Eugénie Delmar only paints landscape pictures for a living, Mme. Monborne describes her in 1834 as "always calm, gentle, resigned, she offered the touching picture of virtue struggling against misfortune."[16] But when Delmar decides to write plays, then, speaking in the voice of the maid—"she had good sense, Marguerite the maid did, which is worth more than cleverness"—Monborne exclaims, "Author! . . . good Virgin Mary have pity on us . . . from the instant that the writing craze takes hold of you, we won't be able to understand you any more . . . Besides I've always heard that men didn't like women who write."[17] George Sand (1804–1876) lived such a scenario; before she settled on her notorious literary career, she contemplated turning her considerable skills as a portraitist (Fig. 8) into a profession.[18]

Wherever Morisot might look among older women in her so-

8. George Sand, *The Artist's Mother, Sophie-Victoire Delaborde Dupin,* date unknown.

cial situation, there were artists. Some were good even by Salon standards. Some were proud of their talents and accomplishments, like Marguerite de Krüdener who looks calmly outward as she represents herself at work, instrument in hand (Fig. 7). Some praised each other, as the authors of contemporary novels did their fictional heroines.

Julie Pradel de Saint-Charles's 1820 self-portrait (Fig. 9) summarizes amateur work's achievements. Pradel (1798–1866), the child of a solidly upper-middle-class family, represents herself at

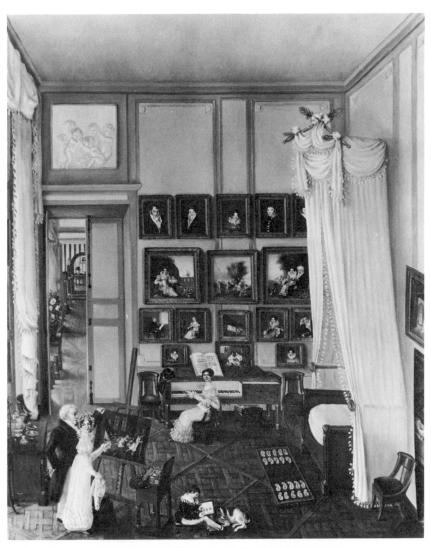

9. Julie Pradel de Saint-Charles, *Self-Portrait with Family and Works*, 1820.

home on the rue du Faubourg-Saint-Denis.[19] She sits in a room which functions as her bedroom and her music room, as well as her painting studio, in the company of her father, mother, brother, and dog. Pradel does not identify herself directly with painting—which is signaled in the picture's foreground by her easel and by her paint-box on a chair—but lets her parents draw our attention to it; she herself sits at a piano, balancing one *art d'agrément* with another. Yet at the same time she boasts by including many paintings within her painting, all of them her work.[20] By academic standards, they are all relatively small and on minor subjects. The painting on the easel represents a childhood scene, the rest are all portraits against plain or landscape backgrounds. Stylistically—again by academic standards—the picture looks stiff and awkward, especially the figures. But her organization of the picture's content reveals another kind of sophistication.

Pradel places herself behind her parents and her brother. Yet the distance between them puts her at the center of the image. Similarly, her brother reads an illustrated book center stage, while her painting and music are spatially peripheral; within the room, however, the products of her activity occupy an enormous surface area in comparison with his, just as the music sheets behind her head dwarf his book. Pradel turns her work in progress on the easel toward a corridor that reaches far back into pictorial space, its length scanned by light coming from unseen windows, half closed to us at one end by the doors to Pradel's room, half opened at the other by a wall and psyché mirror.[21] Playing off against these three dimensional illusions she composes a surface pattern that tightly fits a tiny reflected painting between the door and mirror frames. It echoes the plaster cast of gamboling putti aligned above it, which itself repeats the proportions of Pradel's paintings. With all these references to sight and views and images, Pradel cleverly and self-consciously reminds us that she is a thinking picture maker.

Most amateur women painters, like Pradel, concentrated their artistic energies on their family and domestic interiors. They tended to interpret three kinds of subjects: portraits of family, friends, or

10. Elisabeth-Félicie Desmolins Mallarmé, *View of Naples,* 1846.

themselves; indoor or outdoor scenes of domestic life; and episodes or views of family trips. Each of these categories in turn included images of approved entertainment, often of theatrical performances familial or professional, and of scenes from books. At the risk of arbitrarily selecting illustrations from among many possible examples, none more uniquely interesting than any of the others, I have chosen a few representative pictures, mostly by women referred to elsewhere in this book. Krüdener's and Pradel's images (Figs. 7 and 9) provide examples of self-portraits and interiors. A gouache image of Naples made during a trip in 1846 by Mallarmé's mother, Elisabeth-Félicie Desmolins Mallarmé (1818–1843), illustrates the vacation landscape type (Fig. 10). Among portrait subjects, amateur women painters preferred their mothers, sisters, and children, either singly or in pairs. Typical portraits include: Sand's undated pencil drawing of her mother, Sophie-Victoire Delaborde Dupin (Fig. 8); a pencil and gouache drawing, c. 1840–1855, by the fashion illustrator Heloïse Colin Leloir of her sister Anaïs Colin Toudouze and Toudouze's baby (Fig. 11); a pencil drawing, dated 1837, by Victor Hugo's wife Adèle of their child Léopoldine (Fig. 12); and finally Edma Morisot's oil portrait of Berthe (Fig. 15). This

11. Heloïse Colin Leloir, *The Artist's Sister Anaïs Toudouze with Her Child,* c. 1840–1855.

iconographic pattern remains remarkably constant regardless of intellectual, economic, or political disparities. A woman as exceptional in almost every way as Sand conformed in her picture making to the amateur paradigm. Even a professional illustrator like Leloir reverted to type in images she made for herself.[22]

Amateur women painters depended on the security of these subjects and relied on the familiarity of pencil and watercolor. In 1855, 133 women exhibited pictures in the official Salon; only six years later in 1861, 319 did.[23] Watercolors had begun to be numbered among exhibited works. As soon as the Salon recognized a favorite amateur medium, the number of women whose work could be counted rose and stayed higher than it had ever been, higher both in absolute figures and in proportion to the numbers of male exhibitors.

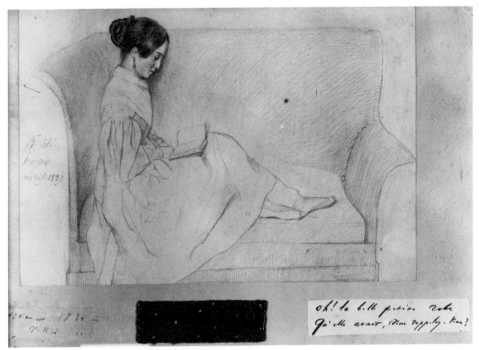

12. Adèle Hugo, *The Artist's Daughter, Léopoldine Hugo,* 1837.

Despite the intellectual or formal merits of much amateur work, and despite forays into the market and Salon exhibitions, the difference between amateurs and painters working in the most prestigious genres and media remained great. Women themselves believed in the superiority of high art. In her 1846 novel *Nélida,* Marie de Flavigny, comtesse d'Agoult (under the pen name Daniel Stern), casts the heroine's aunt, the vicomtesse d'Hespel, as a petty and self-satisfied amateur artist. Stern sarcastically has d'Hespel explain herself to Guermann, the male protagonist.

> You won't think much of my work . . . for all of you history painters, as you're called, you have no use for genre. I started with oil, three years ago; but frankly, it smelled too bad, it was too dirty. I prefer watercolor, and I think I've gone as far as possible in the composition of interiors . . . Oh! it's not much,

she said with a bit of pique, noticing that Guermann hadn't said a word; don't try to find an epic scene; but it's fresh, it's simple.[24]

Guermann loses his temper and expostulates, "Art is great, art is holy, art is immortal. The artist is first among men, because he has the gift of feeling with greater intensity and expressing with more power than anyone else the invisible presence of God in creation."[25]

Sand seems to share this view when, in her autobiography, she skims over her own picture making to dwell on her discovery of the Old Masters: "I entered one day into the museum of painting . . . Lost in contemplation, I was overwhelmed, I was transported into a new world."[26]

Discrepancies in training, exhibition, format, medium, and genre constituted the material signs of more fundamental differences between fine art and amateur art. Even in cases where the formal quality of amateur pictures could be compared with professional work, the assumptions and practices that informed their existence were not associated with great painting; on the contrary, they seemed diametrically opposed to what made art valuable.

Creativity in the nineteenth century operated according to patterns differentiated by gender. Feminine and masculine values divided amateurs from professionals but also female amateurs from male ones. Adèle and Victor Hugo provide an example, extreme perhaps but telling. Both wife and husband drew. She adhered to the usual amateur themes: children (Fig. 12), self, home. He produced caricatures and, more frequently, ink and wash drawings of vast landscapes and picturesque architecture, often Gothic, always grandiose and dramatically rendered with tempestuous contrasts of light and dark (Fig. 13). Her images are meticulously linear, his bold and broad; hers concentrate on people and settings she knows, his create fantasy places.

Although his visual work was, strictly speaking, amateur, it was closely related to his professional written work, both stylistically and thematically. His illustrations were accepted as accompa-

13. Victor Hugo, *City in a Plain,* no date.

niments to some of his novels, such as *Notre Dame de Paris;* indeed several of his drawings were projects for his books' frontispieces. Hugo definitely claimed to be the author of his drawings as well as of his books; in several of his pictures (Fig. 13 among them) his authorial signature even swells to gigantic proportions and looms over the landscape. Hugo's drawings became known in his lifetime to a widening circle of peers. Praised for their conceptual scope and somber strength, they were judged by critics to be art works in their own right. Baudelaire wrote in his "1859 Salon" of "the magnificent imagination that runs through Victor Hugo's drawings, like the mystery in the sky."[27] Already in 1863 some of Hugo's drawings were published with a preface by the professional art critic Théophile Gautier. They have since been published or exhibited many times and have received systematic art historical attention.

Adèle Hugo related her images to intellectual pursuits inasmuch as she depicted her children involved in them, representing Léopoldine, for instance, reading on a couch (Fig. 12). Though the drawing is signed and dated, the prominent place of her husband's signature is taken in her image by a swatch of fabric and a label. The label reads: "Oh! the lovely little dress she had on, do you remember?" These words recall the child pictured in the drawing

by means of a dress she once wore (perhaps when her mother made her portrait), an identification materialized by the piece of the dress fabric.[28] The label's text invokes the beholder's memory of a child whose loss both the drawing and the fabric are meant to counteract, each in its own way: the drawing by its representational evocation, the fabric by its obdurate tangibility. By presenting her image as part of an assemblage of different kinds of meanings, Adèle Hugo acknowledges the insufficiency of any one of them. Fabric, drawing, and writing all depend on each other. She appeals to a spectator not in order to retreat into a separate pictorial world created by the imagination but in order to revive a piece of a lived past. Only to those who share an interest in that past can this work or others of Adèle Hugo's be relevant. History has treated her work accordingly. Most of it is scattered or lost, and what survives is published or exhibited to illustrate her husband's biography.

We can understand something about Adèle Hugo's picture of Léopoldine because her family's history has been recorded and also because the picture's presentation has been preserved. How much less we would know of her intentions had the portrait not remained juxtaposed with fabric and text. Nineteenth-century amateur women artists very often grouped their pictures or assembled them with various objects and captions, binding them together into books called albums or keepsakes.

Initially a volume of blank pages, the album could contain whatever its maker chose.[29] Albums ranged from tooled, leather-bound, gold-stamped books with ornamental clasps to cardboard-covered tablets. They measured between twelve by eighteen and two by four inches, and contained somewhere between twelve and a hundred sheets. Whatever the format, contemporary commentators like Victor-Joseph de Jouy in 1811 designated the album as a feminine object and practice: "Every woman is inseparable from her album."[30] Francis Guichardet in 1841 traced the spread of the album to the middle classes with elitist disapproval.

14. Marie de Krüdener, album page, 1863.

In the past, this luxury object was found only in elevated aris-
tocratic regions, in the salons of elegant society, on the side-
table of the woman of the world: now it has fallen degree by
degree into the middle class: the wife of the manager's assistant
has her album; the porter's daughter, young prodigy moved by
a vocation to follow courses in the free municipal school, is
ready to put together her album.[31]

Both evidence and product of a feminine attitude toward the
visual image, albums subsumed individual pictures. In the album
pictures derive meaning from their relations to one another, from
their part in what album makers defined as significant wholes. Both
Marguerite de Krüdener and her sister Marie made albums. A page
of one of Marie de Krüdener's albums recapitulates the album's
logic (Fig. 14). Grouped on the page are six stereoscopic views: one
of a house, two views over houses to hills beyond, and three of
people, one in a street, one behind a building, and one in a garden.

We know from other parts of the album and from family history that the people are Marie de Krüdener's family, and the house a home she and her family lived in. What the page as a whole shows us is that the views, the people, and the house are each thought of as parts of a larger composite image. The garden is attached to Marie's home, the views are seen from the home, the figures in the street are part of the family, and the house is being pictured because the family lives there.

Women's amateur pictures can be thought of as detached album pages. Many amateur pictures were not made for albums, of course, but they were made on the basis of the same assumptions that produced albums. Albums demonstrate more clearly than separate pictures the principles of amateur pictorial practice, principles as fundamental as the irrelevance of authorship and originality.

The connections women made between the elements of their albums were so much a part of what they were expressing that pictures did not have to be individuated. Marguerite de Krüdener's and Sophie du Pont's albums, like many others made before 1850, contain only pictures they drew or painted. Krüdener and du Pont are therefore the authors of their albums in a conventional sense. But other albums included images by several authors or images that cannot be said to have had conventional authors at all. A picture incorporated into an album could be a copy, by the woman assembling the album or even by someone else; it could be a mass-produced print or a photograph; it could be anything as long as it related to the album maker's sense of herself and her experience. Because the authorship of an album did not depend on the source of individual images, the difference between an original and a copy became unimportant. Léopoldine Hugo (1824–1843), for instance, put together an album that contained nothing by her own hand. She preferred copies after contemporary prints by Gavarni and Tony Johannot drawn by her younger brother François-Victor (1828–1873). As Pierre Georgel has pointed out, Léopoldine and François-Victor were commemorating their favorite shared reading. And as

Georgel has also demonstrated by an erudite analysis of the entire album, Léopoldine Hugo consistently gathered images which were connected only by their relevance to her, both as images of what she wished to record and as images by friends and family she decided to remember together.[32]

Just as feminine album makers mixed images of disparate origins and degrees of originality, so they were willing to interweave images and words. Some albums are filled with nothing but pictures; some contain only inscriptions; many mix images and texts. Annotations or captions can situate an image, provide a date, the name of a maker, an audience, identify an event or its resonance, just as Adèle Hugo's caption did for her portrait of her daughter.

Exactly the tradition that encouraged Berthe Morisot to devote herself to making pictures therefore distanced her from the values that would earn her pictures status and recognition. Her problem was all the more difficult because amateur art was not a trivial or incompetent version of high art, which if improved upon could replicate high art's values. Amateur art was, on the contrary, a very successful exponent of a radically different set of values, the bourgeois feminine values Morisot was raised to believe in.

Women's amateur work represents the places and activities with which the bourgeoisie identified itself. Travel scenes record middle-class leisure: earned, no doubt, and seriously spent. Images of relaxation and tourism balance concepts of labor and office. Landscapes catalogue middle-class vacation spots: beaches, lakes, spas, country houses, or the more exotic Alps, Middle East, and North Africa, sometimes adorned with picturesque peasants. Souvenirs of theater performances and scenes from novels or poetry illustrate genteel amusements.

As rest was to work, so was private to public, and feminine to masculine. The bourgeoisie tried to polarize its experience into separate spheres, ideally finding shelter in the one and purpose in the other. New living patterns decreed new spaces, the sacrosanct spaces of home. Femininity belonged to the home, in the home.

Masculine men occupied and needed a home, but one managed and graced by feminine women.

Women's images described a feminine domain. They helped define it. The outside world in amateur imagery reaches only as far as families went on vacations or unmarried women could go un-chaperoned—not as far as cafés, boulevards, or professional studios, let alone into the realms of erudition, politics, or history. Even within these boundaries only women's places are represented: the park or garden, the ballroom, the parlor—not the office, the billiard room, or the stables. Virtually all women's amateur imagery focuses on the artist's home, and on women's domestic occupations. There, in twos or threes, women often play the piano, read, sew, sometimes pose or draw, occasionally dance. Men make rare appearances in amateur images, and then as family members, and only in women's territory. The objects that recur are women's objects: porcelains, fans, knickknacks, small pets, and above all needlework.

Amateur images emphasize the signs of femininity. Etiquette books of the period, novels, moralistic tracts, and sociological essays all agree in assigning a gender connotation to the places and objects depicted with such persuasive frequency. Women certainly spent time in other places, used other objects; the ones they chose to use as visual self-expression were ones that stood for their roles as daughters, sisters, wives, mothers, and homemakers. The place so often returned to in feminine imagery, the small worktable in the parlor, by window or hearth, was designated a center of feminine gravity, a spot from which the values of home and family emanated. One short story signed by Emmeline Raymond, published in the popular women's magazine *La Mode Illustrée* in 1871, articulates the worktable's significance. A concerned husband chastises his heedless wife: "The most important of all duties, because it subsumes all her obligations, is to know how to stay at home."[33] How shall she learn, the wife inquires? He answers: "Have, I beg of you, a worktable, at which you will acquire the habit of sitting for a few hours each day."[34]

What amateur artists depict is a social role, not a biological condition. They sedulously avoid the female body itself. Here class distinctions that purported to disembody bourgeois women and animalize lower-class women take visual form. Two kinds of women populate feminine imagery: working-class and middle-class (or upper-class identifying themselves with middle-class values). Working-class women virtually all appear as domestic servants performing the kinds of household chores from which middle-class women would like to distance themselves. Images of bathrooms, or bedrooms that do not double as parlors, are equally rare and tend to be relegated to caricatures, disclaimed thereby with pictorial irony. Servants are represented as members of extended families, and only the mother-substitute wet nurse ever gains pride of place.

Women visualized a social, mediated self. Feminine imagery was a performance in which women were the actresses. They were playing a pictorial role that built on but concealed the efforts and conditions of its creation. Stylistic and social innocence should not be confused. Women in their amateur images displayed a conscious sense of social values. Nor should those values be categorized as the passive obverse of active masculine values. The gender polarization determining the outer limits of feminine imagery does not explain its inner structures. Opposed terms of public and private, society and individual, performance and genuine emotion do not fit a feminine imagery which blurs public and private, self and other.

Amateur imagery represents only the most social aspects of domestic life. Middle- and upper-class apartments had their public and their private areas; amateur women's pictures concentrate on the public. They avoid whatever is solitary and intimate and contain almost none of the introspective musing or personal reactions more common in verbal diaries or journals.

Feminine imagery works not just *with* objects or settings, but also *through* them to depict, cultivate, and perpetuate ideals of social harmony and emotional bonding. Amateur pictures represent shared experience. Travel souvenir pictures, for instance, include

many images of companionship and social events as well as pure
landscapes. Often images and especially captions recall the inter-
action, serious or comic, between travelers and local inhabitants.

Self is understood as it affects others. Women dwell on their
presentation of themselves to mutual scrutiny. At resorts, at balls,
in the loges of respectable theaters, on balconies (the domestic the-
ater loge), women go on display: to arrange marriages, conduct
personal business, introduce their children, or engage in the critical
occupation of seeing and being seen.

Women who made amateur pictures did not hide themselves
or their works from a male audience; a number of nineteenth-
century paintings by men represent women sketching out-of-doors,
and women artists used male family members as models. But
women preferred to represent each other, their times together, their
meeting places. Many of their inscriptions address each other. Their
pictorial work celebrates the bonds between artist and subject, es-
pecially those between the artist and her mother, sisters, daughters,
nieces, or their substitutes.

Amateur pictures dwell on the places of feminine sociability,
above all the parlor and its outdoor equivalents, the veranda or pri-
vate garden. Sophie du Pont wrote of the parlor, "We spend day
after day, quietly and happily enough, in reading, drawing, sewing,
conversation and music,"[35] and devoted an entire little album to the
parlor in 1830. There the mistress of the house received and paid
"calls." There women met friends, maintained family ties, broad-
ened their acquaintances, paid deference to social superiors, and
cultivated husband's colleagues through their wives. There infor-
mation was exchanged, alliances forged, business conducted. And
there mothers trained their daughters in the graces, disciplines, and
rituals of their condition.

The social orientation of feminine imagery extended to the
conditions of its creation and exhibition. Women rarely painted or
drew alone, tending instead to work in the company of a female
relative or friend, as in the case of Sophie du Pont and her cousin
Ella, or the case of Edma and Berthe Morisot; more often one

woman would sketch while the other played an instrument or sewed. Women transmitted their skills across generations, from mother to daughter or from aunt to niece. George Sand's grandmother Aurore de Saxe Dupin painted, for instance, as did Mathilde, the daughter of Louise de Broglie, comtesse d'Haussonville. Amateur pictures were hung in family rooms, given as tokens of friendship, exchanged as talismans against separation. Literary descriptions as well as pictures tell us that albums were usually presented on a table or console in the parlor, where they could be leafed through or added to by callers.

A majority of amateur artists were young women between the ages of about sixteen and thirty-five. Of the women who continued to paint or draw for the rest of their lives, a majority seem to have been single. Subject matter, emphasis on social life, and the age of the women involved suggests that amateur art served a transitional function. Women made pictures at liminal moments in their lives, especially just before or after marriage and motherhood. Many started making pictures during adolescence, when they left school, fell in love, or gave birth to their children. Interludes marked by travel also spurred picture making: "finishing" trips after school and before coming out, for instance, or honeymoon trips. Women actively represented feminine conventions during phases in which they had to redefine themselves and their social role. Picture making rehearsed feminine obligations and privileges. Feminine imagery functioned as a means to both learn and perform an identity.

Women's amateur pictures demonstrate pride taken in the accomplished performance of a role, but that pride reached its culmination in self-effacement. The final purpose of feminine art was dissolution into a family context. Many young women took up drawing or painting or album making in a passage toward a married life whose obligations would preclude picture making. Small in size, rapid in execution, feminine art was squeezed in between more imperative domestic or emotional preoccupations. These little pictures were integrated into domestic surroundings or closed between book covers. Gradually they merged into a family's sense of itself, of its

home, characters, kinship networks, entertainments—of its history. Outside their families these pictures had little value of any sort.

Feminine and masculine types of art did not just look different; they obeyed fundamentally different conceptions of meaning and purpose. Albums and amateur paintings were small images perused in intimate settings; ambitious professional paintings were made on an institutional scale. Feminine picture makers tended to work with delicate evanescent materials like paper, pencil, and watercolor; high art painters made their finished works in oil and canvas and framed them with carved wood. Amateur pictures were destined for a secluded family life, within which they would be understood as memorials to emotional bonds and private history. Professional paintings were meant for exhibition and sale, for interpretation by art critics who would extend their significance as far abroad as possible. Albums and amateur paintings shunned the market and its values; paintings sought the market as an objective indicator of worth. Feminine imagery recorded the trace of social situations it hoped to perpetuate, while painting aspired to transcend social situations and create timeless ideals.

The difference between these values made the difference between entering art history and being ignored by it. It made the difference between Berthe and Edma Morisot's careers. For twelve years the two painted together as amateurs. Corot gave them the same kind of casual lessons that countless amateurs received from equally eminent painters. Edma and Berthe Morisot were ambitious amateurs, to be sure, for they worked in oil and they showed in the Salon. But they were not exceptional even in this, as we have seen. They and their work followed the same basic pattern as other young women's picture making: beginning at the same age, following the same seasonal rhythms, apparently treating the same subjects, sheltering in the same family enclaves.

At the end of those twelve years, Edma Morisot's career met the typical amateur end. She married and ceased painting almost immediately. Her paintings have virtually all disappeared, and only a family member's fame preserves a trace of her endeavors. Berthe

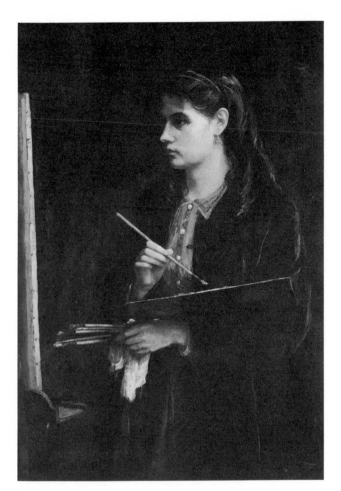

15. Edma Morisot, *Portrait of Berthe Morisot,* c. 1865–1868.

Morisot's background was identical to her sister's. They came from the same family, shared teachers, friends, and opportunities, and worked side by side. If anything, their teachers thought that Edma Morisot's work showed the greater formal promise. But Edma was trapped by amateur values, whereas Berthe was empowered by them.

Of Edma's two known paintings, one represents her sister

(Fig. 15). Berthe stares intently at her work, heedless of any spec-
tator. Her canvas is turned away from us, so that we can only imag-
ine what the hands and palette that occupy the center of the image
have produced. Light picks out the painter's material and instru-
ment, turning the canvas edge and Morisot's brush into twin golden
stripes.

　　　This first portrait of Morisot has always remained in her fam-
ily. It was not exhibited until 1961, nor was it reproduced in a pub-
lication for almost a century after its creation. Yet however secluded
it may have been, it is the image of Morisot's beginnings. It belongs
to the pictorial tradition that nurtured Morisot and launched her
career. Her recognition of the amateur tradition's strengths was her
first great asset. The second was her ability to outwit its limitations.

Heiress to the Amateur Tradition

Long after Morisot had outgrown her artistic origins her work still showed traces of them. Gradually they became less apparent, but the influence of their subject matter, audience, size, and medium, continued to make itself felt in the paintings Morisot made in the late 1860s, the 1870s, and the early 1880s. A feminine amateur tradition furnished Morisot not so much with a style or compositions as with assumptions about how images function, as an intellectual and creative practice and as a pictorial way of expressing a woman's experience in relation to her social role and her audience. Amateur women's imagery represented an attitude to the making of pictures ingrained for at least half a century into the mentality of Morisot's class and sex.

The overall content of Morisot's landscape and figural subject matter in the 1860s, 1870s, and early 1880s corresponds exactly to the contents of typical albums. During the very late 1860s and early 1870s, she produced the painting equivalent of an album about her sister: Edma Pontillon pregnant, Edma with their mother, Edma in her garden, with her babies, with her nieces, in the family apartment. Then in 1874–75 came her own engagement and honeymoon albums: scenes from the Channel islands, a few pictures of Eugène Manet. At the same time, and extending through the 1870s, she accumulated a collection of portraits of friends and family in their homes and gardens. When she and her husband bought le Mesnil in Mézy, Morisot produced her version of a country house album. As a fond mother she assembled volumes on her child that record

Julie at every moment of her growth from an infant to an adolescent. Throughout her career Morisot came back from vacations and trips with souvenir pictures. Both as groups of pictures and as individual subjects, Morisot's work replicates amateur iconography.

In her early years Morisot made pictures of atmospheric forest groves and grazing cows in the Barbizon tradition. Such scenes had a good pedigree, going back to the seventeenth-century Dutch masters whose relevance nineteenth-century republican critics hailed anew. During the 1860s Berthe and Edma also worked in harbors, painting in moored boats—as their mother learned with some concern.[1] But by 1875, Morisot had had enough of the field, as she wrote to Edma from Cowes:

> I made an attempt in a field. No sooner was I installed than I had more than fifty screaming, waving boys and girls around me; it all ended in a fight and the owner of the field came to tell me gruffly that we should have asked his permission to work, that our presence attracted local kids who caused a lot of damage.
>
> On a boat, it's another story, everything rocks, there's an infernal sound of waves breaking; there's the sun, the wind; the boats move at every second, etc. . . . I miss the babies as models.[2]

The babies appealed more, and so did the backyard. There a woman could work in peace. A garden meant "a few hundred meters of one's own, where natural things grow, flourish, blossom: an intimate and special pleasure for an old Parisian, for an apartment-dweller," sighed Edmond de Goncourt.[3] Morisot agreed; from her own garden on the rue de Villejust and the grounds of her country house at Mézy, from the Manet family property in Gennevilliers, came her versions of a natural setting. Other paintings began in the gardens of rented houses: the Villa Ratti near Nice and its neighbor the Villa Arnulfi; 4 rue de la Princesse in Bougival, and Bougival's quiet quais and hayfields; at Mallarmé's much-visited retreat in the Fontainebleau forest.

Wherever she painted, Morisot looked for the signs of home. Even the most exuberant flowers in her Bougival garden are held in place by trellises. In an 1882 picture of that garden, color unifies natural growth and human construction: fence, roof, and flower highlights share the same pale turquoise tones, while another roof and foreground flowers are painted in the same peach. Her fields almost always edge up to houses: between the grain and sky of Gennevilliers runs a dense line of roofs, punctuated by smoke-stacks.

Several of the Impressionists began by painting domestic set-tings but with time sought new settings out of which to establish an innovative tradition. Monet provides a case in point. A number of his earlier canvases represent his gardens and his wife, Camille. After her death, however, he rarely depicted any human being and preferred to go on "campaigns" to cull visions of an untrammeled nature in sites like Belle-Isle or Etretat. Degas painted both his New Orleans and his Italian families as well as the Rouart family at home, but he devoted the great majority of his oeuvre to other sub-jects, like the ballet, the brothel, and the nude.

Morisot found what she needed right outside her door. And she painted it as a version of what lay within her door—as a con-tained space. Some of her landscapes and seascapes have clear ho-rizons and expanses of open air, but not many. As Griselda Pollock has pointed out, those relatively few emphasize their sheltered van-tage point. In the painting *In a Villa by the Seaside* (Fig. 32) a veranda occupies the entire lower third and right side. *Woman and Child on a Balcony* (Pl. II) seems at first to be the picture of a woman and child out for a walk in the city, pausing to contemplate the view over Paris's left bank.[4] The setting is actually the small garden of Mori-sot's home. The railing at which the two figures stand marks the edge of her family's terrain.[5]

"My heavens! the theater changes, the entertainments remain the same . . . Scattered on the coasts, Parisians also find each other," observed a contemporary.[6] Like so many others of her social class,

like the authors of albums before her, Morisot spent her summers at the fashionable seaside resorts of France, on the Côte d'Azur, in Normandy, and in Brittany. The purpose of such holidays was not to live differently but to live the same way in more picturesque surroundings and better weather. When Morisot took her last vacation with Julie, they rented a house in Brittany in a village called Portrieux, where they had an enclosed garden, the Jardin de la Rocheplate, in which to paint. "We've painted in the garden," wrote Julie in her diary, "it's very pretty, it reminds me of the ones at Mézy and le Mesnil."[7]

Morisot made a few foreign trips: to Spain, to England, to Italy, to Belgium and Holland. Abroad she did what other young women did: went to museums, sketched, and recorded her impressions in her notebooks. She admired the artists her peers admired, Peter Paul Rubens above all, especially his religious paintings.[8]

Among Morisot's outdoor motifs, the most often repeated was the Bois de Boulogne. First developed by Napoleon I and brought to completion by his nephew Napoleon III, the Bois (there was no other Bois for elegant society) functioned as a collective garden for the Parisian upper classes, satisfying "this taste for country life, which, in Paris like in London, has seized the commercial or industrial middle class." "For today's generation, the Bois continues to be the capital's only real outing [promenade]," announced an author as early as 1856.[9] Twenty years later, another description hastened to amend the impression we still have of the Bois as a display case for dandys and belles:

> It's an error, shared by many people, to believe that the Bois is exclusively a fashionable spot . . . The wide variety of retreats that can be chosen make an outing in its precincts agreeable and beneficial for everybody . . . from the society lady who goes around the shores of the big lake in her large carriage to the happy mother supporting the first steps her baby tries.[10]

The same year this was written, in 1878, Morisot became one of the "happy mothers." She used the Bois as an alternative to her

PLATE I. Berthe Morisot, *Interior*, 1872.

PLATE II. Berthe Morisot, *Woman and Child on a Balcony*, 1872.

private garden, as a place to go with her daughter, and—since she was Morisot—as a place to paint. Her niece Paule Gobillard recalled:

> She liked the Bois. Its neighborhood, then not very built up, was quite elegant. A few strollers (whom we knew by name). The horse-drawn carriages came few and far between on the avenue du Bois; you could often see charming women, delightfully dressed. My aunt went all the way to the lake, her favorite spot. She went there with her little girl and often brought her models. You could rent a boat. She, on the bank, painted.[11]

Gobillard picks out the familiarity of the Bois, its reassuring social suitability, the interesting presence of other women. Morisot had her favorite spot. She and Julie were "regulars," at home on safe turf. And so Morisot represented the Bois not as a flashy place, thronged and ostentatious, but as a retreat, closely cropped and verdant, in which one or two women stroll at a time, the colors and shapes of their jaunty outfits in harmony with their surroundings, dappled silk dresses like dappled leaves and water (Fig. 27).

All in all, Morisot's exterior views reflect interiors, in the French sense of the word *intérieur,* the closest equivalent to the Anglo-Saxon concept of "home." Amateur imagery, Morisot's oeuvre, and contemporary social analysis all clearly expressed the convention "like house, like woman."[12] It was a convention that bound women's creative energies to the home: "The more ingenious projects devoted to embellishing the interior you notice, the more esteem you have for the mistress of the house,"[13] to achieve "the perfect harmony among the objects that surround you."[14]

Women were raised to imagine themselves in terms of their appearance, their family, and their home. Both women and men represented the respectable feminine woman as an appropriately attired daughter, sister, wife, or mother in a domestic setting. This representation was widespread enough to induce the belief that it sprang not from training but from instinct. "The art they put into their movements, into their appearance, into the design of every-

16. Berthe Morisot, *Portrait of Cornélie Morisot and Edma Pontillon,* 1869–70.

thing that surrounds them, isn't that proof enough of the instinctive visual genius that every woman seems to be born with? And why, seeing things as they know how to see them, should they be condemned to represent them otherwise?"[15] This was written by Théodore de Wyzéwa in 1903 about the general issue of women's pictorial self-expression. But he had already written almost exactly the same phrases in 1891—about Morisot.[16] She, he judged, saw as other women saw.[17]

The interiors Morisot represented correspond to a familiar pattern. Like the typical amateur woman artist, Morisot returned repeatedly to the parlor. The house she lived in during the late 1860s and early 1870s still stands. By matching the proportions and architectural features of its rooms as well the views out its windows to those in Morisot's pictures, we learn that she often worked in the upstairs parlor or *petit salon*—the setting, for instance, of her 1872 *Interior* (Pl. I).

Her exceptional 1869–70 *Portrait of Cornélie Morisot and Edma Pontillon* proves the rule (Fig. 16). Berthe Morisot set her picture of her mother and sister in the downstairs living room or *grand salon*, the most public reception room in the house, almost exactly where Degas had pictured her other sister, Yves Gobillard, only a few months before (Fig. 17). Her double portrait is already notorious for the final touches Edouard Manet added just before it was sent off to the Salon jury. It would seem that Degas's part in the picture's inception was at least as important as Manet's in its completion. Morisot moved over just a bit from Degas's point of view, keeping in her image exactly the same wave of the sofa back and reflection of a window and curtain in a mirror that he had used. In addition, the dimensions of the picture—100 by 81 centimeters—far exceed Morisot's average. Not surprisingly, this picture, so unusual for her because of its public setting, its heavy debts to Manet and Degas, and its size, caused her extreme anxiety. She told her mother she would rather be "at the bottom of a river" than have it shown at the Salon.[18] Yet it was this picture, out of all Morisot's works during

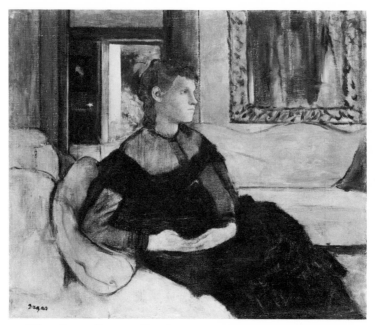

17. Edgar Degas, *Portrait of Yves Gobillard,* 1869.

this period, that best met Salon standards, precisely because of the ways it deviated from her norms.

The objects or pieces of furniture that dominate Morisot's vision of the parlor repeat amateur pictures' emblems of gender. One type of fashion illustration, the panorama of the parlor, uses a laterally extended format to include as many parlor features as possible, linking them for us into the constituent signs of feminine place: bronze or gilded planter, piano, draped window, mirror, small sofa, small table stacked with little books, mantle, stuffed armchair,[19] or else a painting, sofa corner, porcelain cachepot with flowers, draped window, planter, mirror, and armchair.[20] Unstring the elements again and you have virtually all the items of Morisot's interior imagery.

Morisot chose to depict the same occasions, the same times of

day, as amateur women artists did. Her scenes, reserved yet so-
ciable, can be identified not only through their location but also
through their inhabitants' clothing, since upper-middle-class
women changed their dress to suit each time of day or social occa-
sion. *Toilettes du matin,* or morning costumes—themselves of several
different types, denoting different degrees of intimacy—were worn
earliest in the day. Most of Morisot's figures do not wear night-
gowns *(chemises de nuit),* shifts *(chemises),* or even bathrobes *(sauts de
lit).* These were clothes worn when one was alone or in the very
strictest intimacy. Rather, Morisot's women often wear what was
called a *déshabillé* (literally an "undressed"), either a *peignoir* or a *robe
d'intérieur* (see Figs. 25, 34, 59, and Pl. III). Contrary to the impli-
cations of the word, the *déshabillé* was a real day dress, complete
with pale stockings and *mules*—which we would now call slippers
or light shoes: *souliers* or *pantoufles*—and sometimes even jewelry.[21]
The *déshabillé* was loose and white, either a floor-length or finger-
tip-length jacket over a white skirt *(jupon),* with wide sleeves, usu-
ally fastened at the neck with ruffles or lace, and sometimes worn
with a draped silken belt. It was supposed to be "very elegant but
comfortable all the same."[22]

The incontrovertible sign of the *déshabillé*'s serious character,
for all but the youngest women, was its bonnet. Also called a *coiffure*
(but not to be confused with a hairstyle), the morning bonnet bore
an ornament of fine white cotton or lace with ribbons and distin-
guished itself from a casual hat *(chapeau)* in that the ribbons did not
tie under the chin and its crown was not stiffened. Thus arrayed,
women of the leisure classes spent their mornings, noons, and early
afternoons puttering around the house, organizing the household,
eating lunch, and receiving some visitors. According to contempo-
rary accounts, the *déshabillé* was the dress in which one entertained,
but only close friends or family *(intimes* or *habitués).* "It's a home
outfit."[23]

Morisot's women are, even when not alone, in some way with-
drawn from the outside world. Geneviève Bréton, Morisot's con-

temporary, associated the *déshabillé* with an inner life: "I go to my room to take off my wool skirts . . . I put on my big white flannel *peignoir*, and then my own life begins; I go back into the parlor or I stay in my room."[24] There, in the parlor or in a commodious bedroom, a woman might withdraw to the feminine haven of the chaise-longue (Fig. 59).[25] One could receive intimates without exertion from a chaise-longue, or, as Morisot did at the end of the afternoon, rest before the evening's public obligations.[26]

Many of Morisot's women wear informal afternoon clothes, indicating that their stroll in the Bois is casual or that their afternoon call is to a good friend. A number of others wear the cross between a *déshabillé* and an afternoon dress called a tea-gown *(robe de thé):* they are at home, or in the home of someone they know well (Fig. 3). Dress styles, especially hats, signal who is at home and who is not: in Morisot's 1872 *Interior* (Pl. I), for instance, the woman on the left is in her own apartment—she is bareheaded and in plain gray; the woman on the right is a visitor—she wears a *coiffure* and exactly the kind of black silk dress with sheer sleeves prescribed for calls.

In Morisot's country scenes, as well, she concentrates on times of intimate sociability among women. Away from the city women could dress more casually, at ease in long loose white jackets and skirts not only in the mornings, but also, formalized with straw hats, in the afternoons. During the 1870s, especially, to wear a *toilette de campagne* meant one was on vacation away from the city, in the relaxed company of family and neighbors. (Only in Fig. 56, where Edma Pontillon is in mourning, is the country dress black.)

Morisot shunned formality and public occasions. She ignored shopping and parties. Several times she did depict women at the ball, but then her choice of place and pose balances the ostentation of this beloved feminine entertainment. In *At the Ball* (Fig. 18) for instance, Morisot isolates her subject from any sign of the ball's activity: its dancing, its presentations, its tactical chitchat. Her young women at balls sit apart in the areas designated for rest and

18. Berthe Morisot, *At the Ball,* 1875.

quiet conversation, on chairs or sofas sheltered by potted plants. They are at a public occasion but not of it. Morisot's images frame them closely, acknowledging their worldly occupation by their costume and background, yet concentrating on them as individuals.

Morisot insists in her images on their interiority. The interior for her is not merely a place to be recorded but an idea to be expressed. Even when her female subjects are shown outdoors, in the

great majority of images, a barrier confines them—within a veranda, on a path or promenade, or along a railing or arbor. Morisot places women in interiors next to frames of doors, hearths, windows, mirrors, and pictures. These borders act as signs of containment. They reiterate the enclosed character of the interior. They provide—through the window, out the door, within the image of a mirror or picture—views toward an imagined exterior, rendering the inside all the more clearly interior because it is not what is shown to lie beyond. Inner and outer spaces are defined as the opposites of each other.

Ever-manifest enclosure withdraws feminine space from the struggles and confusions of the outside world. Already in the Renaissance this spatial message had been used to construct a crucial aspect of the feminine ideal: a state of sexual innocence prior to sanctioned marriage. The Hortus Conclusus Annunciations of the early Italian Renaissance depict walled spaces, at once garden and interior, to symbolize Mary's virgin state, while the ubiquitous vista depicted beyond shows how preciously contained is the space within and how much lies outside Mary's present scope of imagination. The sanctity of Mary's space guarantees her purity and thereby justifies her election among women to become the mother of God.

Several centuries later, in Holland, Jan Vermeer and especially Pieter de Hooch again used the same pictorial device. Their domestic interiors evoke a feminine role whose difference from a masculine role announces the much more extreme differentiations of the nineteenth century. For in these Dutch pictures, while men and women each have important economic and administrative responsibilities, men act in the outside world and women's work revolves around the home. As capitalism accelerated, painting responded with images in which the open market has an obverse, the still realm of feminine inner space. The values of the interior represent the absence of change: the relationship of mother to child; the simplest objects of daily life used over and over in exactly the same

way; and light, light as it streams in from the outside, caught by the interior, by the surfaces and textures of feminine life, in the painter's suspension of time.

Fifteenth-century Italy and Flanders, seventeenth-century Holland, nineteenth-century France: three moments of dramatic expansion of bourgeois capitalism, three moments of intense artistic concentration of the theme of the feminine interior. The correlation is hardly a coincidence, but rather two facets of one phenomenon. Immutable or natural as contemporaries would have esteemed it, femininity as it is defined in the images we have been looking at is a historically and socially specific concept. The femininity Morisot represented was exclusively bourgeois. But the domination of the bourgeoisie in her time was complete enough for the femininity she represented to become a hegemonic model. It might well be argued that Morisot's images, like amateurs' images, correspond to few women's social or economic condition. But they corresponded to many women's vision of themselves. It was an ideal, and a pervasive one.[27]

Morisot's imagery corroborates that ideal. She shows no scenes of illness or exertion, no scenes, in fact, of the body manifesting itself in any obtrusive way. Even the dining room is shown only three times, and then with a housemaid in it.[28] Maids appear nowhere else in Morisot's images. The dining room may be the maid's "place," but the matching of dining room and maid also situates her employer by distancing Morisot from both servant and domestic chores. Like the mother-substitutes of amateur imagery, wet nurses and children's maids appear in Morisot's images as adjuncts to the child they care for.[29] In these pictures Julie Manet is the center of attention and the focus of the composition. Occasionally Morisot paints peasants working the fields of Mézy, and twice she depicts a peasant woman hanging laundry. Are these, though, individuals, or rather the stock figures of pastoral genre scenes, accessories to the landscapes of home? As people, they have no presence; as elements of paintings, they fade into their surroundings.

Morisot also systematically excludes men from her paintings. Not for want of knowledge, obviously, since she was married, and had several close male friends. Yet her husband, Eugène Manet, figures independently in only five of her pictures and as the father of their child in only a few more. Morisot never portrayed her father, her brother, Mallarmé, Edouard Manet, Renoir, Degas, or Monet. She devoted considerable thought to her 1875 picture *Eugène Manet on the Isle of Wight* (Fig. 19), a picture which subtly enhances his presence. He is looking out a window from the side of the picture. We see his view of boats, women, and a child between the black window sash in the foreground and the black rail of the fence in the middleground; the two parallel black lines seem to push together both top to bottom and front to back, animating Eugène's field of vision with their tensile compression. Without showing us his face, despite his quiet and off-center pose, Morisot makes us feel his attention.

Yet there she ceased her investigation of men and their way of seeing. Later, three little boys made isolated and innocuous appearances among Morisot's sitters. But her world continued to be overwhelmingly a world of women. Margaret Oliphant, a contemporary novelist, wrote perspicaciously to a friend about women's refusal to represent men in their artistic work, connecting writing and picturing, and, significantly, linking women's reluctance to paint men with their not being considered "great painters":

> Sometimes we don't know sufficiently to make the outline sharp and clear; sometimes we know well enough, but dare not betray our knowledge one way or other: the result is that the men in a woman's book are always washed in, in secondary colours. The same want of anatomical knowledge and precision must, I imagine, preclude a woman from ever being a great painter; if one does make the necessary study, one loses more than one gains.[30]

Morisot's subjects are not the subjects of "great painting." They are the women she knew personally. And so her paintings of

19. Berthe Morisot, *Eugène Manet on the Isle of Wight*, 1875.

them, can, like amateur pictures, be considered extensions of these relationships. Rosalie and Louise Riesener, Marie Hubbard, Valentine and Marguerite Carré, all were both sitters and neighbors, models and friends. Above all, Morisot painted the women in her family: Maria Boursier, Alice Gamby, Edma Pontillon and Yves Gobillard and their daughters, as well as her Thomas cousins. In the years just after Pontillon's marriage, Morisot pictures her sister time and again, alone or with her children, in a repeated affirmation

to herself and others that their bond endured. That need subsided, but still her nieces, both Pontillon's daughters and Gobillard's, continued to be favorite subjects, while Julie Manet completely dominated the last fifteen years of her mother's work.

Morisot did not represent only female friends and family. She used hired models with increasing frequency over the years. But the way she chose to represent even these women to whom she did not feel personally close demonstrates the persistence of her amateur habits. Frequently Morisot's hired models masquerade as bourgeois women. They wear middle-class clothing and seem to be engaged in at least lower-middle-class occupations, like skating or boating. In her 1896 posthumous exhibition—for which the titles used were either Morisot's own or her daughter's idea of what her mother's titles would have been—an 1882 picture of two young women in the Bois is titled *Young Women in a Garden,* though the *jardin* is public and the women certainly not *jeunes filles.* (Hired models weren't.) Morisot might even interchange models and real *jeunes filles.* Julie Manet recalled that she and a hired model sat for the 1884 *On the Bois de Boulogne Lake,* of which a replica was later begun with herself and her cousin Paule Gobillard as models.[31]

When models were not playing the roles of bourgeois women or girls, they played the role of "other." Like the housemaids matched with the dining room or the peasants ascribed to landscape, models were located in those places and costumes minimized in amateur imagery: the bedroom, the bathroom, any state of undress. The girl getting out of bed in her shift in *Rising* (1886) is a hired model; the girls wearing shifts in what could be either bedrooms or dressing rooms in *The Psyché* (1876, Fig. 61) and *Young Woman Putting On Her Stocking* (1880, Fig. 65) are hired models.[32]

Even the models who fell outside feminine norms were not, however, entirely strangers to Morisot. She knew her models—including peasant children around le Mesnil—well enough and integrated them sufficiently into her family so that her daughter, annotating records of her mother's paintings a half-century later, not

only remembered many of their names and bits of information about them, but thought that information important enough to include in her mother's catalogue raisonné. "Painted at le Mesnil of Jeanne Bodeau little girl from Mézy"; "of a model who worked in a doll head workshop"; "of Isabelle Lambert young model dead at 17 whom B. M. liked well."[33]

"Berthe Morisot made a painting the way you make a hat," Degas is supposed to have said.[34] With his millinery metaphor Degas associates the femininity of Morisot's facture with its skillful but rapid and apparently spontaneous technique. There are exceptions—some of the later large pictures, for instance, the 1879 *In the Garden* on which meticulous pencil squaring is still visible—but on the whole, Morisot's canvases give every sign of rapid execution. The canvas often shows through her light application of paint; her brushstrokes are large, the image small, and altogether the impression is of dash.

Throughout her career Morisot made rather small pictures. Averaging between 45 to 65 by 50 to 70 centimeters, they retained the format of the initial sketch that an academic painter, or even perhaps a painter like Corot or Manet, would have then expanded to more impressive dimensions for submission to a Salon audience. Like amateur artists, Morisot was making pictures not for public spaces but for family rooms in private homes.[35] She devoted herself as much to the less prestigious media of pastel and watercolor as to oils, but then again, women had long made the best of brief respite, casual equipment, and shared space by dashing off brisk watercolors or summary pencil skits. Over and over again, critics singled out Morisot's watercolors for praise; they were choosing among a woman's work the most familiarly feminine practice, as well as the medium that justified a sketchy style and a diminutive scale. Camille Mauclair, for instance, wrote: "It is a woman's work, but it has a strength, a freedom of touch and an originality, which one would hardly have expected. Her watercolours, particularly, belong to a superior art."[36]

Morisot herself, as well as her sitters, contemporary observers, and subsequent critics, all felt that, for better or for worse, Morisot did not "finish" her pictures. Hoschedé reported in 1881: "'It's not finished!' comes the cry from every side. 'There's nothing there!'"[37] Marie Bashkirtseff admitted to her diary in 1877: "Here's how it is; the sketch is always successful, but to know how to finish you have to have studied."[38] The kind of polished, anatomically explicit, perspectively rigged paintings then setting standards of "finish" took years of specialized training to be able to produce—training Morisot did not have. Like many other women, she tried to get the most effective result from what tricks she did have and made a virtue of necessity.

In a broader sense, though, the sketch was an attitude, as Florence Nightingale complained, using metaphors culled from visual art:

> In general, a "lady" has too many sketches on hand. She has a sketch of society, a sketch of her children's education, sketches of her "charities," sketches of her reading. She is like a painter who should have five pictures in his studio at once, and giving now a stroke to one, and now a stroke to another, till he has made the whole round, should continue this routine to the end.[39]

A lack of training or uninterrupted time, however, had its advantages. Morisot was never inculcated with the academic techniques and assumptions the other Impressionists had to rebel against. She managed to arrive by a different route at some of Impressionism's stylistic and iconographic innovations: its calligraphic notations of atmospheric effects, flat colors, and contemporary subject matter. Yet for Morisot these were not innovations but legacies of an artistic past. For her Impressionism as an artistic movement constituted an extension, a professionalization, an institutionalization of her amateur origins. Her task was to acquire some of the tricks of the trade, whereas for Manet, Degas, Monet, Pissarro, Re-

noir, Sisley, and their followers, Impressionism constituted a challenge to the practices and style of the academic *grande tradition*. Their goal was to shed some tricks.

Morisot and her colleagues were following intersecting trajectories. Her art has much in common with aspects of the work of Monet, Renoir, Degas, Pissarro, Sisley, Caillebotte, and of course Cassatt. Their paintings, like hers, were in most cases smaller than academic showpieces, designed for hanging in the homes of individual bourgeois collectors. Degas worked extensively in pastel. Critics constantly declared most Impressionist paintings to be unfinished sketches. Morisot's subject matter overlapped with the themes her male colleagues chose. They too made pictures of home, vacation spots, interiors, close friends, and family.

Impressionism drew on feminine imagery, as it drew on many other sources. The Impressionists' goal was not to stop making high art painting but to revitalize it, not to paint "unimportant" subjects but to redefine the importance of subjects according to new criteria. As high art painting shifted its boundaries, it could absorb elements common to other kinds of visual expression: caricature, journalistic illustration, photography, Japanese prints, and preparatory landscape studies, as well as women's amateur art.

Feminine imagery, though the overwhelmingly predominant aspect of Morisot's work, constitutes only one aspect of mainstream Impressionism. Manet and the male Impressionists extended the range of their imagery with private, domestic images; Morisot made virtually nothing but private, domestic images. Analogies to her work can be found within their work, but the pattern of her work is not the same as the pattern of theirs.[40] In painting, as in other domains, feminine gender has a more limiting effect on production and especially perception of work than masculine gender does. The male Impressionists could try images of women or feminine places and then turn with impunity to other subjects; Morisot's culture offered her no such recourse.

Morisot's gender affected the ways in which she worked and

what she did with her finished pictures even more than her subject matter or her style. Morisot worked at home. For a time she and her sister worked in a studio built for them by their father in the garden of their home. The studio survives along with the house; the two are connected at one corner, and both give on to the same little garden. That shared studio, so near to home, was to be her last for many years. Jacques Emile Blanche reported that in the next apartment she lived in, she worked in her room. Pictures she made in the years following her marriage, on vacation in the Isles of Wight and Guernsey or living in Bougival, show that she worked on verandas and in living rooms or parlors. When she and her husband had their own home built on the rue de Villejust, Morisot chose not to build herself a studio or even have a room set apart for her painting. Instead she chose to work in the living room.

That room, which has changed little since Morisot's time, is decidedly a domestic place, not a professional studio. Its proportions are slightly unusual for a Paris apartment, having very high ceilings in relation to the almost square surface area. But otherwise, nothing indicates this room is anything but a living room. Its largest windows face southwest. Acanthus-leaf moldings border white walls. The notorious closet into which Morisot would whisk her equipment should visitors chance to call is not a piece of furniture but a recess within one of the walls, closed by an almost imperceptible door. The room contains the standard living room features of hearth, mantel, and framed mirror.

Like many creative women before and after her, Morisot chose not to isolate her work from domesticity. When Morisot pushed her easel out of sight into her closet, she was repeating Jane Austen's concealment of pages of novels like *Emma* or *Pride and Prejudice* under her desk blotter. Elaine Showalter has pointed out that women writing in the 1840s and 1850s in England produced their novels, poems, and essays in similar circumstances, not just because they had no place else to work but because their refusal to separate household from literary production symbolized their conception of

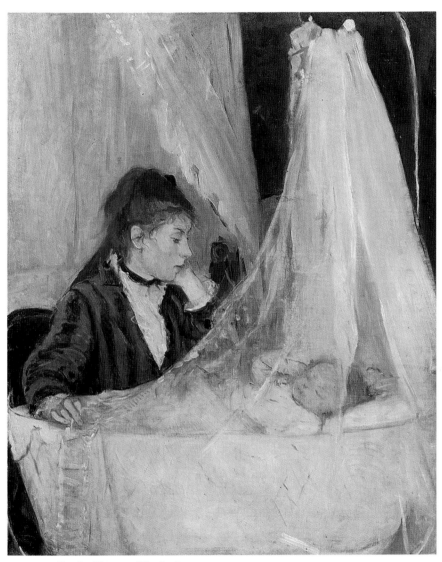

PLATE III. Berthe Morisot, *The Cradle*, 1872.

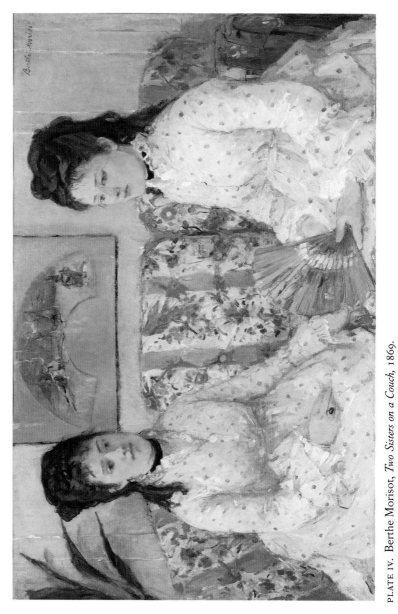

PLATE IV. Berthe Morisot, *Two Sisters on a Couch*, 1869.

the two tasks as two aspects of one personality.[41] She cites Margaret Oliphant, who recalled in her autobiography that she had always written in "the little 2nd drawing-room where all the (feminine) life of the house goes on."[42]

Morisot shared many women artists' misgivings about exhibition. Yet she felt more positively about public display than did the painter Gwen John, for whom the idea of exhibition, almost a generation later, still obstructed creativity. "I paint a good deal, but I don't often get a picture done—that requires, for me, a very long time of a quiet mind and never to think of exhibitions."[43] She certainly had more public confidence than her contemporary Eva Gonzalès, who apparently would have to take to her bed if she so much as copied in the Louvre.[44] But rather than understand Morisot's tendencies entirely as an inability to deal with the art market, it might be useful to consider how, for someone from her background, home was where she wanted her work to remain.

Cassatt's mother wrote in 1881 to her granddaughter Katherine: "Do you remember the one [Mary Cassatt] painted of you and Rob and Elsie listening to me reading fairy tales? She finished it after you left and it is now at the [1881 Impressionist] exhibition—A gentleman wants to buy it—she could hardly sell her mother and nieces and nephew I think."[45]

Rebelliously, Cassatt did either sell or give her 1880 *Family Group: Mrs. Cassatt Reading to Her Grandchildren* to a friend, Moyse Dreyfus. But her family put so much pressure on her that she had to ask Dreyfus to return the painting to her brother, and ever since, it has remained in a Cassatt home.[46] Cassatt's family had enforced the sentiment that kept so many women, including Morisot, from selling paintings; it felt wrong to trade pictures that seemed invested with family love or friendship for cold hard cash. Many artists have a few works they are loath to part with for emotional reasons; Edouard Manet, for instance, was unwilling to sell some of his portraits of Morisot. Morisot had reasons for keeping almost all of her work. She gave pictures to friends and family members, and

even to trusted collectors. She would put her paintings on public display if the exhibition were organized by a friend or someone she trusted. It was selling to strangers that she disliked.

Even the pictures which seem to be more publicly oriented had domestic destinations. Several of her largest, apparently most impersonal, paintings she designed as decorative panels for her living room. *The Cherry Tree* (Fig. 1), which in some ways was of all her paintings the most professionally ambitious, occasioned a revealing episode, recalled by Julie Manet after her mother's death.

> Camentron [a dealer] had taken the painting away to sell it. Maman was only asking 1500 francs for it, but when it was gone, she had regrets and asked Camentron to return it . . . When the "Cherry Tree" came back . . . Maman said to me: "I've done well not to sell it; I worked on it for so long, at Mézy, the last year your father was alive; I'm attached to it and you'll see that after my death you'll be very happy to have it." [47]

At her death a large majority of Morisot's pictures remained in her possession. She left them all to Julie, asking only that a few close friends pick for themselves a painting in her memory. All the remaining pictures went back to the rue de Villejust, to several family apartments on upper floors.

In family homes Morisot's pictures were hung where they fit, up to the ceiling or along staircases, in a dense mosaic alongside other family pictures: pictures by Morisot's sister, daughter, nieces, husband, brother-in-law, son-in-law, father-in law, pictures made by friends and given as gifts. Julie Manet clung to pictures by her mother portraying family members and to pictures made by family members of her mother. She and her family have known the pictures they lived with in a way no casual visitor to a gallery or museum, no dealer or buyer, will know them. In the public world the pictures are "great paintings" by Manet, Monet, Degas, Morisot, separated out from "amateur" work, and placed in an art historical lineage of great paintings. In a private world they hang among im-

ages unified less by style or period than by family meaning: images of a grandmother, testimonials to a mother's relationship with her daughter, tributes from one friend to another, carriers of family history. Private memory replaces labels and catalogues.

Thus some of Morisot's pictures live out the consequences of origins reaching back into the early nineteenth-century women's amateur tradition. They and perhaps all of Morisot's paintings have waited till we could see them on their own terms. The words Julie Manet uttered at her mother's posthumous exhibition still apply to Morisot's work and to the entire amateur tradition from which Morisot emerged. "Everybody is astonished when they enter this room: 'I would never have thought she worked so much.' Maman never showed all these drawings, she hid a part of her work; today it's a revelation."[48]

Chapter Five

Feminine Visual Culture in the Age of Mechanical Reproduction

As Morisot came of age so did a modern visual culture. Industrial values found expression in mechanically reproduced pictures marketed to mass audiences. In this rapidly changing field both women's amateur art and fine art painting were forced to redefine themselves in relation to mass-produced images, and so, therefore, was Morisot. Old pictures and traditional ways of making pictures became outdated; other practices came to take their place. Popular prints designed for women, fashion plates especially, suggested new feminine identities. Through these images, yet also in reaction against them, Morisot matured artistically and became a painter of modern feminine life.

Amateur artists almost never became professionals, nor were families with amateur artists in one generation likely to produce more professional artists in the next generation. Women felt too many pressures, both internal and external, to abandon their work. Though the technical skills of women such as Félicie Mallarmé and Adèle Hugo may have been comparable to those exhibited by professionals in their first efforts, amateur artists were not usually able to develop a professional attitude.

Take the case of Marguerite de Krüdener. Her social position and talent were comparable to Morisot's. Her self-portrait (Fig. 7) demonstrates how far she had developed her gifts by her late twenties. Just as Morisot would a generation later, Krüdener, around the age of thirty, suffered a crisis that called into question her artistic

commitments. She began a journal that records with painful clarity
the interiorization of denial. In its entries Krüdener rehearsed the
prescriptions of religion, the disciplines of abnegation and resigna-
tion. Her self-control proved all too successful. The journal was her
last, and after about 1855 she worked more and more sporadically,
and with diminishing technical concentration. Locked in a stoic si-
lence, her talents atrophied. She had written in her journal that ge-
nius is recognized by its symptoms.[1] Hers was not allowed to be
shown; to the world outside her family it had never existed.

Some women felt the injustice of their situation and still sub-
mitted to it. Five years after she gave up making pictures—five
years, that is, after her marriage—Sophie du Pont lamented:

> To be gifted with quick & sensitive feelings, with warm &
> passionate affections, with genius, with rare talents per-
> chance—& all this to be crushed & wasted, & borne back
> upon the heart, till the bitter medicine works at length the heal-
> ing of the soul.—And is not this blessed healing, this with-
> drawal of affections from earth & fixing of them on eternal
> happiness, worth all that must be borne for it?—Doubtless far
> more—and yet I am sometimes tempted to think with the In-
> dian woman who said "Let not my child be a girl, for very sad
> is the lot of woman!"[2]

In periodical columns art critics dismissed professionally what
they praised socially. While amateur art retained its class status and
approved feminine meanings, its domestic borders were strictly po-
liced, all the more so when women aspired to convert art into ca-
reers. In 1882 Charles Bigot warned women's painting organiza-
tions: "Beware of amateurs, ladies, beware of nice young women
who send you a drawing or a watercolor they would have done
better to leave in the boarding-school parlor; beware of society
women who think they are painters because they're bored and they
bought a paint-box to distract themselves."[3]

The proliferation of mass-produced photographs and prints
exerted another kind of pressure on women's sense of themselves as

makers of art by turning them into consumers of images. By mid-century amateur art was becoming not only restrictively feminine but also redundant. Technological advances in the production and reproduction of pictures made drawing and painting for long hours seem useless. Though women continued to assemble albums, they used new sorts of pictures, and although these new pictures re-cycled amateur imagery, they induced a very different kind of femi-nine identity, which we call "modern."

Though ultimately photography would overwhelm mass-produced prints, in the middle decades of the nineteenth century it had a dramatic but limited effect on women's amateur art. Photog-raphy's potential applications and popularity were recognized as soon as its invention was announced in 1839. Within a few years its techniques and equipment had been simplified, as photographic studios proliferated throughout Europe and America. Above all, clients demanded portraits. The kinds of outdoor scenes women's amateur art had depicted could not be duplicated by photography until the advent of the snapshot camera, and its interior themes not until the much later development of manageable flash lighting. But the portraits amateur artists had painstakingly drawn or painted could now be obtained in minutes for a few francs. In 1854 A. A. E. Disdéri invented the *carte-de-visite,* a type of small portrait priced significantly lower than its competitors because multiple exposures were grouped on a single photographic plate, printed on paper, and mounted on cardboard. As its name implies, the *carte-de-visite* (call-ing card) was intended to provide a visual token of identity.[4] Women exchanged and collected *carte-de-visite* portraits of friends and family and assembled albums with them. Only the very recent advent of the video camera has diminished the enduring popularity of the photo album.

Wood engraving and lithography had been invented in the late eighteenth century but began to be exploited on an industrial scale only in the late 1830s.[5] A succession of inventions enabled much larger editions of prints than had been feasible before, and at much

lower costs. Suddenly any middle-class person could buy pictures, and everyone walking the streets could see the many prints displayed in print shop windows. Precise or comprehensive statistics would be difficult to calculate, but a few figures indicate the extent of the phenomenon. By 1838 there were 262 lithograph shops in Paris and 634 in the French provinces.[6] In 1839 one of these Parisian shops, admittedly the biggest, Lemercier Bénard et Cie, printed work from 30,000 lithographic stones for more than 15 publishing houses and distributors; the firm calculated its value at 500,000 francs.[7] Where once prints had tended to follow in paintings' wake, now they discovered their own subjects and consequently their own audiences. Flexibly responsive to the daily interests of the middle class, prints depicted ordinary urban places, people, and events, and addressed topical issues.

Morisot's early teacher Guichard brought her and her sister Edma to the Louvre to learn to paint, but he also had them copy their father's collection of Gavarni prints. Along with Daumier, Gavarni led the first generation of draftsmen whose work developed entirely within the structures of the mass-circulation periodical. He specialized in lithographs of fashionable Parisian life carried by popular newspapers like *Le Charivari*. Unfortunately we do not know which of Gavarni's many images Berthe and Edma copied. We can assume, though, that the Morisots' ordinary exposure to popular prints was much reinforced by the close attention they had to pay to Gavarni's style and subjects.

The picture industry courted buyers the way other industries did, with reduced prices, high turnover, and specialized products. Diversification turned an existing print subject, the domestic genre scene, into a generic pictorial product. The Kronheim firm in England, which successfully distributed its colored lithographic wares throughout Europe, stamped out its pictures in sets that have survived intact: a sheet of landscapes, a sheet of Parisian monuments, a sheet of hunting scenes, a sheet of nine picturesque feminine genre scenes (Fig. 20), a sheet of six more laconic feminine images

20. Sheet of Kronheim prints, various subjects, c. 1850s–1860s.

(Fig. 21). The two sets that represent women replicate the stock items of women's amateur art, predominantly images of women occupied with the daily occurrences of domestic life, along with a few pictures of theatrical fairies or romance, a few quaint peasants, and some virtuous deeds. Women had been identified as a potential market. Their pictorial interests, evidenced by the pictures they made, were being served commercially. Capitalist profit imperatives

21. Sheet of Kronheim prints, various subjects, c. 1850s–1860s.

continued to differentiate women from men by fostering ever more distinctly gendered visual imaginations.

The Kronheim firm cannily distinguished between more traditional and more modern kinds of femininity. One sheet gathers images of explicit morals and drama, or of women outside the middle class (Fig. 20). The other is exclusively devoted to bourgeois women and their young children, presented in scenes that tell only of place, time, and domesticity (Fig. 21). In this second set, the two pictures on the right, with figures in contemporary (rather than eighteenth-century) dress, look like fashion plates (Figs. 23, 24, 26, 28, 29, 30, 31, 33, 35, 36, 37, 38), for no clear boundary separated

the most fashionable popular prints aimed at a female audience from fashion plates. The similarity between this modern kind of feminine print and fashion plates designates their audience. While many fashion plates were actually sold as separate images, they had all been designed for inclusion in a publication overtly addressed to women only, called "women's magazines" or "fashion magazines."

Cynthia Leslie White traces the origins of women's magazines to the late seventeenth century,[8] and the earliest fashion illustrations date from about the same time.[9] But like other popular prints or illustrated magazines and books, the women's magazine became a real cultural force only toward the middle of the nineteenth century. More than one hundred fashion periodicals were created between 1830 and 1848.[10] Fashion illustration found a style and iconography of its own in the 1830s, under the impulse of journalistic artists such as Achille Devéria and Gavarni, who worked in many genres. Honoré de Balzac credited Gavarni, whose work Morisot studied so carefully, with the reinvention of the fashion plate in an article introducing his first efforts in the October 1830 issue of *La Mode*. He claimed that Gavarni had done away with "the uniform doll" in favor of women who were "really truly women" because as an "artist and even a superior artist" he "conceived of fashion illustration as a specialization" which translated a feminine "physionomie parisienne."[11] What he meant was that Gavarni had done away with figures stiffly posed against blank backgrounds, in favor of figures occupied in scenes from daily modern life. Gavarni had brilliantly merged two previously separate print genres into a new commercial hybrid.

If that hybrid was immediately successful with female customers as well as with male writers, it was because, like domestic genre prints, it corresponded closely to the kinds of pictures women were used to thinking of as their own. Fashion illustration appealed so quickly to so many women because it tapped into the tradition of amateur women's imagery. The women's magazine, moreover, imitated the album's book format and its mix of diverse images with

captions or narratives; the women's magazine found its place, alongside the album, on the parlor table at the center of feminine domestic life.

Paris, capital of European and American fashion illustration as well as of fashion, produced by far the most innovative, numerous, and influential of these hybrid images. In Gavarni's wake came artists who devoted the better part of their careers to fashion illustration and set the tone for the rest of the profession, notably Comte Calix, Jules David, and the three Colin sisters: Heloïse Leloir, Anaïs Toudouze, and Laure Noël.[12]

In France alone, *La Mode Illustrée,* whose plates set the highest standards for the genre, enjoyed a circulation of 52,000 in 1866, and 100,000 in 1890. The *Moniteur de la Mode* had 200,000 subscribers in 1890, as did the *Petit Echo de la Mode.*[13] Every month each of these magazines came out with black-and-white illustrations scattered throughout the issue, and with as many as three full-page, hand-colored plates, depending on the price of the edition. Plates were printed separately and could be reproduced in greater numbers than the text; the *Moniteur de la Mode* printed its text in runs of 4,000 in 1866, but its plates in runs of 35,000 in 1853. Parisian plates were sold to women's magazines in other countries, pirated, and plagiarized. Women's magazines were a big business, organized in conglomerates; two publishing magnates, Louis-Joseph Mariton and Adolphe Goubaud, between them owned some thirty magazines.[14] Women shared magazines with friends and relations, so that even supposing a considerable overlap in readerships, the number of women exposed on a regular basis to fashion prints in France numbered easily more than a million by the end of the century.

Fashion prints colonized women's visual culture. Considerable in numbers alone, they also had the advantage of their contextual presentation. Women's magazines associated the fashion print image of femininity with the championship of domestic virtues, with practical instruction about household tasks, and above all with fantasies of feminine social and sexual success. Visual and textual inte-

gration of new messages into traditional definitions of femininity validated innovation. Fashion prints appeared to resemble previous kinds of women's pictures, but in fact they were fundamentally different because they advertised products for sale.

Women's magazines distinguished themselves gradually from more general interest periodicals intended for both sexes. Advice about beauty, dress, and household management evolved from homemade "recipes" into recommendations of brands and promotion of designers, shops, and, later, retail stores. This evolution was paralleled by the increasing importance of fashion plates in terms of their size, prominence, number, and professionalized production. Fashion plates were advertisements, both specifically and generally. In a very particular way they spread information about individual designers, shops, and retail outlets. More broadly, they promoted the notion of fashion, which in turn promoted the interests of the clothing and accessory industries and coupled their interests to those of the publishing industry. Fashion magazines presented themselves as a medium of desirable knowledge by realigning economic and class mobility. They appealed to a rising middle class on the basis of a class hierarchy of appearances, offering women a shortcut to respectability. This maneuver, however, subverted the class stratification it invoked. It diminished every determinant of class status except money, for the women's magazine promised that the signs of respectability and influence could be bought, urged their purchase, and itself put the knowledge of what to buy on sale. Since women's magazines traded in the feminine version of class, and fashion plates provided its visual definition, it would be fair to say that fashion plates offered the modern image of bourgeois femininity.

Women substituted domestic genre prints and photographs in their albums for pictures they made. Some women continued to draw and paint, and others mixed types of images, but the majority of women's albums after about 1865 were photograph albums or collections of found images we would call scrapbooks. By the end

of the century entire albums were assembled out of promotional images distributed by manufacturers or department stores. Fashion prints, however, not only substituted themselves for the images women had previously made; they changed women's relationship with images from one of production to one of consumption. They proposed a new definition of femininity passively identified with the commodities they represented, a new conception of self identified with the commodity that the image had become. The similarities and differences between Marguerite de Krüdener's self-portrait (Fig. 7), a Delsart studio portrait taken around 1865 of an anonymous woman (Fig. 22), and an 1866 fashion print based on a watercolor by Anaïs Toudouze (Fig. 23) exemplify the changing relationship between women's sense of self and the dominant images of feminine visual culture.

The studio portrait inherits some of the self-portrait's characteristics. In both images a female subject gazes directly out at the viewer, initiating a visual exchange between individuals. Both images concentrate on the subject's facial expression, while light glides over the plain surfaces of the clothing, accessories, and background. Both women hold and show the viewer instruments of self-representation. Krüdener in her painting holds a pencil and sheets of paper; the anonymous studio subject holds a photo album designed for images like the one for which she is posing. In both cases, the reiteration of the image's medium as the subject's means of self-representation affirms her confidence in it, a confidence she invites us with her look to share.

The woman in the photograph went to the photographer's studio to produce an image like Krüdener's self-portrait, which she intended to bring back home and put in a family album or to give to intimates for their family albums. Although the image can be mechanically duplicated it represents one specific person at one moment. The subject has participated in the creation of the image by seeking out the photographer to record an appearance she had already constructed of respectable femininity: straight back, graceful

22. Delsart studio, visiting card, c. 1865.

gesture, clear skin, silk dress, family album. She is, though, only indirectly the image's author, along with the photographer and whoever developed the negative. She can identify with the final image but not entirely with the process of making it. That process has taken her out of the domestic domain into the public world of professional photographers and the money they charge for their services.

Toudouze's print (Fig. 23), like virtually all full-page hand-colored plates, splits its subject into two women. One holds an album like the woman in the studio photograph, the other looks at herself in a mirror. The use of images to represent oneself has been

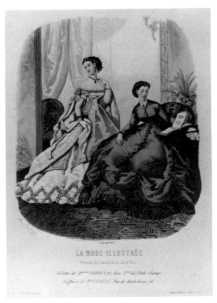

23. After a watercolor by Anaïs Toudouze, *La Mode Illustrée,* pl. 9, 1866.

joined by the absorption with oneself as an image. The two women look neither at us nor at each other. Each woman turns toward an object in which she sees a kind of image of herself. Each side of the image reflects the other. What matters is not one person or one image but the infinitely reproducible spectacle of femininity. What matters is for sale: the clothing, larger and more detailed than anything else in the picture, and at the center of this ideal of femininity.

No individual presence emanates from the fashion print because no individual is posited as prior to its image. Fashion prints functioned as harbingers of a self that might be constructed with the commodities they displayed. All sense of self devolves into a promise that hovers between the social connotations of the setting, the costumes, and the caption. And whereas women's album captions close the small gap between image and intimate viewer by specifying an original context, fashion print captions do the opposite: they keep image and viewer apart by diverting identification with the

feminine subject toward the channels of commodity consumption. Fashion prints hold personality forever hostage against a limitless ransom.

Fashion prints altered the very meaning of "subject" and "author" in feminine visual culture. Toudouze painted a watercolor of someone else's clothing designs. She then sold the image to *La Mode Illustrée*. An editor in turn had the image transformed into a printing plate by an engraver. Next the image was printed and colored. Finally it was bound into a magazine and sold to 40,000 different women as part of a product. By the end of the process, the "subject" of the image had become the promise of self-representation offered to tens of thousands of women by the fashion industry. The "author" of the image is at once Toudouze, the engraver Bonnard, the printer Leroy, the *Mode Illustrée* editorial staff, Croisat the coiffure designer, and Mlles. Raboin, the clothing designers, all of whose names appear on the image, signatures of a new industrial sort.

Nineteenth-century feminine pictorial culture moved rapidly toward mechanical forms of reproduction and the promotion of consumer culture. The feminine "self" represented in amateur women's pictures was permeable, heavily invested in other people, in symbolic objects, in domestic interiors, in family places. These feminine values were opposed to the values of a capitalist economy inasmuch as they stressed affective bonds and family nurturing, or, more basically, an altruism at odds with individualistic opportunism. Yet these same selfless values rendered women susceptible to a capitalist denial of women's individuality and their transformation into passive consumers whose identity was invested in material objects. Some critics have wondered whether under such conditions any woman could imagine herself as a subject at all. Abigail Solomon-Godeau in her study of the comtesse de Castiglione and mid-nineteenth-century photography has characterized "the conundrum of feminine self-representation" as "the lack of any clear boundary between self and image, the collapse of distinctions be-

tween interiority and specularity,"[15] so extreme that for a woman "there is no space, language, or means of representation for any desire that might be termed her own."[16]

But these are the ideals of a middle-class and masculine subjectivity to which working-class and even many middle-class women had never had access anyway. The immense majority of women did not enjoy better or greater opportunities for self-expression before industrialization. Even the socially privileged possibilities of amateur art were so limited that their demise cannot be mourned. At least the jobs created by industrialized visual culture granted some women a measure of economic autonomy or even professional prestige. Financial independence is also a "desire that might be termed her own."

The Colin sisters, for instance, turned fashion illustration into a way to support themselves and their children. Gifted daughters of a now obscure painter, the three sisters (Heloïse: 1820–1873; Anaïs: 1822–1899; Laure: 1827–1878) were born into art as a family trade. The training they received from their father was therefore at once professional and familial. By the time they were twenty they had exhibited genre paintings in the official Salon. The Colins, unlike amateur artists, had to earn their living with their work. Eldest child of a somewhat improvident father, Heloïse while still adolescent supported a motherless household by selling her watercolors. When Heloïse married, it was still her income that kept her new household afloat. She sold watercolors to the publishing conglomerate Mariton for its fashion magazines, painted miniature portraits, illustrated popular novels, and maintained a drawing school for girls.[17] When Anaïs's husband died, leaving her a widow with three children at the age of thirty-two, she too had to support a family with her art. Anaïs became the most prolific fashion illustrator of the nineteenth century, publishing in at least twenty major magazines,[18] as well as the collaborator, with Heloïse, on collections of lithographs for the women's print market. Less burdened by financial responsibility, the third Colin sister, Laure, nonetheless pro-

duced, over several decades, a considerable number of fashion illustrations printed in prominent magazines.

The images of femininity in fashion plates turned women away from a past they had no reason to be nostalgic for. The new identities industrial imagery suggested were profoundly different, but not therefore worse. A capitalist marketplace and its consumer institutions (like the department store) helped release women from the domestic interior, whether to work or to shop, and allowed them to spend and sometimes to earn money. Above all fashion plates gave women a sense of potential control over their individual and class identity. Fashion deflected social scrutiny onto objects available to anyone with money. A democracy of appearances began to replace the elitism of breeding.

Morisot believed in democracy, and in some ways she was among the most upwardly mobile women of her generation. But she sought cultural, not class, advancement. The Colins came from an artisanal background which they parlayed by means of hard work and marriage into a solid middle-class social position. Their income depended on the commercial viability of their work and its appeal to a mass audience. Morisot belonged to an upper middle class that resisted the incursions of lower-middle-class *couches nouvelles* into respectability by disdaining what it considered vulgarity. In her youth her mother had encouraged her and her sisters to become amateur artists because it would connect them to the genteel feminine tradition of a cultivated (preindustrial) bourgeoisie. As an adult, Morisot's position in the radical *grande bourgeoisie* of the Third Republic prescribed a polite distance from the leveling tendencies of popular women's pictures and oriented her toward an art practiced by social and intellectual elites.

The Colin sisters had to participate in new forms of pictorial culture in order to succeed, both because they were poor and because they were women. For decades the three sisters dominated their field. Yet their careers remained almost as gendered as women's amateur work had been and were clearly placed in a subordi-

nate position relative to the artistic careers of even—or perhaps especially—the men in their family. While the Colin sisters specialized in women's prints, their father painted historical subjects; Heloïse's husband, Auguste Leloir, painted religious scenes; Anaïs's husband, Gabriel Toudouze, was an architect and engraver; Laure's husband, Gustave Noël, was a painter; their half-bother Paul was a marine painter and engraver. The pattern perpetuated itself in the next generation: Heloïse's son Maurice Leloir became a painter and historian; Laure's daughter Alice became a ceramic decorator and miniaturist; Anaïs's son Edouard became a painter, winner of the prestigious Premier Grand Prix de Rome; while her daughter Isabelle became another fashion illustrator, as well as a flower painter.[19]

Morisot could afford to practice an art that would not guarantee her an income but might free her from the cultural constraints of gender. By the very distance it purported to put between itself and popular or applied art, avant-garde painting promised freedom from all constraints. While women's popular visual culture commodified the female subject, and proposed that women buy rather than make images of themselves, painting advanced the claims of the individual's creative prerogatives. The advent of mass culture forced high art to define itself by opposition to values it had never had to contend with before. Amateur art's values had operated within a marginal cultural space relegated to women and offered high art absolutely no competition. Mass visual culture, of which women's pictures were so important a component, not only competed with high art for attention, audiences, and money but also threatened the values of originality, authenticity, and erudition on which high art had based its superiority.

In the years when Morisot was deciding on the course of her career and the nature of her work, new high art institutions emerged based on the individuality of authorship and the value of the unique art object. The Impressionist group that Morisot chose to join was the first to take concerted advantage of these institu-

tions: the art dealer who traded in "names," the privately organized exhibition that bypassed state bureaucracies, the art critic who applauded rebellious style, the one-man show, the art historian who organized pictures by artist and history into artists' biographies.[20] Against the values of cheap mechanically reproduced images available to the many, high art reinforced its definition of painting as priceless works of the imagination created for an intellectual elite.

Morisot scorned mediocrity in others and in herself first of all. Like the masculine dandy who exaggerated anonymity as a form of self-expression, she cultivated reserve as a form of self-effacement and self-discipline, yet arrived thereby, in person and in pictures, at a remarkable rigor with standards which daunted both women and men.

In one of her notebooks she had pitiless words for amateur women's art. But then again, in the same paragraph she passed stern judgment on a professional male artist:

> Ah, when all France quibbles about painting it will be as if run over by a huge roller of impotence; that would be the triumph of Pissarro! Everyone talented and no one a genius!!!
>
> How we will regret the time when Ingres and Delacroix were painting their masterpieces and when young ladies were satisfied with absurd amateur accomplishments.[21]

Even to herself Morisot would only admit the most limited and traditionally feminine aspirations:

> It's been a long time since I've hoped for anything and since the desire for glorification after death has seemed to be a disproportionate ambition. Mine would limit itself to capturing something of what passes, oh just something!, and well, that ambition is still disproportionate! . . . one pose of Julie's, one smile, one flower, one fruit, one tree branch, just one of these things would satisfy me.[22]

Nonetheless she implicitly referred herself to the lineage of masterpiece painting. At the age of twenty-three, Morisot copied

several chapters from a treatise by Léon Riesener, a family friend, on the history of great art.[23] Riesener, a competent painter himself, derived further authority from his close friendship with his cousin Delacroix. Riesener's text began with "Instruction offered by Egyptian Art and by Greek Antiquity," and then traced the lineage of Renaissance masters such as Michelangelo through Rubens, Gros, Géricault, and on to Delacroix.[24]

Since Morisot's manuscript has been lost, we cannot now know how many chapters she copied. Geneviève Viallefond, who published Riesener's manuscript and read Morisot's version sometime before 1955, mentions one copied chapter that signals Morisot's early interest in color issues as well as in resistance to academic precepts: "Definition of Color: Those Who Do Not Know Her Libel Her." The chapter hailed Rubens, Titian, Correggio, Chardin, and Veronese as heroes,[25] emphasized the importance of color nuances and self-consciousness ("French taste, at all times, has sought in painting memories of painting"), and praised an anti-academic stance for which it found precedents in the cases of Chardin, Gros, Géricault, Delacroix, Bonington, and Rousseau.[26] (This early lesson of Morisot's in the history of art later became the first to include her in its canon when Riesener updated it with references to her Impressionist work.)

In notebooks written during the late 1880s and early 1890s, Morisot went on citing revered names. "It seems to me that Rubens is perhaps the only painter who has completely rendered beauty . . . It would be fair to add those of the last century . . . Boucher and La Tour . . . Perronneau . . . a few English masters: Reynolds, Romney. Ingres . . ."[27] "Of course I visited the National Gallery. I saw a lot of Turners . . . some Wilkies, Gainsboroughs, and Hogarths."[28] Morisot literally copied the Old Masters in the Louvre as a part of her training.[29] She learned by imitating Veronese, Rubens, and Boucher in the Louvre, and later Boucher again as well as Mantegna in the Tours museum.

Among her contemporaries, too, Morisot identified with a cul-

tural elite. Although her strongest emotional bonds were to her daughter, her husband, her sister, and her mother, she repeatedly referred to Edouard Manet, Degas, Renoir, and Mallarmé as authority figures in artistic matters. Their opinions are scattered throughout her notebooks: "Degas said," "Edouard himself," "Dinner with Mallarmé ... he explains," "Visit to Renoir ... he tells me," "Edouard often used to say," "Duret came to see me. He tells while talking of Edouard," "Degas says," "Delacroix composed his palette," "Renoir says." [30]

The very way in which Morisot wrote about the painting tradition she aspired to explains why it could never be entirely hers. That tradition belonged to men, and she could only speak of it in someone else's words. She admired men's work with citations or copies of their opinions. Even her earliest resolution to become a painter comes to us through a man's voice. In the 1880s Morisot adapted a passage by Baudelaire and copied it into a notebook. "And high time it is to act, to look upon the present moment as the most important of moments, and to make of my daily torment, that is to say of work, my perpetual pleasure." [31] Morisot clearly identified with this and other phrases of Baudelaire's; quite uncharacteristically, she did not put quotation marks around the passage, nor attribute it, and, although she altered or deleted some parts of the passage to conform to her own situation, she left its date, 1862, as if it were the year of her own thought. The thought in some sense was hers, but she could only enunciate it in Baudelaire's words.

It seemed impossible for Morisot to ignore or repudiate the feminine visual culture she was raised in and join a masculine artistic tradition. It appeared equally difficult not to believe in the elite art that retained the exclusive authority to express her ambitions. Modernism saved Morisot from this dilemma, inasmuch as any woman could be saved. What we call "avant-garde art" has cyclically engaged, co-opted, transformed, and anesthetized popular imagery. Thomas Crow has found the process intrinsic to modern art's place in a larger cultural field: "From its beginnings, the artistic

avant-garde has discovered, renewed, or re-invented itself by iden-
tifying with marginal, 'non-artistic' forms of expressivity and dis-
play—forms improvised by other social groups out of the degraded
materials of capitalist manufacture."[32] Whether such forms are
"marginal" or "degraded" from any point of view other than that
of avant-garde artists and their supporters could be debated, as
could the exclusive ability to liberate forms from economic or class
servitude Crow implicitly attributes to Modern art. If "non-artistic"
forms do represent disenfranchised groups in some meaningful
way, however, then Crow's point that Modernism forces high art to
incorporate them becomes all the more pertinent to a case like Mor-
isot's. If images like fashion plates did offer mid-nineteenth-century
women some kind of escape from past gender constraints, if they
did represent a feminine self that eluded at least some masculine
definitions, then Impressionism's attention to the fashion plate of-
fered Morisot the—slim—possibility of salvaging those meanings
while at the same time exercising the privileges of painting.

The painters and writers around Morisot looked at many kinds
of modern, industrial, or exotic prints.[33] Some, like Japanese prints,
attracted almost everyone in the group, while others appealed in
varying degrees to different individuals. Morisot was hardly alone
in her appreciation of fashion prints. Most of her colleagues com-
mitted to the concept of modernity involved themselves with fash-
ion in one way or another, both because it manifested modernity in
a spectacular and pervasive way, and because fashion could produce
profits. Mallarmé tried to earn money by editing a fashion magazine
called *La Dernière Mode*. Morisot, Manet, and Renoir, along with
painters like Carolus-Duran, Stevens, and Tissot, painted their ver-
sions of a French "type," the "Parisienne." "Parisiennes" merged
fashion plates and paintings quite simply by magnifying the fashion
plate's image of an anonymous woman in elaborate costume stand-
ing against a blank background and by transposing the fashion
plate's meticulously engraved record of costume detail into oil paint
on canvas. Mark Roskill has shown how Cézanne based two of his

24. *Le Moniteur de la Mode,* pl. 887, 1868.

paintings on plates from *La Mode Illustrée* and suggests that Monet's *Women in the Garden* may also have originated in a similar source.[34]

Morisot's vision, however, had been more singularly structured than her male colleagues' by the cultural forces that produced fashion illustration. Whereas motifs from fashion plates might appear occasionally in the early work of Cézanne, Manet, Monet, or Renoir, they recur constantly in Morisot's images during the late 1860s and 1870s, and somewhat more sporadically and indirectly in the 1880s and 1890s. Male Impressionists cited the many kinds of sources they had access to, often several at once; Morisot kept returning to the images designed for women in her social position. Virtually all of Morisot's subjects that include people in them belong to the fashion illustration repertoire.

Not only do individual settings, costumes, poses, and compositions match, but the range of fashion's femininity is also exactly the same as Morisot's. The women in fashion illustration and in Morisot's images live in the city (Fig. 36; Pl. II), relax in the park (Figs. 26, 27, 37), and vacation in seaside resorts (Figs. 31 and 32).

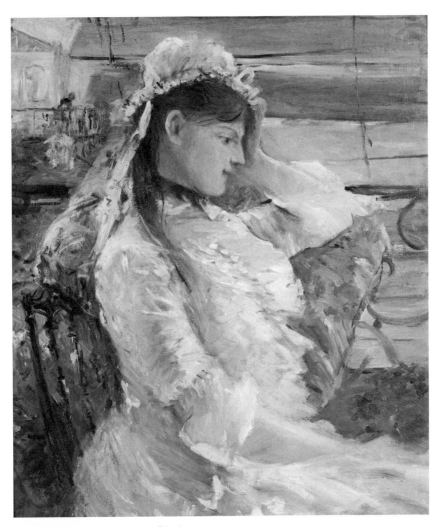

25. Berthe Morisot, *Behind the Blinds,* 1879.

Taking their cue from amateur imagery, both kinds of modern pic-
tures begin a woman's day once she has donned a *déshabillé* (Figs.
24 and 25), take her through public appearances like afternoon calls
and strolls in the Bois (Figs. 26, 27, 37), ignoring any chores, and

26. *La Mode Illustrée,* pl. 37, 1879.

end the day at balls (Fig. 33 and Pl. VII). The intimacy of the shift and nightgown, or the work of the kitchen and scullery, which in amateur pictures is relegated to caricature and in Morisot's images to hired models, is only represented in women's magazines by black-and-white engravings of isolated clothing items. Fashion illustrations, whose figures and settings encourage women's identification not just with clothing but with a way of life, are reserved for the representation of a respectable bourgeois domesticity.

Fashion plates and Morisot's paintings look alike because they share the same attitude. The iconography and style of fashion plates revised women's relationship to images of themselves in a thoroughly modern way that appealed to hundreds of thousands of women, including Morisot. She may or may not have been inspired by the compositions, color schemes, and spatial orderings of specific fashion plates, but she certainly saw with an eye and a mind informed by the cultural conditions that produced fashion illustra-

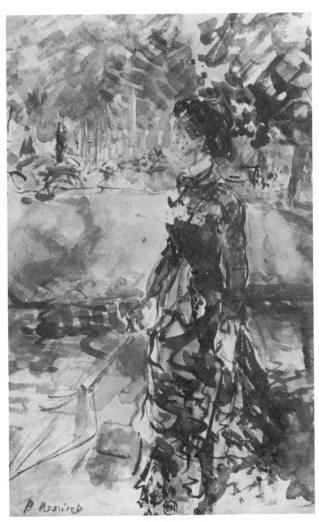

27. Berthe Morisot, *Woman Strolling*, 1883.

tion. Without contending that Morisot copied any single painting from any single fashion plate, nor even that she borrowed from any particular set of fashion images, we can use comparisons between specific images in order to discern their pattern. By locating the

convergences between fashion plates and Morisot's paintings made during the late 1860s and the 1870s, we can map out the configuration of Morisot's feminine modernity. If Morisot borrowed or copied, the forms she took had to fit her own project.

That project did not exactly duplicate fashion's. Though all of Morisot's women and places can be found in fashion illustration, the reverse is not true; not all of fashion's interests found a place in Morisot's imagery. She shared with the other Impressionists and the Manet brothers a republican disdain for religious ceremonies; the Catholic baptisms, communions, and weddings so frequently illustrated in women's magazines are completely absent in her work, as in her colleagues'. Nor did she show the commercial aspects of modern femininity so vital to fashion's power. Though women's magazines illustrated shopping with increasing frequency after the 1860s,[35] Morisot remained impervious to the attractions of the boutique, unlike Degas who painted a series of millinery shops. In this respect she perpetuated the delicacy of the more cloistered amateur tradition.

In many more ways, however, Morisot did adopt fashion's innovations. If we turn back to the two sheets of Kronheim prints (Figs. 20 and 21) and compare them with Morisot's pictures and with fashion plates, we can easily see that she has declined all the moralistic and theatrical scenes of the popular print trade, as well as pictures of bourgeois domesticity in costumes from the past, in favor of the resolutely modern results of fashion illustration's iconography. Of the sorts of popular imagery available to a bourgeois woman, only fashion illustration consistently matches Morisot's laconic mood, her resistance to anecdote and narrative. Nothing "happens" in fashion plates or in Morisot's pictures. Moments have no immediate and illustrated cause or consequence, though they are embedded in the more diffuse "story" of bourgeois femininity.

Morisot fills her paintings with the same social clues as fashion illustration. Costume and setting always indicate which moment of which feminine ritual we are observing. Morisot's 1872 *Interior* (Pl. I), for instance, combines the ubiquitous elements of two plates,

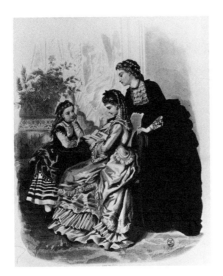

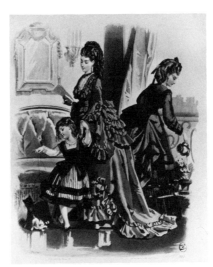

28. *La Mode Illustrée,* pl. 36, 1872. 29. *Le Moniteur de la Mode,* pl. 995, 1871.

one from an 1872 issue of *La Mode Illustrée* (Fig. 28), one from an 1871 issue of *Le Moniteur de la Mode* (Fig. 29). In the 1872 plate we see the same group of women—two adults, one seated in profile at the center, together with a little girl—the same formal afternoon dresses, sheerly curtained window, and profuse vegetation in a bronze planter. In the 1871 plate we find the same group in the same clothes again—this time with one of the women leaning in profile toward a wrought-iron window railing just as in Morisot's image— the curtain slightly pulled back, its edge marking the middle of the composition. The women in these *petits salons* are giving or receiving afternoon calls, accompanied by a dutiful daughter.

Yet none of these women tell us anything about the significance of the particular moment at which they have been pictured. Unlike the vivacity and sprightly emotional variety of amateur pictures, a polite detachment freezes both Morisot's images and the fashion plates. Their figures, though close to each other and to us, make no psychological contact. They and their accessories are each isolated within shallow spaces perfectly parallel to us. Figures and

30. *La Mode Illustrée,* pl. 45, 1873.

objects have been accumulated into three rigidly separate registers: people; objects; and backdrops, either walls or outside vistas. In fashion plates this effect can be explained stylistically by the perfectly uniform black outlines of engraving meticulously filled in with flat washes of color and by the sharp contrast between each object's color area. In Morisot's images the effect is all the more striking because each figure or object has the fullness and modulation of skillful oil, pastel, or watercolor painting. Gestures and facial expressions have been reduced to an expressive minimum. Figures rarely touch each other, and then only perfunctorily; they stare without communicating. The fashionable modern woman betrays nothing of her inner life.

This cool detachment, characteristic of many Impressionist pictures,[36] almost never wavers in Morisot's work. Often her women, like so many women in fashion imagery, appear to be concentrating on some intellectual activity: reading (Fig. 29), writing, sketching (Figs. 87, 100), playing music (Figs. 30, 98), even painting. Eyes on their work, heads resting on their hands, attentively

31. *La Mode Illustrée,* pl. 32, 1878.

listening or watching their companions, they are absorbed but not active. Even when they look straight out at us (Fig. 30), we perceive no overt appeal, no need for sympathy or empathy, no invitation to intimacy. One woman's occupation does not affect another's; one may be playing the piano while the other faces us (Figs. 30 and 98), two companions may turn their gazes in opposite directions (Figs. 23, 24, 26, 29, 30, 31; Pl. I). With their figures always satisfyingly large in proportion to the image, neatly centered and posed at eye level so we can clearly see a front, side, or back view, neither fashion plates nor Morisot's pictures offer us the kind of intriguing, privileged, or dynamic perspectives Morisot's colleagues, especially Caillebotte and Degas, knew how to exploit to heighten a picture's psychological tension.

Fashionable women ignore us no matter how closely modern life throws us together. We enter right into private spaces without being noticed. Standing on a shaded veranda next to an impeccably hatted Parisienne (Figs. 31 and 32), in her drawing room (Pl. I), or even in her dressing room as she prepares for a ball (Fig. 33 and

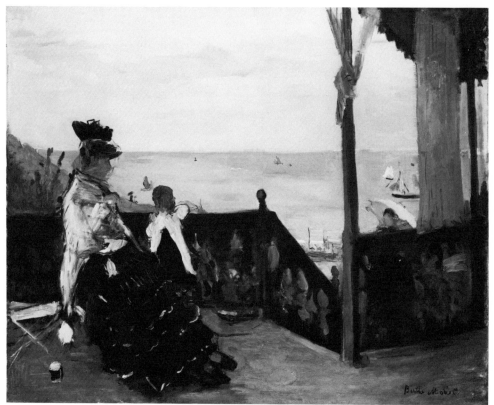

32. Berthe Morisot, *In a Villa by the Seaside,* 1874.

Pl. VII), we can observe her in every (respectable) moment of her day with the scientific scrutiny of the naturalist. We can inspect her costume, her bearing, and the company she keeps; we can check behind her shoulder to see what she is looking at. She permits us this scrutiny yet ultimately deflects our investigation with her urbane anonymity.

We look at fashionable women the way they look at each other. Are the women on the verandas (Figs. 31 and 32) relatives, acquaintances, or merely fellow tourists? Do they know the women under parasols coming up the ornate stairs or sitting on the beach?

33. *La Mode Illustrée,* pl. 52, 1874.

Nothing in the pictures informs us. We can't even be sure the woman and child are mother and daughter, for they behave with the same reserve as everyone else. Morisot often pictures two women together in a discreetly ambiguous relationship, just as fashion plates tended to. When she shows us a single woman, we watch her as if we were with her in a fashion plate. The woman in black glances over the back of her companion in white toward a slanted mirror in an 1874 plate from *La Mode Illustrée* (Fig. 33). She sees what we see in Morisot's 1880 *Young Woman Seen from Behind at Her Toilette* (Pl. VII).

Morisot treats family members and strangers alike. The democracy of fashion levels distinctions. If we did not know from later titles and from biographical information that the figure in a white *déshabillé* seated by a window in her 1869 *Portrait of Edma Pontillon* (Fig. 34) was Morisot's sister Edma, or from the same outside sources that Edma sits again by a window near her mother and

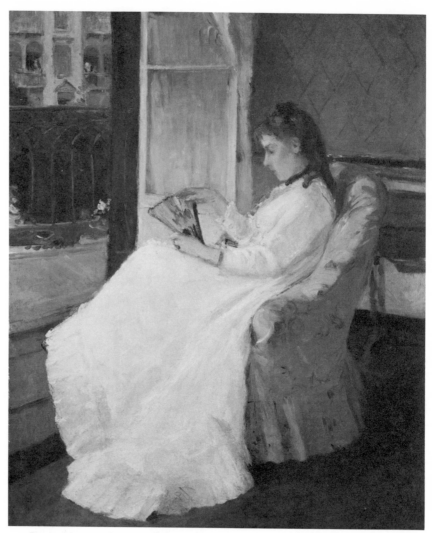

34. Berthe Morisot, *Portrait of Edma Pontillon,* 1869.

Morisot's, Cornélie Thomas Morisot, in the 1869–70 *Portrait of Cornélie Morisot and Edma Pontillon* (Fig. 16), how else could we know? With very few exceptions, Morisot pictures all women in the same modern way. She identifies her sister and mother the way a fashion

35. *Le Moniteur de la Mode,* fig. 139, 1871.

plate from an 1871 issue of *Le Moniteur de la Mode* (Fig. 35) identi-
fies its figures. Objects tell us as much about people as fashion
deems sufficient. These are middle-class women in their well-
appointed parlors, where they should be in the morning, in proper
and up-to-date *robes d'intérieur* and lacy *coiffures,* decorously occupied
by the sewing so prominently displayed in work baskets on stands
or small tables, and by reading letters or inoffensively short and
small books. To a modern mind, a more emotional or personal mes-
sage would be excessive.

Yet, obviously, Morisot's pictures do something more. The for-
mal attention lavished by fashion illustration on the details of cos-
tume has been transformed into a painting technique so ingenious
it seems spontaneously generated by the natural play of light on
surfaces. Spatial distinctions between people, objects, and settings
have been emphasized in order to activate our perception of them.
The back walls of fashion plates, for instance, include as many win-

dows as Morisot's; but Morisot uses the weight, color, and application of oil pigment in order to create the illusions of deep recession and sudden escape that make us understand what "interior" means. Her women hold back from us with dignity. In fashion plates we feel women give little because they have nothing left to give—their personalities have been extruded into their clothing, settings, and accessories. In Morisot's pictures, where so much less has been invested in the details of objects, and yet a rich atmosphere of light and color sparkles around the stable center of a calm gaze, we sense that form obeys the laws of gravity. Behind Morisot's women's reserve we sense a life all the more intense because it is withheld. The modern women of fashion illustration have attained self-sufficiency by acquiring sufficient signs of self. Morisot's women have cultivated an inner being.

Between Edma's marriage in 1869 and the return to stability of France after the disasters of the Franco-Prussian War and the civil war of the Commune in 1871, Berthe Morisot went through a time of total artistic reevaluation. Doubts about herself and exposure to the latest work of her friends Bazille, Degas, Manet, Stevens, and Tissot turned her in a new direction. Three things happened at the same time. Morisot destroyed virtually all her previous work, she began painting modern figural subjects, and fashion illustration themes started to appear with concerted insistence in her imagery.

At least one critic immediately noticed the difference in Morisot's 1870 Salon pieces: "The very luminous and limpid sketch by Mlle. Berthe Morisot, a *Woman at a Window* [*Portrait of Edma Pontillon,* Fig. 34] which, with another feminine study, mark by their subject a new orientation in her work."[37] Later Morisot would herself write: "Contemporary novelists, contemporary painters bore me, I only like extreme novelty, or things of the past; to be honest only one exhibition amuses me, the Indépendants, and I love the Louvre."[38] While respecting the past, represented by the Louvre, Morisot was embracing not just the modern but what was most fashionably modern, *la nouveauté extrême.* In painting that meant

pushing away from Corot's example and finding a "new orienta-tion." Bazille, Degas, and Manet could encourage her to paint in a modern way and draw on the lessons of popular or exotic prints. But she had to find an "orientation" that was both "new" and "fem-inine," and therefore not quite like theirs.

Morisot may have been distracting herself by leafing through more women's magazines than usual. Personal loss, political and military upheaval, the demands of modeling for Manet, as well as the impossibility of working during weeks of bombardment, hun-ger, and conflagration could all have driven her to seek fashion's entertainment. For whatever reason, a spate of themes and compo-sitions appear in Morisot's paintings made between 1870 and 1872 that had also appeared in the 1870 and 1871 issues of the *Moniteur de la Mode,* then France's most elegant women's magazine and among the most widely circulated. Whether we assume Morisot ac-tually saw and remembered these particular prints, or whether we suppose that she and fashion prints were inspired by the same ideas, we can compare two of her most important paintings with fashion prints to see how Morisot's concept of a feminine modernity reached its full power as soon as it had found its way.

Figure 76 of the *Moniteur de la Mode*'s April 1870 issue shows a rear view of two women, faces in profile, standing at an iron railing that ends on the right with a broad column, all in front of a deep urban vista (Fig. 36). The next year, the *Moniteur* pictured a woman with a little girl on her right standing in a park, also seen from behind, in figure 69 of the July issue (Fig. 37). In or just before 1872, Morisot decided to paint her sister Yves with her daughter in front of the railing of their family garden, looking across the Seine over the Parisian Left Bank (Pl. II). And by 1872 she imagined some aspects of the scene as it had been represented in the *Moniteur.* Her basic decisions about what should be in the picture, where, and in what size had precedents. She chose, as the *Moniteur*'s illustrators had, to show two figures, one adult and one young, seen at full length from behind, up close and in the center of the image, the

36. *Le Moniteur de la Mode,* fig. 76, 1870.

woman's face in profile; they lean against a garden railing, with a broad column on the right; the city beyond them seems far away. To these decisions Morisot added some which were more personally her own: formal choices about limpid tones, delicate contrasts between textures and weights of white, pink, blue, black, and gold, between an open sky and a glistening landscape. The combinations of these choices produced a painting so satisfactory to her that she repeated it in another painting medium, as if to confirm her mastery of the art. Now we have two versions of *Woman and Child on a Balcony,* an oil and a watercolor.

In June of 1871, right around the time Edma gave birth to her second child, the *Moniteur* published an engraving of a mother tending her new baby in a cradle (Fig. 38). According to the image's caption, the young mother wears a blue *toilette d'intérieur.* She stands by the oval cradle with its diamond-shaped quilting all around the outside and lacy curtains hung above from a ring, her hand exquis-

37. *Le Moniteur de la Mode,* fig. 69, 1871.

itely poised on the cradle's rim; the curtain's edge slopes down from
the right past a blank bit of wall and a window curtain pulled back
to the left. There was more to the engraving, but that upper left
corner had been marked off by the edge of a frame (Fig. 39). Within
a year Morisot had finished her most famous painting, *The Cradle*
(Pl. III).

Many paintings of the subject had been done before, but this
one was different, very restrained, distilled of all sentimentality,
yet infinitely suggestive. The cradle is the fashion plate's, as are
the mother in blue, her gesture, and even the overlapping curtain

38. *Le Moniteur de la Mode,* fig. 142, 1871.

edges against the plain wall. By adjusting all those elements, though, and by using the painter's ability to shift and alter space, color, weight, and material, Morisot puts into her image what the fashion engraving could only, perhaps, evoke. Both the baby and the mother belong in a space defined by a curtain; their gestures mirror each other, for both their arms are bent back, elbows almost touching, so that their hands rest against their faces. Mother and child are alike, but in different stages of development and consciousness. We see the baby asleep behind a veil; to us she looks like a sketch. The mother emerges in full light, for the curtain behind her has been pulled back from its window. She can see the baby more clearly than we can, yet she contemplates with reserve. The mother shelters the baby from us by holding the cradle curtain gently in her hand. She has created the boundary marked by Morisot as the thick pink ribbon that slides in heavy strokes across the

39. Detail of Fig. 38.

canvas, dividing the mother's reality from the child's.

Morisot along with most women of her time had witnessed a similar scene. They believed that the experience of maternity was among the most important in a woman's life. If a woman had been a mother herself, or, as in the case of *The Cradle,* if the mother were a dear friend or relative, she would know personally what this image of a woman looking at a new baby in a cradle could mean. But making an image into a convincing picture does not depend entirely or even largely on experience; it also depends on the availability of pictorial models, on the audiences able to take them seriously, and on the institutions that will sanction them. The print industry accustomed women to images of themselves engaged in the

activities that structured their social identities, images like the *Moniteur de la Mode*'s fashion engravings. Once such images had been accepted as suitable subject matter by avant-garde artists, it became possible to invest them with the intellectual and formal power of painting. A woman could then introduce her point of view into a national cultural institution like the Musée du Jeu de Paume. There *The Cradle* hung on public view, for decades one of the rare images by a woman to be so honored. During the Second World War a list was drawn up of paintings to be protected in case of danger; *The Cradle* came among those with first priority.[39]

Chapter Six

Painting Women

But, ah me! you only see me,
 In your thoughts of loving man,
Smiling soft perhaps and dreamy
 Through the wavings of my fan,—
 And unweeting
 Go repeating,
In your reverie serene,
"Sweetest eyes, were ever seen."

Elizabeth Barrett Browning,
"Caterina to Camoens," 1844

By the late 1860s "Parisiennes" had become a fashionable subject for young painters. Not only the Impressionists, but also more conservative painters, turned to the depiction of contemporary women. Some, like James Tissot and Alfred Stevens, virtually specialized in the subject. When, around 1876, Mary Cassatt joined the Impressionists, she too devoted her art to the representation of a modern femininity.[1] Closely knit both socially and professionally, all these painters monitored each other's work.

Morisot's style and subjects evolved within this collegial context. Her individual options and choices should therefore be sifted out from those of her group. One issue especially requires our attention, because it so particularly affected Morisot (and Cassatt): the ways in which her peers represented the relationship between women and images. Paintings that juxtaposed women and pictures not only set the professional tone for Morisot's work, they also, more personally, suggested what position she occupied in her col-

40. Gavarni, *Balivernes Parisiennes,* " . . . et combien . . . ," 1846.

leagues' eyes. Many artists could imagine painting modern women; fewer could imagine a modern woman painting.

Convention assigned women passive artistic roles. Traditionally cast as patronesses, muses, models, or objects of desire, women appeared no differently in contemporary popular imagery. Gavarni, on whose lithographs Morisot had been raised, expressed women's creative status eloquently and repeatedly. According to the caption of an 1846 lithograph, a woman asks the lithographer: ". . . and how many things can you get, with an affair like that?" He replies: "As many as you can with . . . Romeos, Juliet" (Fig. 40).[2] He deflects her inquiry with a gendered and prescriptive analogy; his business is producing pictures, while hers is love, and he casts her affairs according to a canonical Shakespearean script. In another of Gavarni's 1846 lithographs, a woman walks away, ogled for us by a dapper flaneur (Fig. 41). Gavarni reminds us with his caption that she is "within lorgnette range," like prey in a rifle's sights.

Within avant-garde painting, however, men and women began

41. Gavarni, *Balivernes Parisiennes,* "A portée de lorgnon," 1846.

to revise convention. Members of the Impressionist movement
treated Morisot and Cassatt with unprecedented professional re-
spect. Morisot and Cassatt earned that respect, with their work and
with their professional behavior. But old ideas die hard, and if there
was anything more difficult than for a male painter to represent a
woman actively and independently engaged in the production of
elite art, it was for a woman to represent herself that way.

We can begin with a masculine reference point, Degas's 1868
portrait of Tissot (Fig. 42). Straight in front of us, in the center of
the image, hangs a copy of a Lucas Cranach portrait impressively
displayed in a wide gilded frame.[3] Just to the left, Tissot's own head
echoes Cranach's; if the young master sat upright he would occupy

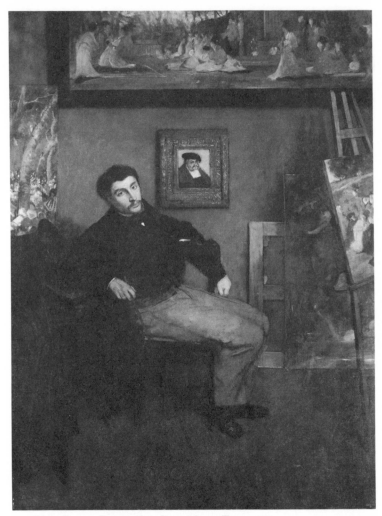

42. Edgar Degas, *Portrait of the Painter James Tissot*, 1868.

the position of the Old Master. Degas marks Tissot's place in a tradition of painting both chronological and geographic; above the Western portraits he places a painting in Japanese style. To the left and right, works in progress lean against the wall or wait for the artist on an easel, evidence of continuing production. Tissot

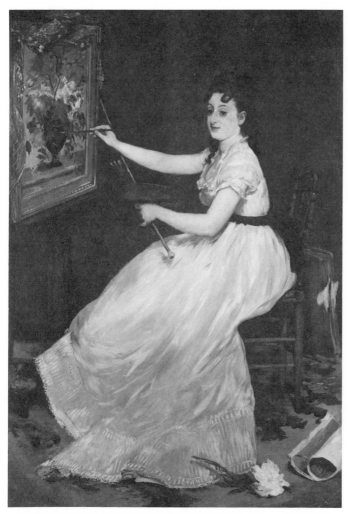

43. Edouard Manet, *Portrait of Eva Gonzalès*, 1870.

lounges at his ease among all these paintings, walking stick in hand, top hat by his elbow, a man of the world.

In comparison, Manet imagines his disciple Eva Gonzalès dabbling ornamentally (Fig. 43). She sits at an easel and touches a paintbrush to a canvas, as well she might, since until her death in

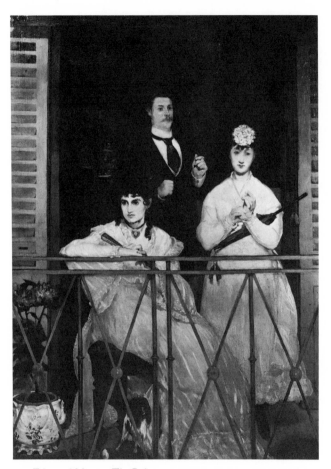

44. Edouard Manet, *The Balcony,* 1868–69.

1883 she produced paintings consistently if quietly; but her arm curves so delicately, her white dress drapes so immaculately, that we cannot believe this woman is actually working. The still-life subject of her picture, moreover, lowers its status to the bottom of contemporary iconographic hierarchies.

Manet found eleven different ways to represent Morisot, none of them as a painter. In several of his most vibrant portraits of her, in his 1868–69 *The Balcony* (Fig. 44), for example, she does hold an

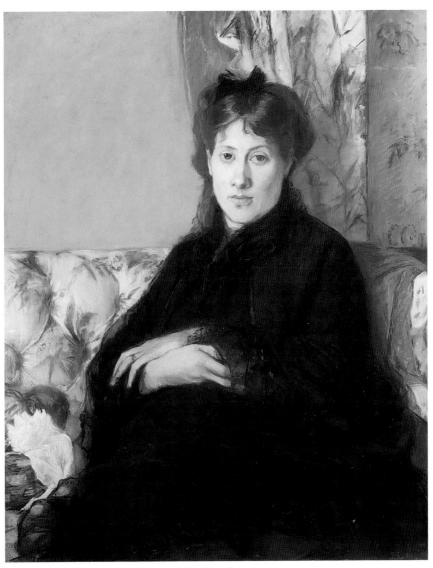

PLATE V. Berthe Morisot, *Portrait of Edma Pontillon*, 1871.

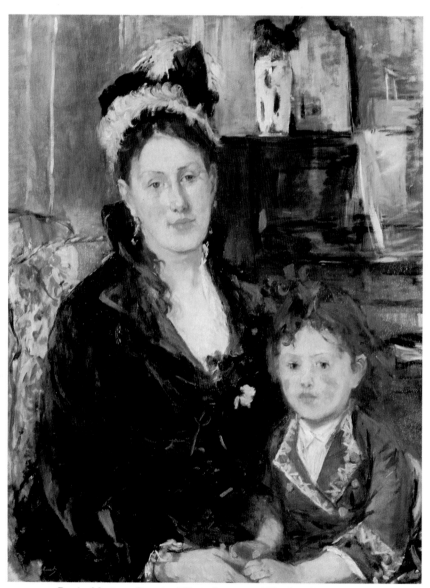

PLATE VI. Berthe Morisot, *Portrait of Maria Boursier and Her Daughter,* 1874.

instrument—not a paintbrush but a fan. If masculinity wielded the brush, femininity waved the fan. "The fan is the most important piece in a feminine arsenal ... Everywhere you find a woman, you're just about sure to find a fan."[4]

Taught to be seen not heard in public, trained to move little and gesture less, women used fans as a kind of language. Entire codes were devised by which women could mutely and secretly express themselves with this "interpreter of your hidden feelings."[5] The extent of the fan's language, however, was almost entirely limited to "amorous enterprises," and more precisely to rituals of seduction, "the flirtations of intimate receptions."[6] Contemporary sources describe seduction sometimes as a negotiation but much more often as a battle. Women invariably fought on the defensive. The fan, "the most important piece in a feminine arsenal," turns out to be "the defensive weapon," a "screen,"[7] or a "shield."[8] Moreover, the fan is also characterized as a trivial thing, a "jewel" or "rattle," and not quite real, a "magic wand."[9] Its meanings vanish into thin air. The nineteenth century assigned to women a feminine language whose only meanings were those of erotic exchange with men, and inadequate even for that purpose.

Yet the fan was the only instrument of meaning Manet ascribed to Morisot. In 1872 he thanked her for the time she had spent as his model with a tiny painting. The bouquet of violets she had worn in her corsage in his most recent portrait (Fig. 45) reappears without her (Fig. 46). Natural flowers stand for her, wittily translated into painting by him. Behind the bouquet Manet has placed two kinds of language: her fan (the same red fan she held in *The Balcony*) and his writing on a small white sheet of paper. His language identifies her—"To Mlle Berthe"—as the recipient of "E. Manet"'s art, of both his words and his image, the two signed as one.

Nonetheless, we know from biographies and correspondence that Manet took Morisot's painting somewhat seriously—offering her, for instance, an easel for the 1881 New Year[10]—and certainly never daring to behave toward her with anything but the utmost bourgeois respect. Whether for artistic or for class reasons, Manet

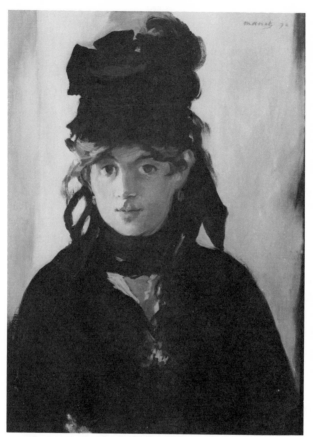

45. Edouard Manet, *Berthe Morisot with a Bouquet of Violets*, 1872.

acknowledged Morisot's intellectual priorities. However tenuously, his portrayal of her as a seductively beautiful woman suggested a woman might be both intellectual and feminine. To an uninformed public, Manet's images of Morisot reiterated women's role as men's models and as objects of visual delectation. But to Morisot herself and to those around her, they affirmed the duality of her character. They promised her she could be both an artist and a desirable woman, just when she most feared the contrary, during the five years between her commitment to professional painting and her unexpected marriage.

46. Edouard Manet, *Bouquet of Violets,* 1872.

Degas went farther. Rather than praise Cassatt's beauty, his images repeatedly conceded her artistic intelligence. Around 1880 he was working on a painting of two anonymous women in the Louvre Grande Galerie, of which he said to the painter Walter Sickert that "he wanted to give the idea of that boredom and respectfully crushed and impressed absence of all sensation that women experience in front of paintings."[11] Apparently he exempted Cassatt from his rule, for in those same years he represented her as anything but bored or crushed in his etching of her at the Louvre (Fig. 47). She stands alert, thrusting her umbrella sideways more than leaning on it. Her sister, Lydia, sits indolently and consults a catalogue, but Mary looks directly at the Louvre's treasures. A faceless spectator, not an identified creator, Cassatt nonetheless fixes her

47. Edgar Degas, *Mary Cassatt at the Louvre: The Paintings Gallery,* 1879–80.

attention on high art, rather than on us, and Degas uses a painting frame to locate the exact direction of her gaze. Having tried an initial version which set Cassatt in an Etruscan sculpture gallery, Degas then involved her with the kind of art she made—paintings— and himself became so involved with the image that he reworked it twenty-three times.[12]

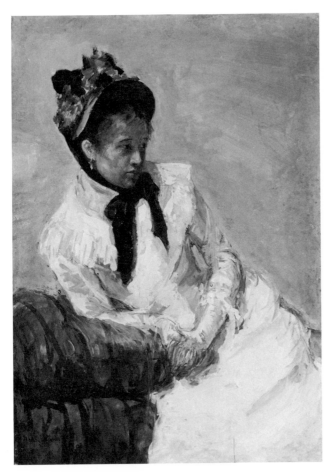

48. Mary Cassatt, *Self-Portrait*, 1878.

At first Cassatt seemed more ambivalent about herself. In the earliest stages of her acquaintance with Degas, before she had exhibited with the Impressionist group, in 1878, Cassatt painted a self-portrait that gives no sign of any intellectual occupation (Fig. 48); she looks diffidently sideways and staidly clasps her hands; her hat makes a more colorful and densely painted bid for pictorial attention than her face.[13] A small gouache, this image remained private for many years; Cassatt gave or sold it to her best friend,

49. Marcellin Desboutin, *Portrait of Berthe Morisot*, 1876.

Louisine Havemeyer, who did not include it in her donation of the majority of her collection to the Metropolitan Museum of Art.

But as Cassatt and Degas began to spar with each other, a new image of Cassatt emerged. Perhaps, as Barbara Stern Shapiro has suggested, Degas intended to liken Cassatt to Morisot by citing

50. Edgar Degas, *Portrait of Mary Cassatt*, c. 1880–1884.

Marcellin Desboutin's 1876 drypoint portrait of Morisot (Fig. 49).[14] He adjusts Morisot's posture in his *Portrait of Mary Cassatt* (Fig. 50), made sometime between 1880 and 1884, to compose Cassatt's torso and arms into a powerful angle that pushes three *carte-de-visite* photographs out toward us.[15] Cassatt may not be shown to be a painter, but she certainly has a grasp on images. The contrast with Manet's portraits of Morisot as well as Desboutin's is all the more striking because the way Cassatt holds the photographs makes a visual pun on playing cards and on a fan.

Wearing the same dress and hat, Cassatt represented herself in a very similar position, seated a bit more upright, but in just the

51. Mary Cassatt, *Self-Portrait*, c. 1880.

same direction and at the same distance from us (Fig. 51). Where in Degas's portrait Cassatt looks abstractedly down and slightly sideways, in her self-portrait she meets our gaze. Instead of holding someone else's images, she paints her own. Her work, her paper

and brush, appear only faintly, sketched in with just a few dry
strokes. Cassatt's image measures less than a third the size of De-
gas's, and rather than his substantive oil medium, she chose fragile
watercolor. Still, she has made her statement.

Who responded to whom? We know Cassatt disliked his por-
trait of her.[16] Did Degas's image elicit a retort? Or did his portrait
attempt to rectify her self-portrait? Since neither picture is exactly
dated, we have no solution to the enigma of this particular pair.
What matters is that the entire episode, regardless of its internal
dynamics, could take place at all, and that it occurred within the
broader intellectual exchange Impressionism fostered between
women and men. Upper-middle-class solidarity helped, but individ-
ual efforts like Manet's and Degas's, and above all Cassatt's and
Morisot's own reevaluations of themselves, made the crucial differ-
ence.

We can measure that difference by comparing Cassatt's, De-
gas's, Manet's, and Morisot's images with analogous images by Tis-
sot and Stevens. Degas and Morisot knew Tissot well. Degas, as we
have seen, painted his portrait. Morisot visited him during her 1875
trip to London, and she refers admiringly several times in her letters
to the prices he fetched. The Stevens and Morisot families moved in
the same social circle as early as 1867; Stevens owned at least two
of Morisot's paintings. Besides being friends and sometimes profes-
sional allies, Tissot and Stevens were the most institutionally and
financially successful among a group of youngish painters who in-
troduced the academic art world and the European art market to the
subject of the "Parisienne."

Just as in Degas's oil portrait of Tissot and his print portrait of
Cassatt, we look behind the subject's head to an emblem of sight in
Tissot's 1864 *Portrait of Mlle. L.* (Fig. 52). Whereas behind Tissot
and Cassatt we saw consecrated paintings, behind Mlle. L. we see a
mirror; Tissot associates his female figure with vanity rather than
art, with reflection rather than creation. The mirror reminds us of
Mlle. L.'s appearance, of the dress and hairstyle whose expanse and

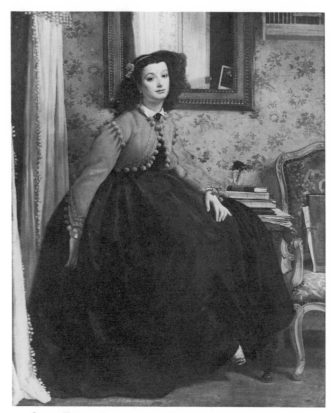

52. James Tissot, *Portrait of Mlle. L.,* 1864.

detail reduce her face to insignificance. In the mirror Tissot places reflections of Mlle. L.'s head, a window, and an open door, as well as a *carte-de-visite* photograph tucked in the corner of the mirror frame; he renders them all equivalent objects of contemplation. His clever plays on representation and reflection within his image do not engage Mlle. L. with these signs about signs, any more than she notices the books stacked up beside her; they underscore the painter's craft, his ability to present us with an optically convincing display of Mlle. L. as a fashionable spectacle.

Stevens in his *Family Scene* (Fig. 53) also constructs an image

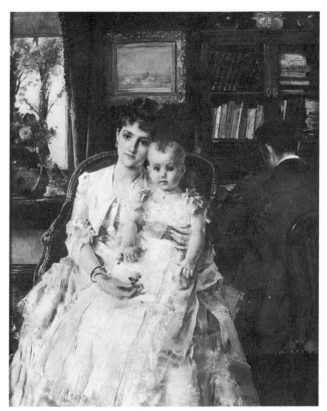

53. Alfred Stevens, *Family Scene,* date unknown.

of femininity through its relation to images. In the center of his
domestic interior sits a young woman with a baby on her lap. We
assume the child is male because it wears blue ribbons rather than
pink. Stevens establishes a natural bond between the woman and
baby by the identical pink flowers they each hold in their right
hands, one placed directly above the other. He signals a matrimon-
ial bond between the woman and the man next to her by placing a
gleaming wedding ring on her finger almost in the center of his
image. Stevens distinctly differentiates the husband's and wife's
areas with references to words and images. The husband occupies

the side demarcated by a writing desk and bookshelf. Like Cassatt in Degas's print, he is absorbed in thought. We face in his direction and we, too, are absorbed in an intellectual occupation (looking at painting) so we identify with him, and our gaze with his. The wife is situated on the other side by two views of nature. A window frames a view of trees, which we see behind a vase of flowers on the windowsill. The wife is connected to this view by the flowers she and her child hold. She is also associated with nature by her placement directly below a painting that frames a landscape just as the window does. Nature has been domesticated: the outdoors is seen from within, the flowers are in a vase, the landscape has been turned into a painting. The domestic interior, conversely, has been naturalized. Thus elided, nature and domesticity define the wife's position. In that position, she, like Tissot's Mlle. L. has nothing to do but display herself to us, to our gaze, our intellectual, masculine gaze.

Both Stevens and Tissot use sophisticated formal devices to convey their messages: juxtaposition, axial alignment, visual metaphor, metonymy, assonance, and alliteration.[17] The force of their image comes less, however, from these devices themselves than from the mimetic content they structure. Stevens and Tissot, along with other Salon or academic painters of their generation, invested their technical skills most heavily in optical illusionism. They sought to convince us that what they represented was more important than how they represented it.

Images like *Portrait of Mlle. L.* and *Family Scene* posit the truth of their perception. Ideological constructions guaranteed by stylistic coherence, they deny the contingency of their meanings and present themselves as flawless fact. Their laborious technique perfects and idealizes circumstantial relationships among objects, people, and places, uniting them immutably. The conviction they inspire depends on the proposition that paintings reflect "reality" or "what painters see," an artistic doctrine we loosely refer to as "realism." "Realism," in short, can make a mid-nineteenth-century European femininity look like women's reality.

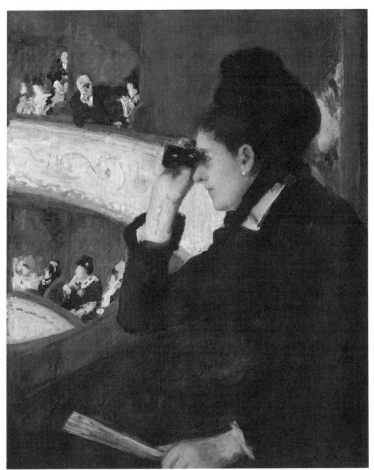

54. Mary Cassatt, *Woman in Black at the Opera*, c. 1878–1880.

10.35

Cassatt's technique operates in much the same way, but in order to posit a different women's reality. Every recent writer on Cassatt has stressed the changes she introduced into the representation of contemporary women,[18] depicting them absorbed in newspapers, for instance, or secularizing the venerable theme of the Madonna and Child. In her 1878–1880 *Woman in Black at the Opera* (Fig. 54),

perhaps more clearly than in any of her other paintings, Cassatt reverses women's traditional visual passivity. Setting and costume alone could tell us this woman in black is staking out new ground for women; she appears unaccompanied in a public theater, yet the sobriety of her dress indicates her unassailable respectability.[19] With one hand she grasps a seeing-tool, an opera glass, and leans toward the object of her attention. Whatever this may be, we do not see it; the very act of her looking dominates the image. Cassatt, furthermore, emphasizes the radical quality of her subject by placing the feminine fan in her figure's other hand, a fan the woman in black lays aside to use the opera glass instead. Her magnifying instrument dwarfs its counterpart held by a small male viewer in the background. He gazes eagerly at the woman in black, but she does not even notice his presence.

Morisot shared Cassatt's ability to imagine women differently but chose another intellectual and formal style. None of Morisot's early pictures ratify current gender stereotypes the way Stevens's and Tissot's do, but they do not overtly revise them either. Morisot objects to conventional representations of women by turning themes against themselves, by self-consciously differentiating between signs in ways that highlight the artifices of representation. In this respect Morisot, especially in the late 1860s and early 1870s, resembles Degas, whose images so often expose the ambiguities of their subjects in covertly formal ways.

Morisot's affinity for Degas's attitude may explain the crucial part his work plays in her 1869 *Two Sisters on a Couch* (Pl. IV). This image has elicited considerable commentary, and for good reason; it can be seen as a visual parable for Morisot's entire pictorial endeavor of the subsequent decade. At the brink of her maturity, Morisot articulated her premises.

Like Cassatt in *Woman in Black,* Morisot in *Two Sisters* suggests a new kind of women's vision and compares it with a man's perception of her subject. But where Cassatt makes her meaning evident as a subject or theme, Morisot's meaning requires more decoding.

Matthew Rohn has alerted us to the significance of the picture's two figures.[20] Rohn proposes on the basis of biographical evidence that the two sisters so named in the picture's title are in fact Edma Morisot on the left and Berthe Morisot on the right. Whether or not this is accurate (and it might be), Rohn argues convincingly that the issue of the image is one of double or shared identity and anxiety over the loss of what Morisot felt to be a part of herself when she and Edma were separated after twelve years of artistic partnership. The sisters look almost like the same person and yet are different.

Rohn briefly discusses the picture represented in the background of *Two Sisters*. It reproduces a fan painting given by Degas to Morisot titled *Spanish Dancers and Musicians* (Fig. 55). Degas's image may have been inspired by Alfred de Musset's 1830 *Tales from Spain and Italy,* for Morisot's family identified the guitar player as Musset himself.[21] This has prompted Rohn to suggest that the female dancer in the fan could represent George Sand, Musset's notorious companion, and that Degas, by giving Morisot this fan, declared her a latter-day Sand. John Paoletti in his response to Rohn

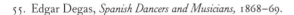

55. Edgar Degas, *Spanish Dancers and Musicians,* 1868–69.

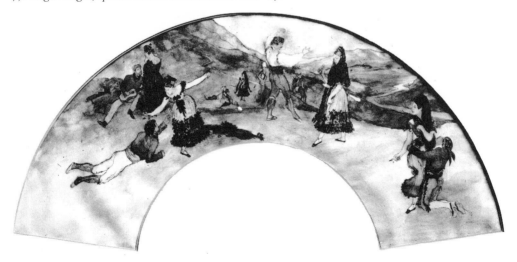

asserts that more should be said about this image-within-an-image and that more should be read into the image's visual content, with less reliance on auxiliary texts.[22] Rohn's approach and Paoletti's comments converge if we consider *Two Sisters* as an image about different kinds of images and about how women identify with and are identified by images.

We must look at *Two Sisters* as a painting about Morisot's sense of self, since she was a woman dedicated to making images about women's identity. If she consciously gave the righthand figure her own physical features, she would only have been adding a superficial dimension to a deeper pictorial investigation of who she both was and was not. *Two Sisters* explores the difference between painting and conventionally feminine self-expression, between masculine and feminine signs. And biographical evidence makes it incontrovertibly clear that in 1869 Morisot was tormented by the contrast between her choice to paint and Edma Morisot's choice to abandon art in favor of marriage and children.

Morisot echoes her two figures with two fans. The women repeat each other from side to side, the two fans above and below. Just as the women are both like and unlike, so the fans are alike but different in that one is represented as an object and the other as a representation. The difference between the fans is both emphasized and confused because Morisot allows us to read the image on the picture-fan quite clearly, while we are unable to decipher anything on the object-fan. The paradox that an image-within-an-image should be more legible than an image is reinforced by the layers of meaning already inscribed in this particular picture-fan.

Whether Morisot used Degas's fan to corroborate an intellectually flattering analogy between herself and Sand depends on our acceptance of Rohn's admittedly conjectural hypothesis. Certainly she was confirming her artistic allegiance to Degas, at once paying him the tribute of direct quotation (only he received this compliment until much later in her career) and proudly demonstrating his esteem for her. The comparison between the object-fan's opacity

and the painting-fan's multiple intellectual statements enunciates the comparison Morisot makes between the two versions of her identity, superficially alike and yet so different. The object remains inert while the painting communicates volubly and intricately; one sister has been silenced, while the other continues to paint.

Yet Morisot refuses to adjudicate between the two sisters. The painting she uses within her painting is, after all, of a fan. Degas had given it to her with a double meaning, acknowledging her works with one of his, but also offering her a conventionally flirtatious fan. Morisot revels in the ambiguity, drawing our attention to the shape of Degas's gift by its repetition in both the other fan and in the domestic plant at the picture's edge.

Whereas "realist" painters like Stevens or Tissot used signs to provide definitive answers about women, Morisot used them to ask questions. In her image it is entirely unclear what kind of signs belong to which women; both kinds of fans link the two different women; the feminine fan hides what we assume to be their clasped hands; the masculine fan connects them at eye level. If this contrasts a nurturing physical feminine bonding with a masculine imagination that bridges physical separation, then in Morisot's image women enjoy both kinds of communication.

Cassatt's image announces a new kind of woman who looks differently, and who has a right to be looked at differently. Morisot's image problematizes seeing itself and proposes that a woman has the right to be seen in several ways at once. Each tactic has its merits and its limitations. If Morisot's strategy is more cryptic, tentative, and self-conscious than Cassatt's, it addresses fundamental issues of representation Cassatt leaves untouched.

Morisot disclaimed "realism." In her notebooks, she returned again and again to the distinction between art and reality.

> Thursday, Degas said the study of nature was insignificant, that painting was an art of *convention* . . . and that it was infinitely more worthwhile to learn to draw.[23]

Edouard himself, however he prided himself on copying nature with servility, was the most mannered painter in the world.[24]

Dinner with Mallarmé. The art is in the counterfeiting![25]

This word realist is senseless.[26]

Any painter copying nature can call himself realist and none deserves the name in its absolute sense.[27]

Morisot also rejected fixed rules for painting. She wrote in a notebook: "Real painters understand with a brush in their hand . . . What does anyone do with rules? Nothing worthwhile. What's needed is new, personal sensations; and where to learn those?"[28] She refused to equate the "personal sensations" of her art either with rules such as those governing the academic pictures of her day or with a supposedly direct experience of nature. Her images, Morisot understood self-consciously, reflected her individual perceptions and their stylistic translation. She had no illusions of recording some immutable "reality" available to the eye. Nor did she feel bound either by the conventions of the academy or by those of any "realist" school.

Nonetheless, the visual conventions governing painting as Morisot came to artistic maturity have to be taken into account as the norm from which she might deviate according to "new personal sensations." The optical mimesis, the smooth surfaces, the homogeneous illusions of light meeting detailed volumes and textures in an evenly receding box of space, all characteristic of paintings deemed "realistic" in Morisot's time by official arbiters of taste as well as by the burgeoning "genre" market, constitute the professional standards against which Morisot reacted.

The anti-academic Impressionist program encouraged Morisot to abandon technical habits. Tracts like Edmond Duranty's *The New Painting* also urged her to rethink her subjects in terms of her contemporary experience of them. Her conception of herself as an avant-garde painter allowed her to experiment with image making both stylistically and thematically. She, moreover, understood these two kinds of freedom as one.

For Morisot and Cassatt to learn, through Impressionism, how to represent themselves as painters, they had to convert the traditionally passive relationship between women and images into an active one. Their new self-conception implied that other women's relationships to images, to seeing, and to being looked at, might also be rethought. The novelty of Cassatt's vision found expression primarily in her choice of subject matter, and during the early 1890s in her experiments with prints inspired by Japanese art. Morisot adopted a stylistic mode of individuality. Like many fellow avant-garde painters, she invested her handling of pigment itself with a personality.

When critics commented on Morisot's difference from other women artists, they usually mentioned her seemingly spontaneous and carefree technique. Indeed few women had the confidence to embed a signature in style, to assert any individuality with their brushwork, let alone an identity so casual and vivid. Of course Morisot's style was not spontaneous at all, any more than Monet's was, or Renoir's. Like theirs, the apparent rapidity of her execution and the exuberance of her marks derived from years of practice and concentration. Each of the principal Impressionists designed effects calculated to convey an attitude to their subjects and in turn to their audience. For Morisot, whose subjects were modern women, style carried her interpretation of contemporary femininity.

During Morisot's lifespan femininity was being recast socially by bourgeois conceptions of women's roles as wife, mother, and homemaker, and economically by the consumption of industrially produced commodities. Each of these cultural constructions relied on an imagined relationship: the domestic role on an imagined relationship between women and nature; the economic role on an imagined relationship between women and objects. Morisot reproduced these fictions in her images, but her individual style made them obviously fictional. Her images concur with contemporary signs of gender, then caution that signs are only signs, not women themselves.

In the early 1870s, Morisot made several pictures of young

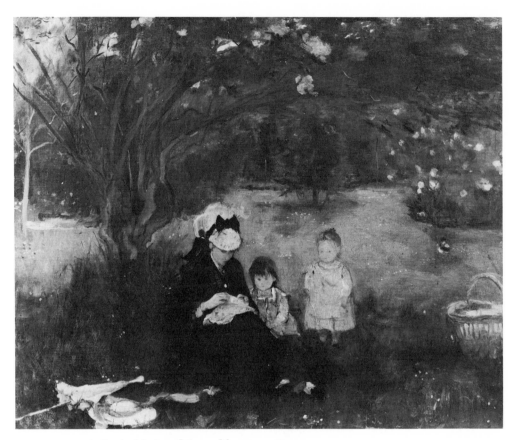

56. Berthe Morisot, *Lilacs at Maurecourt,* 1874.

women with children in gardens. In each of them she places her figures at the center of the image near a single prominent plant, a leafy tree or flowering bush, and relates the people and plants compositionally. Visual likenesses render femininity natural with the metaphors they articulate. In Morisot's 1874 *Lilacs at Maurecourt* (Fig. 56) nature and woman echo each other. Across the top of her image arches the lilac bush, whose movement, punctuated by heavy blossoms, continues around the image along the white blossoms of another bush, picks up the warm yellows of a wicker basket, and

then dips through the bright straw hat and white parasol. The flowering bush and protective objects together form a complete circle. Within this sheltering circle nestles another circle made by a woman and children. The woman sews; the parasol points through her occupation at the two children. The young woman is to the two children what the lilac bush is to the entire image: a strong crescent in whose curve others may be ensconced. The image is so familiar, so effortlessly repeated, that we hardly notice how it is constructed. Morisot fully enunciates the analogies between women and nature, or between women's nurture and nature, though we could have extrapolated them from the slightest hint.

Lilacs at Maurecourt, like many of Morisot's images of women, has no horizon, no open sky. In her work we can barely see farther than women's enclosures, and they themselves almost never look out to a view beyond. Like Yves on the Morisot balcony overlooking Paris (Pl. II) or Edma in the family parlor (Fig. 34), the women gaze back homeward. Morisot's spaces both shelter and restrict. In garden clearings or on veranda porches, along the Seine or in their drawing rooms, every woman has her barrier. Railings, fences, balconies, bench slats, trellises, window sashes, mirror frames, picture edges, sofa corners, or hearth moldings: these are the limits within which women are contained.[29] Like countless other nineteenth-century painters, Morisot uses borders to frame women into place.

In *Portrait of Edma Pontillon* (Fig. 34), Morisot fits her sister between the lines of the interior. On the left appear the grid of building facade above iron railing above window frame above baseboard, the panes of glass in their white wood casings next to curtain edge. On the right we see the diamond design of wallpaper above molding stripes above sideboard above floorline. These lines fasten Edma into place, head inclined to just before the curtain edge, nape just at the juncture of armchair and molding, foot resting right on the top of the baseboard.

Objects supplement the meanings of the interior's boundaries. In Morisot's 1872 *Interior* (Pl. I) a woman sits upright along the line

between a window and a bronze planter. Windows we cannot see through once again affirm the interiority of the scene, a meaning amplified this time by furniture. The small, curving, carved chair and the bronze planter filled with tall green leaves and blooming flowers convey the signs of domesticated nature, precious craft, dependence on care, and fragility. Morisot has articulated the planter, the woman, and the window into a metaphor that includes and thereby defines a woman. Zola constructed the same metaphor verbally when he described an interior in *Au bonheur des dames:* "The salon, with its flowered brocade Louis XVI furniture, its gilded bronzes, and its big green plants, had a woman's intimacy [*une intimité de femme*], in spite of the height of the ceiling; and through two windows you could glimpse the chestnuts in the Tuileries."[30] "A woman's intimacy" has been described as an ornamented, luxuriant, and enclosed place in Zola's as well as Morisot's image.

Femininity is established, in Zola's and Morisot's images, as a correlation between a woman, a place, and objects. The objects they chose had already been invested with the connotations of gender. The chairs in *Interior,* for instance, are the black and gold *chaises légères* of the style and weight prescribed, beginning in the Second Empire, for women's receptions or afternoon visits. Porcelain vases and cups, silver tea sets, bird cages, little stuffed sofas for two called *causeuses,* low stuffed armchairs called *chaises Marie-Antoinette* or *fauteuils anglais,* sweeping window draperies, these along with the *chaises légères* and the bronze planters were the props of the *petit salon.* In whatever varying combinations, Morisot used them constantly in her images to create a sense of feminine place.

Emblematic objects can serve to identify women all by themselves, regardless of place. Privileged accessories punctuate appearance with concentrated significance. For a "Parisienne," quintessence of French femininity, "the accessory, in her outfit, is for her the most important point . . . Above all else it's the completion of a harmony, the embellishment of a utility, the perfect finish of an *ensemble.*"[31] Accessories carried so much meaning precisely because

they had no function other than to recapitulate the message of the *ensemble.* Lace, flowers, and fans received unanimous endorsement. "A bouquet in the hand of a woman seems to me to be the image of her beauty,"[32] advised one author of a women's behavior manual. "Be the flower that gently perfumes the atmosphere of the family home,"[33] wrote another. Small dogs also had supporters, "that other favorite . . . an accessory and a bibelot."[34]

Objets de toilette belonged to a category of their own. Crystal flasks for *eau de violette* or *eau de toilette,* trinkets and caskets in precious materials for pastes, unguents, or rice powder, were ceremoniously placed on the dressing table *(poudreuse),* a small table equipped with a mirror and usually veiled with light draperies, at which women sat to arrange their hair, apply cosmetics, and verify the details of their appearance. The *poudreuse* was sometimes located in the dressing room *(cabinet de toilette),* sometimes in a woman's bedroom. Toilette items served cosmetic functions and also symbolized the entire enterprise of feminine embellishment. Jacques Emile Blanche, who had known Morisot in his youth, characterized her Passy world, and her artistic vision, with these objects: "a whole series of objects in ivory and mother-of-pearl, album bindings, caskets, ring-holders, rice-powder puffs, little brushes on a dressing-table draped in white on pink; glass bud-vases with arums inside, cream lacquer psychés in a room done in sprigged muslin."[35]

Morisot represented women in the same places and with the same objects as did her colleagues. Her old friend Fantin-Latour, her more commercially and critically successful rivals Stevens and Tissot, Cassatt's teacher Charles Chaplin, along with many others, made images of modern femininity into a genre of painting by consistently repeating a set of themes. They, like Morisot, all placed women in interiors, parks, and seaside resorts, in apposition with porcelains and plants and adorned with flowers, lace, fans, and tiny dogs. Their success rested on the technical and esthetic skill with which they confirmed popular assumptions about gender.

Morisot never quite managed the smooth reassurances of her colleagues' style. She represented the same people, places, and things as they did, but not in the same way. Her handling of her medium added another perceptual dimension to her subjects, one that questions imaginary gender relationships by intruding the materiality of paint itself into the illusions of representation. In an overall color scheme of whites, blacks, and browns, Morisot places sudden thick, brush-ploughed spots of turquoise blue, lilac, brick-red, and sea-green. The hair ribbon, the bouquet, the pillow, and the handkerchief in the 1869–70 *Portrait of Cornélie Morisot and Edma Pontillon* (Fig. 16) advance both physically and optically from the rest of the picture, so much so that the spatial relationships between the pillow, handkerchief, and table edge become difficult to decipher. If Manet left his mark on this painting in his reworkings of Mme. Morisot's face and skirt, Morisot left hers in her concentration on the emblems of her gender.

Morisot emphasizes both personal adornments and bibelots. In her 1875 *At the Ball* (Fig. 18) she rings her figure with them. Double tracks of white ribbon swing around the edge of the bodice, lead to yellow and black bursts of flowers, on to bright red and blue daubs on the fan, and more flowers, until finally the circle closes at the spray of red and yellow flowers in the planter behind. The density of these objects' pigment and color contradicts perspectival space. They orbit around Morisot's woman, much like the parasol, the hat, the lilac bush and the basket in *Lilacs at Maurecourt* (Fig. 56).

Suspended on the surface of the 1872 *Interior* (Pl. I), objects acquire a pictorial life of their own. Pink and red flowers burst from the background and off the woman's shoulder, a brilliant lilac cushion shines in the foreground, while the planter confuses all the spatial relationships around it with its gold swirls that seem almost to merge into the adjacent gilded carving on the *chaise légère* and its screen below, whose location we cannot make sense of. The long green leaves must be behind the planter, yet they have been described with such thin strokes that they look like a veil in front of it.

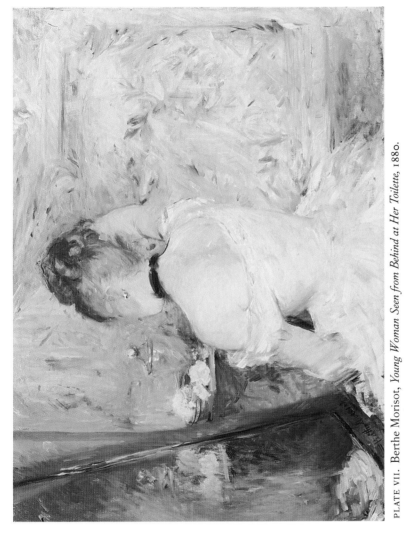

PLATE VII. Berthe Morisot, *Young Woman Seen from Behind at Her Toilette*, 1880.

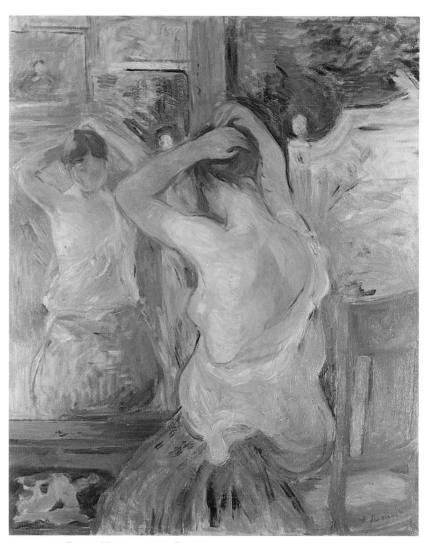

PLATE VIII. Berthe Morisot, *At the Psyché,* 1891.

Superficially, everything holds together—all the right pieces have been provided. But inside the image, the pieces fit together at fissures rather than at seams. Morisot's stylistic discrepancies undermine the coherence of her conventional subjects. We must perceive women and objects differently within the same pictorial spaces. Women are represented by the more convincing fictions, the more mimetically correct illusions. But it is the objects that surround them, circle them, move behind and past them, and hem them in, that are most tangible. Needlework, porcelains, ribbons, flowers, and other bibelots trail through Morisot's images, at once the most unbelievable and the most substantive elements in her representations of feminine experience.

Of all the purchases a woman made, her acquisition of bibelots was said to demonstrate best the femininity of modern consumer behavior. A woman wrote in 1885: "'Bibelot' is a modern word. It's the supreme expression of our attention to detail and our inquisitive spirit . . . An astonishing mania, that, under the pretext of art, has seized woman."[36] If women had begun to identify with bibelots "under the pretext of art," then art reciprocated by defining femininity under the pretext of bibelots.

A painting like Stevens's *The Painter's Salon* (Fig. 57) surrounds women with the signs of their femininity: gilded frames and furniture, mirrors, flowers, bibelots on the mantelpiece and, in a vitrine, a screen, embroidered pillows, little paintings, jewelry, rich dresses, kid gloves, and a fan. Three women occupy the center of his image, but they are only three among a profusion of ornamental objects, and by no means the most prominent or precious. Stevens, far from denying women, was attempting to represent his perception of modern women's psychological reality. As an admiring critic wrote of his images in 1870:

> With his admirable understanding of the feminine world and that love for the least bibelot caressed by woman of those who feel deeply for her, he has realized that she exists not only in her nudity, but also in everything that covers her, adorns her,

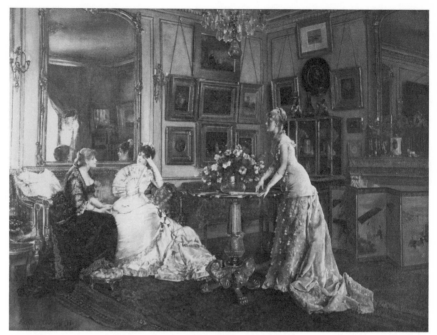

57. Alfred Stevens, *The Painter's Salon,* 1880.

touches and approaches her. The boudoir, the salon, the little mysterious refuges where she hides her weakness and her charms, are in reality [*en réalité*] as full of her, as penetrated by her grace, as perfumed with her adorable odor as her flesh itself.[37]

Women under the sway of the commodity are represented by fashion and by the bibelot. Endowed with autonomous significance, objects can stand for women, "as perfumed with her adorable odor as her flesh itself." Morisot herself detached feminine objects from women in the still-lifes she made intermittently throughout her career. Teacups, porcelains, birdcages, flowers, more flowers, fans, and small dogs carry the meanings of gender on their own. Imagined relationships between women and objects have become so convincing that objects alone suffice to communicate femininity.

In her 1880 *Young Woman Seen from Behind at Her Toilette* (Pl. VII) Morisot takes up the question of feminine beauty. As in many versions of this rather traditional subject (see Figs. 33, 78, 79, 80), the mirror serves both to double the spectator's visual pleasure and to indicate the woman's desire to be visually pleasing. But Morisot complicates her image by placing brightly colored and vigorously brushed cosmetic containers and a flower near the center of her canvas, between her female figure and the mirror. Since the woman is turned away from us, since her mirror reflects only the cosmetics and the flower, and since those objects are so much more literally prominent than anything else in the painting, we are given to understand that feminine beauty resides materially in the objects, that is, in the artifices of adornment, as much as in the woman herself. Placed along what we perceive as the trajectory of her gaze, the *objets de toilette* relay the woman's sight of herself. She looks in the mirror and we see there a pale reflection of objects.

Every once in a while Morisot pushed aside the encumbrances and ambiguities of femininity: the settings, the costumes, the objects, all the paraphernalia. Then she produced images limpidly resolved and tenderly attentive to personality.

We expect a portrait to concentrate on a subject's face. In the nineteenth century men expected their hands as well as their faces to convey their character. Victor Fournel, flaneur and pundit, elaborated: "It's rare that a bourgeois has himself painted without hands, or else it's in spite of himself. A portrait without hands doesn't exist for the bourgeois: it's something incomplete, like an amputee. The pose and expression of the hands preoccupy him to the highest degree."[38] Women's hands mattered much less. Gloved and soft, gently poised but never pointing, appendages to fans, bouquets, or needlework, feminine hands conveyed character only by their restraint. Behavior manuals and pedagogic tracts strictly enjoined women to control their gestures. In Manet's paintings of Morisot, in Stevens's and Tissot's paintings, in fashion plates and in popular prints, no woman's hand strays farther than the nearest bi-

belot or accomplishes any action, other than picking fruit. Degas's portraits of Cassatt (Figs. 47 and 50) provide the exceptions that confirm the rule even Morisot usually obeyed.

But of course a woman who paints works with her hands. She must grasp tools, reach, and leave her mark. Her hands mediate between eye and canvas, just as Edma Morisot represented Berthe's hands working in the center of the portrait she made of her sister (Fig. 15). Yet Morisot rarely represents hands with conviction. She was not impeded by a lack of skill or anatomical knowledge, for she delineates and articulates the majority of the hands in her paintings no less finely than the Impressionist colleagues who shared her tendency to abbreviate pictorial notations. Only hands freed from social obligations appear clearly in the center foreground of her images, quiet but definite, as if they were the only hands she could fully believe in. Those hands belong to the women with whom Morisot most directly and deeply exchanges gazes. Her ability to concentrate on a woman's inner life was ineluctably coupled with her ability to concentrate on their hands. And she could do both only when she knew her subject very well.

We cannot be sure whether Valentine or Marguerite Carré posed for Morisot's 1873 *The Pink Dress* (Fig. 58). Both sisters had been Morisot's close friends from the time she moved to Passy. Morisot represents one of them with both hands confidently outstretched. Carré looks and gestures in harmony, gaze and hands extending together toward the artist. This was how Morisot also imagined her friends and fellow painters Louise and Rosalie Riesener.

Edma Morisot's hands lie crossed in the center of Berthe Morisot's 1871 pastel portrait (Pl. V). At first we cannot quite understand why, in the middle of the seemingly flat black field of Edma's shawl, they appear so high and so far forward from her torso. Then suddenly we realize that Edma is pregnant, much more obviously pregnant than we have ever seen a woman in a full-fledged nineteenth-century portrait before. Subtly but unmistakably, Berthe

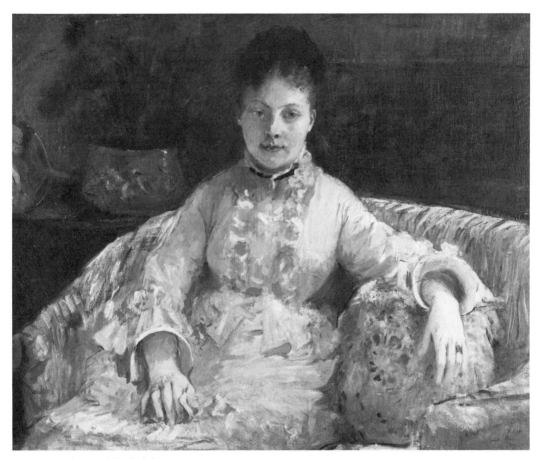

58. Berthe Morisot, *The Pink Dress,* 1873.

Morisot has depicted one of the most dramatic and one of the least artistically avowed moments in a woman's life. Nor has a lack of precedent perplexed her; once again eyes and hands give the same grave, forthright message. Edma's hands convey calm, expectancy, protection, and grace. Her physical condition has been acknowledged but her intellectual presence still dominates the image.

Berthe Morisot remained more interested in the emotional

consequences of maternity than in its biological facts. She devoted some of her finest early paintings to the relationships that mothers enjoyed with their daughters. In addition to *The Cradle* (Pl. III) and *Woman and Child on a Balcony* (Pl. II), she made another portrait of a mother and daughter, her aunt Maria Boursier with her little girl (Pl. VI). Mother and daughter sit near each other but independently, both upright and dignified, equally serious yet relaxed. Toward the bottom of the portrait their arms curve in exactly the same way, the daughter's a miniature version of her mother's. The two of them are joined in the middle of the picture's lower edge by their hands, one of the child's tucked within her mother's, the other laid gently on her mother's thumb. This gesture of confident and tender complicity anchors the image, a stable source from which the mother and daughter can each become a separate person, and from which their portrait can unfold its meanings.

After Morisot gave birth to her daughter Julie in 1878 and her work moved into a new phase, it was on the strengths of these portraits that she built. The signs of femininity she had struggled with since the late 1860s lost much of their hold on her imagination, and she turned instead to the prospects opened by maternity.

Chapter Seven

Mirrored Bodies

The Show is not the Show,
But they that go –
Menagerie to me
My Neighbor be –
Fair play –
Both went to see –

Emily Dickinson

Toward the second half of her career, Morisot shifted her ambitions. While still trying to establish herself both personally and professionally in the 1860s and 1870s, she addressed the conceptual problems of current feminine imagery and the stylistic challenge of translating it into an Impressionist idiom. But by 1880 she had reached several goals: the birth of a child in 1878 turned her successful marriage into a family, and the early Impressionist exhibitions were securing her artistic reputation. She could then afford to concentrate less on her relationship to the outside world and ask herself more difficult inner questions about the limits of her painting. Nothing demonstrates this reallocation of her energies more clearly than her changing representations of the female body.

In the 1870s and early 1880s Morisot played with the same disparities between material fact and representational illusion that she used in her earlier representations of women's bodies as objects. While acknowledging that the sight of women's bodies was supposed to be erotic, Morisot turned eroticism into an empty spectacle by refusing to provide the sexual content a viewer would expect.

59. Berthe Morisot, *Portrait of Marie Hubbard,* 1874.

These early images of the female body refuse us illusions of real bodies and give us only opaque representation.

A nineteenth-century woman who reclined publicly on a sofa invited sexual attention, whether in life or in an image. Manet's *Olympia* (Fig. 68), in its own confrontational way, cited the receptive mood of Titian's *Venus of Urbino,* repeated ever since in paintings like Ingres's 1814 *Odalisque* (Fig. 66). Nude or clothed, a woman who lay down in front of men made herself available.

Yet how chaste Morisot's 1874 *Portrait of Marie Hubbard* (Fig. 59) seems in comparison with Manet's and Ingres's paintings. Of course she is clothed from neck to toe. But Marie Hubbard wears what could have been an alluringly diaphanous white peignoir, and her slippers, like Olympia's, fall enticingly away from her feet. The moment is intimate, the point of view as well. Morisot, however, shares a different kind of intimacy with Marie Hubbard, one of her

closest friends. Hubbard holds up a fan like a signal. Morisot paints
it impenetrably, like all her other fans within paintings. We can only
read her brushwork on it: molten flourishes of red against broad
strokes of black. Morisot echoes the fan in Marie Hubbard's peig-
noir. Calligraphic gray veins hint on vaporous whites and palest
blues that a body lies beneath fabric. But even the direction in which
the body lies has been counteracted by the white track of parallel
square marks on the middle of the peignoir, which slide down over
and off the sofa, pulling the peignoir across the canvas and making
it into a cool abstract expanse. Our attention has been diverted to
the much more realistically painted face on the right, to Marie Hub-
bard's level direct gaze at us. Morisot has usurped the body's eroti-
cism with her focus on a woman's psychological presence.

What if Morisot recognizes that her subject is being appraised
by fantasies of possession? In the seven paintings of toilette scenes
she made between about 1876 and 1880, Morisot represents wom-
en's self-image under masculine scrutiny. In these pictures she en-
lists the same strategies she had used in the *Portrait of Marie Hubbard*
but for a more problematic purpose.

Contemporary texts and pictures both make the toilette scene's
erotic implications explicit. They emphasize that it is the sight of a
woman at her toilette which is erotic, and explain that a woman's
exposure to a male gaze at that moment designates her as his actual
or potential sexual possession.

> This moment when the worldly woman is still enveloped in
> waves of brilliant white batiste, in a peignoir of the finest cot-
> ton, fringed with lace . . . It's a dangerous thing for a man . . .
> to see this lovely morning *négligé*, this disorder of dress more
> apparent than real, that opens the scope of the imagination, if
> ever he had any, which tickles all the senses and awakens them
> if ever they had energy . . . A young woman who respects her-
> self must never receive [*recevoir*] anyone but her husband at her
> toilette . . . She who receives any other man at that moment,
> obviously has nothing left to refuse him.[1]

60. Berthe Morisot, *Young Woman with a Mirror,*
1876.

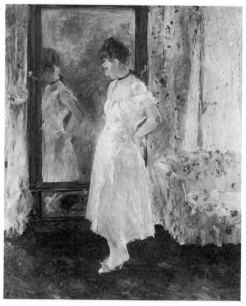

61. Berthe Morisot, *The Psyché,* 1876.

This moment at which a woman becomes so vulnerable to a masculine sexual gaze is also the moment of most intimate feminine creativity. During her toilette a woman produces her self-image. The comtesse de Gencé's advice book described the toilette in terms of mysterious yet rigorous sacred ritual: "One can never repeat often enough that the *cabinet de toilette* is an inviolable asylum . . . beauty's confessional . . . her laboratory."[2] The toilette enhances and disciplines nature with the secrets of its sanctuary, its atonement for sins, and the formulas of its science. There a woman designs and implements the feminine appearances on which depend both self-esteem and social judgment.

In all seven of her toilette paintings Morisot juxtaposes a woman with references to vision: mirrors, windows, and pictures; the white tones of women's shifts or peignoirs, moreover, duplicate the white light that filters through curtains or glances off mirrors.

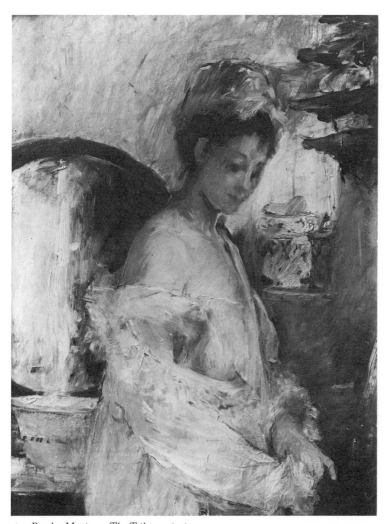

62. Berthe Morisot, *The Toilette*, 1876.

The woman in *The Psyché* (Fig. 61) stands between a psyché mirror
and a window; in *Young Woman with a Mirror* (Fig. 60) the figure sits
in front of a window and looks down at herself in a little round
mirror; in *The Toilette* (Fig. 62) and in *Young Woman Seen from Behind
at Her Toilette* (Pl. VII) the women stand or sit next to a mirror; in

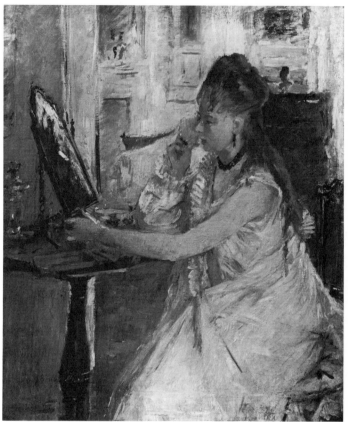

63. Berthe Morisot, *Young Woman Powdering Herself,* 1877.

Young Woman Powdering Herself (Fig. 63) the woman sits at her mirror in front of a wall hung with framed pictures; and finally in *Woman at Her Toilette* (Fig. 64) and *Young Woman Putting On Her Stocking* (Fig. 65) the women sit next to a window. Women have been likened to surfaces through which or in which we look at images. Moreover, in her toilette paintings Morisot represents women at junctures between modes of seeing: at the edges of windows, just touching mirror frames. In *Young Woman with a Mirror* (Fig. 60), the woman's head silhouetted against the curtained window just above the sofa's rim looks down to a mirror placed just below the rim.

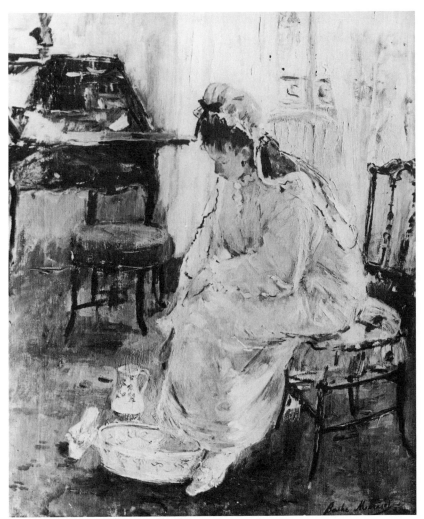

64. Berthe Morisot, *Woman at Her Toilette*, 1877.

Multiple references to sight encourage us to think about seeing, about the differences or boundaries between kinds of seeing, and about the way we see women or they see themselves in this particular situation. Morisot's unusually insistent emphasis on sight in her toilette pictures seems to reinforce her invitation of a public

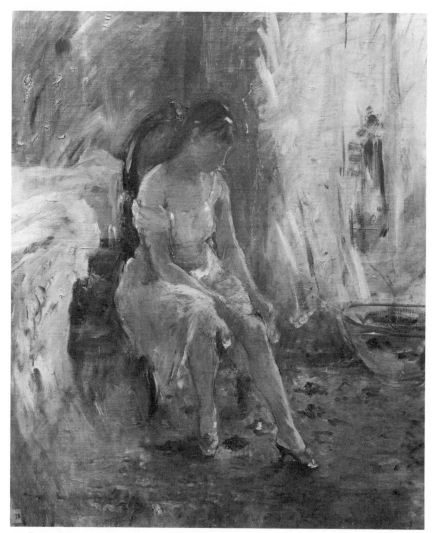

65. Berthe Morisot, *Young Woman Putting On Her Stocking*, 1880.

and masculine gaze into private feminine space. She appears to be welcoming masculine desire, implying that the women in her images make themselves beautiful in order to please the men whose look they court. Yet these toilette images contradict themselves.

They contain as many denials of a sexually possessive gaze as solic-
itations. The woman most uncomfortably on the boundary between
ways of seeing is Morisot herself.

More obviously than the other toilette paintings *The Psyché*
(Fig. 61) reveals its subject's preoccupation with public appear-
ances. The young woman stands in front of a mirror, gathering her
loose chemise around her waist. She considers how her figure
would look if she were formally dressed, wearing the corset that
would lend her torso a fashionable hourglass silhouette. She is ab-
sorbed by the mirror image of alterations intended for the public
eye, more specifically by the artifices of contemporary eroticism.[3]
That mirror image is directed to us.[4] She and almost all the other
women in Morisot's toilette pictures try to arouse us almost too
obviously, too self-consciously. Pert ribboned slippers coyly set off
ankles and calves, four shoulders have been carefully exposed and
turned toward us, one arm disingenuously removed from its peig-
noir sleeve.

Displayed erotically at their toilette, the women in these seven
images seem to be at our disposal. Morisot hired models for all
these paintings. She—a woman of the *grande bourgeoisie*—was al-
lowing herself a kind of superiority and impersonality toward her
subjects, working-class women, quite unlike what she felt for her
friend Marie Hubbard. But that class difference did not reproduce
the sexual difference between a masculine audience and an erotic
female subject. Morisot could not even fully maintain a class differ-
ence. While she did set working-class women in a scene she spared
her peers, she mitigated its connotations with signs of middle-class
respectability. Her toilette scenes manifestly take place in comfort-
ably large airy rooms, amidst exactly the flowered cottons and
bibelots Blanche had ascribed to Morisot's social world. Even
though they seem enticing, we wonder if such neatly bonneted
women in lavishly ruffled peignoirs would respond to our advances.

They certainly have not responded yet. Their absorption in
their own appearance has kept them from noticing our approach as

well as from establishing any eye contact with us. All seven women look at themselves or at their mirrors. Our gaze, refused theirs, looks elsewhere for a cue, in the mirrors, windows, or pictures that represent sight. Virtually all of them turn us away; four out of five mirrors are blank, four out of four windows are opaquely curtained, all the paintings are illegible.

After teasing us with shoulders and ankles, Morisot withholds the rest. Though the erotic potential of the toilette scene resides in the transparency of the peignoir or chemise, Morisot reveals almost nothing of women's bodies. Wherever we expect sexuality, Morisot diverts us. In *Young Woman Powdering Herself* (Fig. 63), for instance, our attention is distracted from the figure by the busy bright areas of the red wall hung with pictures and by the clustered objects on the *poudreuse.* Once we look below her bare arm where we expect at least breasts, a waist, and thighs, we see nothing but passages of white. In *Young Woman with a Mirror* (Fig. 60), the figure holds her round mirror just high enough so that the central action of her gaze into the mirror occurs above her chest.

Morisot substitutes the sensuality and skill of her own craft for the sexuality of women's bodies. In place of erotic illusions she gives us abstraction. Oil pigment blazes, clots, and scrapes, now gliding broadly, now scarring and scumbling the canvas surface, sometimes wriggling above layered sediments with calligraphic flourish. The work of a painter makes itself audaciously evident, for this intricately handled material plays the hardest painterly game, the game of monochrome variation. It has often been remarked that Morisot glories in whites,[5] and in her toilette images she indulges herself. Icy, iridescent, pearly or blushing, redolent of creams and honeys, violet or verdant in the shadows, gilded in full light—white is the color of Morisot's technical mastery.

Linda Nochlin has written of these pictures:

> The notion of the work of painting itself is never disconnected from her art and is perhaps allegorized in various toilette scenes, in which women's self-preparation and adornment

stand for the art of painting or subtly refer to it. A simulta-
neous process of looking and creating are prime elements of a
woman's toilette as well as picture-making, and sensual plea-
sure as well as considerable effort is involved in both.[6]

Morisot invests more purely painterly energy into the white
passages of her toilette scenes than almost any other work of the
same period. And, as Nochlin points out, it seems fitting that this
should be so in images about women's creation of appearances. But
it may also be ironic that such work and intellectual brilliance were
deployed defensively, pitted against the gaze she taunted. For of all
the paintings she made before the middle 1880s, these toilette pic-
tures ventured farther from safe feminine territory than any others.
Torn between bourgeois respectability, eroticism, and pictorial am-
bition, they may represent irresolvable conflicts more than satisfac-
tory compromise. But they demonstrate Morisot's efforts to extend
the scope of her work.

Yet she remained dissatisfied with her representation of the
female body. In 1886 Morisot visited Renoir's studio and afterward
jotted in a notebook: "His nude women entering the sea charm me
as much as those by Ingres. He tells me the nude seems to him to
be one of the indispensable forms of art."[7] Morisot had been con-
vinced. She believed it was "indispensable" for her to paint the
nude. And so she attempted the impossible.

To Morisot's entire generation, "the nude" meant the female
nude. The genre had been renewed by Ingres in works such as
Odalisque (Fig. 66) and was being perpetuated by Renoir in works
such as *Seated Bather* (Fig. 67), the kind of painting Morisot saw
during her decisive visit to his studio.[8] These works represented
women's bodies as the passive objects of masculine desire. Whether
academically neoclassical, smoothly rendered and languorously
posed, or more daringly avant-garde, the nude offered to the gaze
as much of a woman's body as a man could easily consume. In T. J.
Clark's neat summary, "A nude could hardly be said to do its work
as a painting at all if it did not find a way to address the spectator

66. Jean Auguste Dominique Ingres, *Odalisque,* 1814.

and give him access to the body on display."[9] Ingres and Renoir could just tease the imagination with what they withheld.

The Academy placed the nude at the apex of its hierarchies. Deemed the ultimate evidence of an artist's mastery over drafts-manship, anatomy, color, and composition, it was also supposed to represent an artist's most innate sensibilities. Romantics, Realists, Impressionists (and by 1886 post-Impressionists) accepted these assumptions, however differently they expressed them formally. Controversial nudes like Manet's *Olympia* (Fig. 68) and hallowed nudes like Ingres's had as much in common thematically as they had little in common stylistically. From Ingres to Manet to Renoir and on to Pablo Picasso and maybe even Marcel Duchamp, the nude triumphantly continued a masculine artistic tradition.

Painting promised unfettered creativity. But access to that free-dom was controlled by a highly structured profession, dominated by a small elite of middle- and upper-class men. In practice it was

67. Pierre-Auguste Renoir, *Seated Bather,* c. 1883–84.

only through adherence to their values that painting's privileges could be attained. Nothing better protected those privileges than the fiction of impartiality, otherwise known as painting's "fidelity to nature." In matters of sexuality, the nude provided this neutrality. The subject purported to represent a universal sensual force, transformed by an individual's native genius into absolute esthetic ideals. Carol Armstrong and Carol Duncan, each in different ways, have argued that Modernism waged its formal battles across the available territory of women's bodies.[10]

68. Edouard Manet, *Olympia,* 1863.

The longevity and the masterpieces of the modern nude tradition attest to its satisfactory expression—at least in painting—of sexuality. Despite intermittent crises, notably the furor caused by *Olympia* when it was first shown in 1865,[11] the nude persisted. Even *Olympia,* after all, had become safe by 1889. But was what I will call simply "the nude" (as Morisot did) as satisfactory a representation of women's bodies for women as for men? More particularly, could it be the way a woman painter represented sexuality? Certainly Morisot identified strongly with male authors, their works, and their definition of the nude as female. In 1889 she participated actively in the subscription campaign to buy *Olympia* for France's national museum so that it could attain the art historical status she felt it deserved. When she wrote about Ingres's and Renoir's nudes, she did not merely admire them, she said they "charmed" her.

Morisot's identification with the nude proves how completely

painting's conventions had precluded any other possible represen-
tations of sexuality. It never occurred to Morisot to paint a male
nude, though she was heterosexual. Even if it had occurred to her,
she lacked both the technical training and the logistic means to do
so. She had not been allowed to attend anatomy classes or life-
drawing classes with male models; and if the idea of a naked man
posing in her bourgeois living room, even when it was not in do-
mestic use, seems ludicrous, it is because the male nude has still
today not regained currency. Women could not simply adopt the
same attitude to a male nude that men exercised while painting the
female nude.[12]

Yet it was not so easy, either, for a woman artist to feel the
same way a man might about a female nude. If she painted a female
nude she would be painting a kind of reflection of her own body.
She would therefore have to transform desire into being desired and
enjoy pleasure by giving pleasure. For a woman who wanted to do
the looking—and no one, arguably, needs to look more actively
than an artist—identifying with a masculine point of view meant
being two contradictory things at once: the one who looks and the
one who is looked at. To paint a successful nude demanded that a
woman artist paint a version of her own body and offer it com-
pletely to masculine viewers.

The nude posed a particularly acute problem for the kind of
women whose social position enabled them to paint. Although his-
torians like Peter Gay remind us that the cliché of Victorian prudery
has been much exaggerated,[13] many progressive middle-class
women nonetheless felt ambivalent about their sexuality. To the ex-
tent that they had to identify with masculine norms, they had to
identify their physical selves with an objectified sexuality difficult to
reconcile with intellectual ambitions.

To accomplish this feat, many women resorted to the compro-
mise of "sentiment." The English word conveys the relevant mean-
ing of the more general French term *sentiment,* which can also be
translated by the vaguer "feelings." When Morisot, in 1890–91, in

the midst of her attempt to paint the nude, tried to define a woman's artistic potential, she wrote: "Our value lies in *le sentiment*."[14] Her contemporary Geneviève Bréton defined the concept in her journal: "In love, there's sentiment and passion; I know only sentiment through myself, passion through others. I hear certain voices I know say: sentiment = the love of the intellect; I can answer: passion = the love of the body."[15]

Bréton cannot experience the physical directly. She does not wish to, for she aspires to what she believes is its opposite, the spiritual. Bréton clearly and succinctly declares sentiment the antonym of passion. Morisot expressed the same idea more circuitously in her notebooks: "Not that desire and aspiration aren't there too, but everything that approaches realization is very likely to overwhelm *le sentiment,* and the material fact is never anything but a degeneration [*déchéance*], even in the moment of its pleasure [*jouissance*]."[16] Morisot acknowledges both her "desire" and her "aspiration," but the passage of either into fact frightens her, for "realization" annihilates a delicate "sentiment." Her *jouissance* entails her *déchéance.*

If Morisot feared sentiment could not survive "realization," then how could she translate it into visible form? Trapped between equally forbidden intellectual intentions and physical instincts, sentiment merely expressed an empty compromise; it was neither one thing nor the other, neither a woman's experience nor a man's, but the "feminine" that floats in between the two. To paint a nude on the basis of sentiment required enacting an idea that had no substance; how could a nude, which by definition represented the active projection of desire onto a sexual object, be represented as the denial of that active desire?

Morisot's nudes are failures. Between 1886 and 1892 Morisot repeatedly tried to paint or draw the nude, but she could never arrive at a resolution of her dilemmas. Compare for example her *Model at Rest* (Fig. 69) with Renoir's *Seated Bather* (Fig. 67). Where

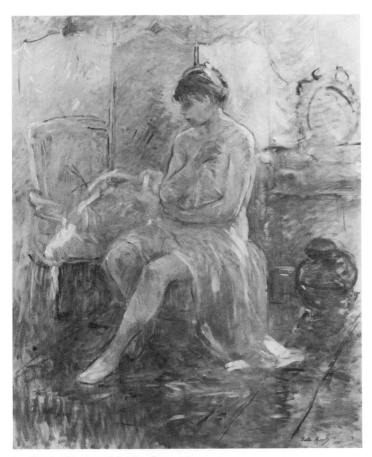

69. Berthe Morisot, *Model at Rest*, 1887.

he provides voluptuous relaxation integrated into nature, she presents a nervous model in a makeshift studio. He renders flesh, sea, and rocks with lustrous fullness, while her brushstrokes coagulate or scatter. Renoir's drapery falls away enticingly from his figure's hips, while Morisot seems unable to decide whether her figure should be naked or not and settles for drapery clutched to an un-

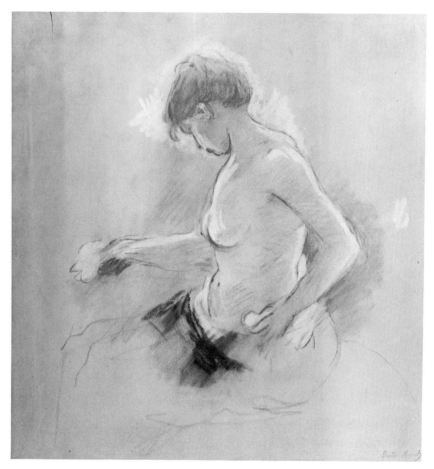

70. Berthe Morisot, *Young Woman Dressing*, 1887.

clothed torso. A decision to reveal only aggravated her hesitations. In her *Young Woman Dressing* (Fig. 70) Morisot sacrifices hands, face, and legs for a nude torso. Clumsily insistent red and black lines clench the stomach, armpit, and breasts, mark one nipple but not the other, exhaust themselves at the arms, backtrack sloppily at the ear. Morisot created another kind of distraction in her 1891 pictures of the peasant girl Gabrielle Dufour lying nude in the grass or sit-

71. Berthe Morisot, *Sleeping Girl*, 1892.

ting at a pond's edge; a glaring turquoise background and orange handkerchief divert the eye away from an already chastely posed figure.

Morisot managed to paint successful nudes only to the extent that she imitated nudes made by men. By far her largest and most convincing nude is the copy she did of a François Boucher painting to decorate her living room. In 1892 she made her last attempt at the nude, *Sleeping Girl* (Fig. 71). This picture shows a woman asleep, her head tipped back on a strangely amorphous pillow, her breasts fully exposed to the viewer in an intimately shallow space. Morisot's only sensual nude is unconscious, and her image dreamlike. *Sleeping Girl* closes the phase of Morisot's nudes by returning to her first inspirations. The painting illustrates Morisot's feelings shortly after

she visited Renoir's studio in 1886. Directly following her record of that visit, she wrote: "Saw yesterday at a curio merchant's on the faubourg Saint-Germain an engraving after Boucher that was extremely improper and yet adorably graceful. That extraordinary man has every grace and every audacity; you can't imagine anything more voluptuous than this sleeping woman, her breast swollen with love."[17]

Morisot can imagine no painting more "voluptuous" than the way a man represents the nude. But before she gave in to the citation of Boucher, before she gave up on the nude altogether, she tried once to represent her difficulties with the nude as difficulties; that is, she tried once to show why, for her, the nude was at once indispensable and impossible.[18] In 1891 she painted *At the Psyché* (Pl. VIII), an image about the "extreme impropriety" of a woman either experiencing or representing desire. In a bedroom, a nude woman sits arranging her hair with both hands, a loose shift slipping off one shoulder and draping around her waist. She turns her back to us and looks into a large looking glass mounted in a heavy frame, the French psyché mirror. We see her face and the front of her torso in the mirror. The nudity we expected from the woman's back, as well as from countless other images of similar subjects, is delivered to us as a mirror image.

Morisot's contemporaries believed women were obsessed with their mirror image. Jenijoy LaBelle has compiled an entire book of references to women's preoccupation with the mirror in nineteenth- and twentieth-century literature,[19] and the same could be done in the visual arts. Such references recur incessantly in all types of books, not just in fiction. The female narrator of an 1885 advice book for women adopts the voice of the mirror: "I'm everywhere, from the mansard to the townhouse, and all women, from the peasant up to the queen and the empress, consult me in all of life's acts."[20] Although dependence on the mirror seemed to indicate women's weakness, or even their narcissism, the mirror was conceded to be a crucial tool for feminine survival. Women looked at

themselves constantly because their livelihood depended on their appearance. Alphonse Karr admitted in a book of essays entitled *Women:* "Women receive everything from men; men give to women because they love them; they love them because they find them beautiful."[21] Subject to endless visual evaluation, women internalized their condition, and the mirror became the symbol of their self-scrutiny. Another author of advice books for women recommended: "Looking glasses are marvelous instruments that allow us to be the spectators of ourselves, in every way and no matter how we turn."[22]

More specifically, art critics assumed that art made by women reflected their mirror image. In his *Women's Art Book,* Jean Dolent wrote in 1887: "The work of woman is in the image of woman . . . the picture that offers itself most often to a woman's eyes is the picture her mirror returns her; her work testifies to it."[23] Initially, this would seem to be an accurate description of Morisot's *At the Psyché.* According to this interpretation, her image of the nude would be the way a woman sees herself in a mirror. It would be possible to give a more personally artistic version of this reading. In Morisot's living room, where she was working at the time, hung a nude by Manet (*Nude Arranging Her Hair,* Fig. 72). The woman's pose resembles the pose of Morisot's figure, though shown from a different angle and without any mirror. Instead of looking in an ordinary mirror, Morisot could have been looking at the mirror of Manet's painting. In much the same way as she had written about seeing the print after Boucher, Morisot could be painting a woman painter's image of the nude as the reflection of herself (a woman's body) in a man's painting.

To see a mirror as if it were a painting, however, questions whether what one sees in the mirror inevitably or perfectly reveals one's real self. A mirror reflects, a painting interprets. Not only is the mirror in *At the Psyché* framed as if it were a painting, but three framed paintings or portions of paintings reflected in the looking glass conflate mirrored and painted images. Nor do any of these images, mirrored or painted, reflect anything very well. We see sur-

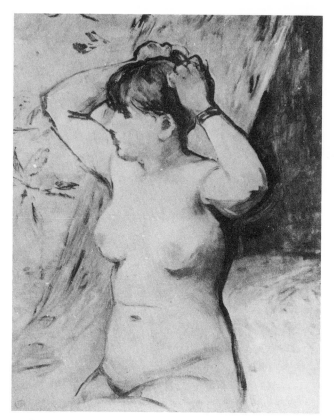

72. Edouard Manet, *Nude Arranging Her Hair,* 1879.

prisingly little in Morisot's mirror, considering how close it seems to be to us. The nude's face appears almost featureless, and her breasts seem to have no nipples, her body almost no volume. Virtually nothing can be deciphered in the three reflected paintings. Morisot shows us that a woman looks for herself in the mirror, but then represents nothing there except artificial and contentless images.

At the Psyché, however, does reflect something very clearly. Not only the painting itself, but also the process of its preparation, mirror Mary Cassatt's 1891 *The Coiffure* (Fig. 73) and its conception.[24]

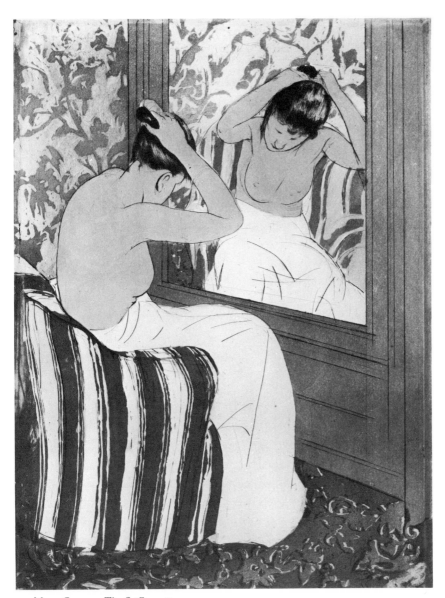

73. Mary Cassatt, *The Coiffure,* 1891.

Only by working together could Cassatt and Morisot bring themselves to confront the nude's difficulties.

Cassatt and Morisot never became very close friends. They were cordial colleagues in the 1880s.[25] Like Morisot, Cassatt reached a new professional stage around 1890. She received her first one-person show in 1891 at the Durand-Ruel Gallery. At the same time she acted as an art expert, notably for Louisine and Horace Havemeyer as they formed their collection, advising them to purchase El Grecos and Goyas, but also many paintings by Degas, Manet, and Monet that were added to the twenty paintings of hers the Havemeyers owned.[26] Cassatt had claimed the authority to evaluate Old Master paintings and to pronounce which modern works should continue their tradition. Meanwhile she hastened the institutionalization of her own work, for Cassatt hoped that the private collections she encouraged would eventually go to American museums.

Morisot did complain about Cassatt once, writing to a friend after the opening of her show in 1892: "You can imagine it's not Miss Cassatt who would write me a note about an exhibition of mine."[27] Cassatt, however, was praising the show, not to Morisot perhaps, but to Pissarro.[28] She had openly admired Morisot in the past,[29] and Morisot's daughter remembered no rift between the two women.[30] Yet they may have perceived each other as rivals, especially during the years 1890–1893, when Cassatt and Morisot seemed to be racing against each other. Morisot's impatience with Durand-Ruel and her subsequent switch to the Boussod and Valadon Gallery, which had promised her a one-person show, followed quickly on Durand-Ruel's offer of that accolade to Cassatt. Cassatt turned around and held a second exhibition at Durand-Ruel's in 1893, the year after Morisot's in 1892. At her first exhibition Cassatt had shown *Young Women Picking Fruit,* an ambitiously large canvas depicting young women plucking fruit from a tree branch overhead: not, admittedly, an unusual subject either in painting or in popular prints. But we know Morisot saw Cassatt's version of the theme

74. Mary Cassatt, *Study for "The Coiffure"*
(*no. 2*), c. 1891.

75. Berthe Morisot, untitled drawing, c.
1891.

because Cassatt, much later, grumbled to a friend that Morisot
hadn't liked it.[31] Morisot was working on exactly the same subject
that year in her two versions of *The Cherry Tree* (Fig. 1). The next
year, Cassatt began work on her monumental and politically en-
gaged *Mural of 'Modern Woman'* for the Woman's Pavilion of the
1893 Columbian Exposition in Chicago. Before the painting went
to Chicago, Cassatt exhibited its central section in her second exhi-
bition, a section that depicted two young women picking fruit from
a tree overhead.

 One-person exhibitions, large-scale canvases, classic themes,
political commitments, architectural murals—all of these projects
took Cassatt and Morisot into masculine professional territory. But
could they go as far as the nude? Did each dare the other to try
independently, or did they move tentatively together?

 First came a pair of schematic drawings: Cassatt's *Study for
"The Coiffure" (no. 2)* (Fig. 74) and an untitled sketch by Morisot
(Fig. 75). Both drawings show a seated, half-length woman, naked

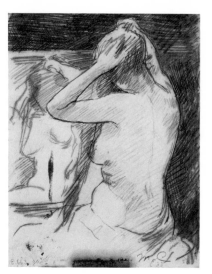

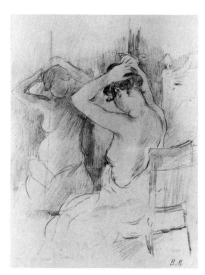

76. Mary Cassatt, *Study for "The Coiffure,"* c. 1891.

77. Berthe Morisot, *At the Psyché,* 1891.

to the waist, arranging her hair with both hands while she looks toward the left at her faint reflection in a mirror. Then came a second pair, each of them equally developed in the same direction: Cassatt's *Study for "The Coiffure"* (Fig. 76) and Morisot's *At the Psyché* (Fig. 77). The four drawings have identical subjects and compositions. Their details mirror each other almost exactly, details like the positioning of the hands right above left, the set of the shoulders, the dark line of the necks tilted at precisely the same angle. In both the second drawings Cassatt and Morisot have delineated their mirror more firmly—introduced quick hatching, down from right to left, across the faces in the mirrors, placed adjacent areas of dark and light between the torsos and their reflections in the mirrors—without either of them quite resolving the transitions between left breasts and curving stomachs.

 Cassatt and Morisot each used their drawings in a larger project of their own. The stylistic differences between their drawings announce their author's individual intentions. Cassatt's drawings,

sparer and more graphic, along with five other catalogued draw-
ings, were reversed and made into one of Cassatt's color prints, *The
Coiffure* (Fig. 73). Morisot's drawings, more tonal and volumetric,
joined four other catalogued drawings to prepare the oil painting *At
the Psyché* (Pl. VIII).

We do not know in what circumstances Cassatt's and Morisot's
two pairs of drawings were produced. They could have been copied
one from the other, or they could have been made at the same time
from the same source, whether another picture or a live model. No
record of either kind of collaboration survives. Nonetheless, some
encounter between Cassatt and Morisot must be posited, not only
because of their drawings' similarity, but also because the projects
that include those drawings are so anomalous in both their authors'
careers. Only the mirroring of each other's work allowed them to
question the mirror image of their bodies.

Cassatt made virtually no other image of frontal nudity. Ade-
lyn Breeskin's catalogue lists one early academic study and one
very late pastel, both rather tentative and unconnected to other pic-
tures. *The Coiffure* belongs to Cassatt's suite of ten color prints, and
though Cassatt, primarily an oil painter, did produce a sizable body
of graphic work, these 1891 color prints stand out by virtue of their
inventive techniques and their coherency as a suite. Only in *At the
Psyché* did Morisot escape both prudery and imitation. It was her
largest, most extensively prepared, and most richly painted nude. In
1891 both Cassatt and Morisot not only tried the nude, they also
tried harder than they ever had or would again to understand what
the nude meant to them as women painters.

These boldest of Cassatt's and Morisot's nudes still equivocate.
The attitude of the woman artist to the nude had apparently not
changed at all since Mary Brunton described it in her 1811 novel
Self-Control. "She could not portray what she would have shrunk
from beholding—a female voluptuary. Her draperies were always
designed with the most chastened decency."[32]

At the Psyché (Pl. VIII), for example, presents us with a body

but only partially with a nude. The figure's back, neck, shoulders and arms have been firmly modeled. The sense of their tangible volume dominates the image, so that the mirror, bed, chair, and bright blue walls function as the body's setting. Yet this figure is turned away from us, concealed from the waist down by heavy drapery, and the indistinct mirror image blurs almost all signs of the sexuality we might have seen frontally.

As for Cassatt, her entire suite of color prints diverges from the robust substance of her oil paintings and pastels. Only in the thin air of her prints' rarefied brilliance did the female nude appear. Cassatt's ambiguous colors—taupes and terracottas, muted roses and pale creams—limpidly skim the paper, forms stretching tautly across the sheet, line playing against curve, stripe against pattern. The body in *The Coiffure* (Fig. 73) sits ensconced in a protective chair, and, like the body in *At the Psyché,* turns away from the spectator, or shimmers in the glass, modestly covered.

Cassatt's and Morisot's images do not offer us any solutions to the problem of the nude. They neither represent a woman's physical pleasure nor criticize in any overt way the masculine conventions governing the nude. Perhaps what they do represent is the impossibility, from their point of view, of any such solution.[33] *The Coiffure* and *At the Psyché* mark Cassatt's and Morisot's deepest incursions into the domain of fine art painting. No women went farther in the nineteenth century than Cassatt and Morisot, but with the nude they had reached an impasse. They were blocked not by a lack of technical skill, nor of intellectual courage, but by the ineluctably gendered relationship between the masculine artist and the female body, as well as by its consequence, the relationship between the nude and an audience of masculine men, and women who at least attempted to identify with a masculine vision.

Cassatt and Morisot do not identify with that masculine vision of the nude. The only way they can represent their sexual difference is to make their disbelief in a masculine vision abundantly evident.

Their 1891 images of women's bodies not only decline but subvert
the most fundamental assumption of the nineteenth-century nude.
They refuse to provide the visual pleasure of direct access to the
female body and, moreover, use the mirror to question the validity
of that access.

Cassatt and Morisot both make the mirror the crux of their
images. Large, emphatic, occupying a quarter of both picture sur-
faces, the mirror defines the spaces of print and painting only to
render them ambiguous; it establishes the back wall of pictorial
space yet shows us another space. The mirror thematizes the act of
looking but then confuses it. In both print and painting we see two
bodies, the "real" body in the foreground and the reflected body in
the mirror, which is the "real" nude. The body we see from behind
has been represented without the mediation of the mirror, yet the
nude we see indirectly in the mirror is the direct view of the sexual
female body promised by the nude tradition. Our gaze oscillates
between the two figures, which divide our attention as they divide
the print and the painting into almost equally weighted halves. We
can settle on neither kind of body without being distracted by the
other. Every time we try to concentrate on one body, the other calls
into question our way of looking. The reflective capacity of the mir-
ror questions the accuracy of the painting, while the painting's in-
terpretive ability undermines the mirror's credibility.

The mirror warns that the nude offered for our sensual plea-
sure might only be an image. By reframing their nudes within the
mirror, Cassatt and Morisot remind us that we are looking at a pic-
ture, not a person. Nor can we find some clue, some personal con-
tact, to reassure us that one of these bodies is unquestionably ours
to look at. No gaze answers ours; all eyes are averted from us and
from each other. All four of the figures, real bodies and mirrored
nudes, bend their heads toward the lower edge of the mirror frame,
toward nobody, toward the threshold between one kind of vision
and another.

Yet Cassatt's and Morisot's images acknowledge that image and body cannot be separated into entirely distinct registers of perception. They use the pictorial devices of illusionism and composition to elide depth and surface, the body and the nude, the self and its image. Perspectival and volumetric constructions of three-dimensional space situate two figures near us, two farther away. But the mirror's representation of flatness reasserts a surface pattern that unites these women. In both Cassatt's print and Morisot's painting the mirror's frame hinges real and reflected women. Even more securely than it contains the reflected nudes, it positions the real bodies, running down the vertical axis of the image, behind the joined hands, behind the axis of the torsos, and making its corner behind the women's laps.

The masculine tradition of Western art offers Cassatt and Morisot no way out. Yet in their images of the nude we see the glimmerings of two alternative directions. As they confronted the problem of the nude, Cassatt and Morisot relaxed the individuality of their authorship. Instead they collaborated, basing their work on repetition rather than originality, duplicating each other's images, and images within their images. When they tried the nude, which of all subjects normally provided artists and audiences with the most convincing fantasy of exclusive visual possession, Cassatt and Morisot multiplied and shared. And at the same time as each sought reinforcement from the person in the professional situation most like her own, they both turned to an art utterly different from theirs. One kind of marginality attracted another—in this case, Japanese prints, which were even more foreign to the Western painting tradition than women painters were.

Several of Cassatt's color prints retain traces of Japanese influences, none more than *The Coiffure.* She herself admitted that Japanese prints had inspired her work. Morisot's interest in Japanese prints has been less evident, though when her *At the Psyché* is compared with Cassatt's print it becomes clear that she too was galva-

nized by them.[34] Both Cassatt and Morisot avidly collected Japanese prints. Some of Cassatt's collection has been preserved. All the prints Morisot hung in her apartment, many of them obtained from the prominent dealer Tadamasa Hayashi, were dispersed without any record of their exact number, subject, or makers.[35]

In 1890 a major exhibition of Japanese prints took place at the Académie des Beaux-Arts. Cassatt invited Morisot to the exhibition. She wrote her urgently: "You could come and dine with us and afterwards we could go see the Japanese prints at the Beaux-Arts. Seriously, *You must not* miss that ... You *must* see the Japanese— *come as soon as you can.*"[36]

By 1891 the two women who had gone to the Beaux-Arts exhibition together in the summer of 1890 had finished their unprecedented attempts at the nude. What had happened in the few intervening months? While we may never know if a particular print shown at the Beaux-Arts exhibition inspired both of them, or if they were moved by disparate motifs in many prints to invent a variant of their own, we can assume that the Beaux-Arts exhibition triggered something in their minds. The prestige of its locale, as well as the quantity and the quality of the prints on display, all legitimized and valorized what before had often been treated as exotic curios. Perhaps visiting the exhibition together occasioned some epiphanic comment, observation, or dialogue.

Cassatt and Morisot could have been looking at any number of Japanese prints or drawings. Two scenes of a nude woman—one arranging her hair and the other seen from behind looking at herself in a mirror—recur frequently in Ukiyo-e prints, especially in the work of printmakers who specialized in "pictures of feminine beauty," notably Kitagawa Utamaro and Hosoda Eishi. Cassatt owned one herself: Utamaro's *Takashima Ohisa Using Two Mirrors to Observe Her Coiffure* (Fig. 78). Closer stylistically to Cassatt's and Morisot's drawings, and remarkably similar in the position of the hands, the tilt of the head, and the folds of the drapery around a

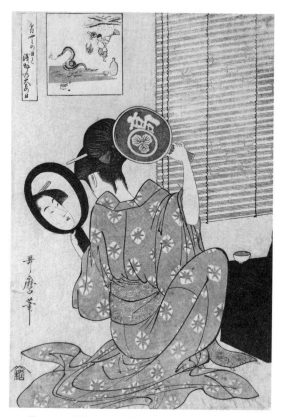

78. Kitagawa Utamaro, *Takashima Ohisa Using Two Mirrors to Observe Her Coiffure: Night of the Asakusa Marketing Festival,* c. 1753–1806. *21.6410*

plump stomach, is a drawing by Katsushika Hokusai titled *Woman Adjusting Her Hair* (Fig. 79).[37] After having been lured by the sophisticated but alien color and composition of prints, Cassatt and Morisot might have used a more neutral and schematic drawing like Hokusai's to bridge Eastern and Western styles.

It matters little which specific print or drawing might have served as a model. The point is really that Cassatt's and Morisot's nudes were inspired by something outside the Western artistic tradition. Michel Melot has shown how such "influences" sanctioned

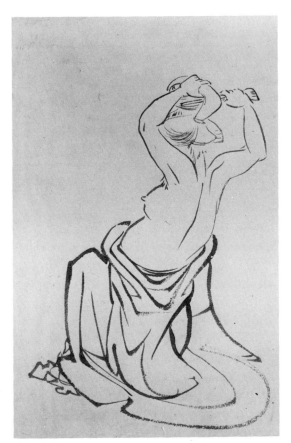

79. Katsushika Hokusai, *Woman Adjusting Her Hair*, c. 1800.

artists' use of foreign sources to achieve frightening or illicit objectives without having to take full responsibility for them. The exoticism of the image exonerates the Western artist by projecting his or her desires onto "other" places and people. Specific pictures, according to Melot, merely furnish pretexts.[38] Cassatt's and Morisot's joint venture demonstrates "influence" in one of its most liberating and constructive manifestations; Japanese prints enticed these women painters to represent women's bodies on their own terms.

A passage in one of Morisot's notebooks, probably written during the same year she worked on *At the Psyché,* corroborates the idea of a vision induced by difference.

> I saw passersby on the avenue with the clarity, the simplicity, and in the style of Japanese prints. I was delighted. I knew with certainty why I had only done bad paintings; so I won't do any more . . . yet I'm fifty years old and at least once a year I have the same joys, the same hopes. People repeat ceaselessly that woman is born to love but that's what's hardest for her. It's the poets who've written the women lovers [*amantes*] and ever since we've been playing Juliet for ourselves.[39]

Morisot begins with exultation in the clarity of her artistic vision, which she compares to Japanese prints. She recalls how rare in her life such clarity has been. She then immediately contrasts a professional pictorial clarity with the personal confusion of women as a group. She ascribes responsibility for that confusion to a self-image fostered by a Western tradition of representation (identified by the reference to Shakespeare's *Romeo and Juliet*).

Once Cassatt and Morisot had seen the female body through foreign eyes, they could begin to see it differently themselves. Whether or not they understood all the nuances and rules of Japanese eroticism, the mere fact of difference between the way Japanese prints and Western painting represented the female body meant that no one way could be absolutely right. Cassatt and Morisot could have looked at any number of Western images of women seen from behind and at their mirrors. Such images, among them a banal 1858 photograph by Marie-Alexandre Alophe, *After the Bath* (Fig. 80), were commonplace. Yet only after they had seen foreign interpretations of the theme at the Beaux-Arts exhibition did it activate their interest.

Japanese prints diverted Cassatt more than they did Morisot. Cassatt was impelled to imitate their medium as well as their themes, and to experiment with the medium so radically that her color prints did not resemble any others in the West. Morisot, by

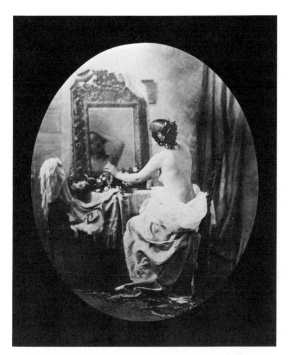

80. Marie-Alexandre Alophe (Menut), *After the Bath,* 1858.

contrast, tried to integrate what Japanese prints had taught her into
the efforts she had expended on the nude since 1886. Her *At the
Psyché* makes several concessions to European traditions; the most
obvious, of course, was her loyalty to oil painting. Where Cassatt
included in her work such signs of influence as the slightly Asiatic
features of her figures, Morisot introduced a reference to neoclassi-
cal sculpture in hers. Although Morisot's preparatory drawings
show the drapery around her figures falling in folds around the
waist the way Hokusai's does, in her final painting her figure wears
a shift falling off one shoulder in the "slipped chiton motif" of
Greek and Roman statues, of which Morisot could find an example
in the *Venus Genetrix* at the Louvre Museum (Fig. 81).[40]
　　Neither individual inflection significantly altered the basic pro-
ject or made it any easier. Both Cassatt and Morisot abandoned the

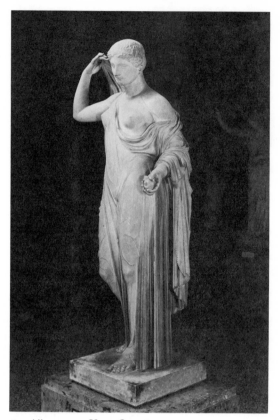

81. Alkamenos, *Venus Genetrix,* 430–400 B.C.

nude not long after their joint effort. Each had found that the subject of maternity offered them a more viable means of representing the female body. Their images of the mother-child relationship express all the pleasure that had eluded them when they tried to picture the nude. Cassatt's modernization of the Madonna tradition earned her a lasting and far-reaching fame. The representation of maternity required Morisot to break from all traditions and paint what a mother feels for her daughter. In order to do so, she had to explore once again the issue of her own identity.

Chapter Eight

An Image of One's Own

Edma Morisot left us the earliest image of Berthe Morisot's artistic identity: her 1865–1868 portrait. Edma pictured her sister as an artist within the secluded amateur tradition. Only when Berthe ventured outside that tradition and joined the world of male painters did she become publicly known as an artist. But the first appearance of this public persona was quite unlike the one her sister had imagined. Very soon after he met her, probably in 1868, Edouard Manet asked Morisot to become his model. Her image entered the history of painting in Manet's portraits of her. Already in 1864 she had posed for her sculpture instructor, Aimé Millet, and lent her features to one of his bas-relief medallions (now under the entrance porch of 14 quai de la Mégisserie), but Manet's work was by far the more notorious. Morisot's public self was initially the object of men's vision, her self-image a self-presentation to their gaze. She did not clearly represent herself until much later. Her 1869 *Two Sisters on a Couch* (Pl. IV) had explored issues of her identity she would not pursue until the mid-1880s.

Just as Cassatt, sometime between 1880 and 1884, worked her way toward self-representation as a painter in the context of other images of her, notably Degas's portraits, so Morisot, around 1885, worked her way toward self-portraiture by seeing herself in multiple guises. The conventional self-portrait could only partially represent Morisot's self-image. It could not represent her even partially until maternity eased the dilemmas of her identity.

Morisot made her most conventional self-portrait in 1885,

when she was forty-four years old (Fig. 82). The image seems to record that unmediated confrontation between solitary self and mirror we associate with the self-portrait. Morisot's handling of her medium corroborates an essentialist reading, for she conveys her message as much with the physical characteristics of pastel and paper as by mimetic means.

Morisot's strokes sweep back and forth, emphasizing the evanescent nature of fragile pastel crayon marks. The sure touch of her execution and the sophistication of her color harmonies, characteristic of her best work, are here quickened to pathos. On the right of her divided face, the deep shadows at the corners of her eye and mouth, the reddened rims of eye and ear, contradict all conventions of feminine beauty, replacing them with signs of anxiety or exhaustion. Morisot almost denies the physical substance of the left side of her face. The eye on that side, a black smudge, bores into a dense black, cream, and brick-red field, a field from which the face, between hair, background, and bow, barely emerges. Floating against an expanse of gray paper, the entire image seems less constructed than in the process of being effaced.

Morisot's pastel self-portrait invites a traditional interpretation of its content as irreducible psychological data. The self-portrait, after all, is supposed to be the artist's remorseless display of her most intimate self. But in Morisot's case, we have portraits, Edma Morisot's and especially Edouard Manet's, to compare with her self-portrait—comparisons which enable us to understand the meanings of the self-portrait much better.[1] If Edma Morisot represented an artist whose work could not be fully recognized as art, Manet represented a woman who could recognize herself as art but not as an artist. How could a woman whose identity was thus formulated be able to paint a self-portrait that was anything but self-denying? The self required to produce a self-portrait had yet to exist.

Edouard Manet painted eleven equally, and differently, brilliant portraits of Morisot. His 1872 *Berthe Morisot with a Bouquet of Violets* conveys an admiration for his subject's character as well as her per-

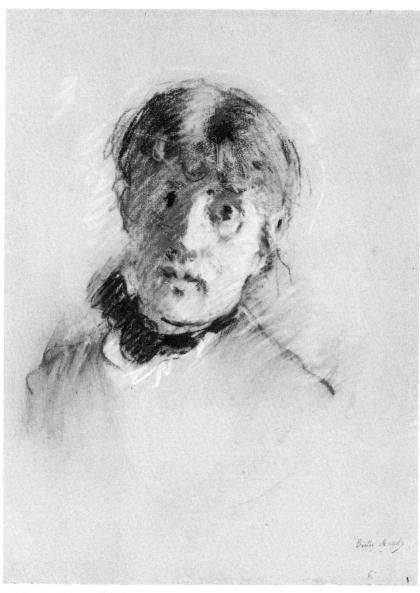

82. Berthe Morisot, *Self-Portrait*, 1885.

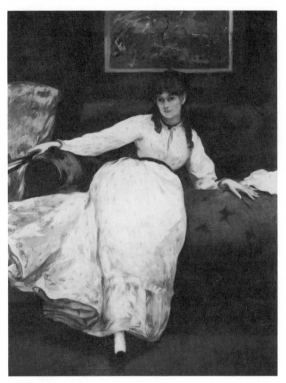

83. Edouard Manet, *Repose,* 1869–70.

son (Fig. 45). Manet's portrait, like Morisot's self-portrait, differentiates the two sides of her face. But the disjunction in the self-
portrait is represented by Manet as engaging, and engaged,
subtlety. He passes from the luminous blond tone, the limpid intelligence of the wide eye, the decisive, relaxed brushwork of the left,
to the tawny reserved calm of the right, with its gently blended
tones emerging from still shadow. His image of Morisot is forthright and elegant; her jaunty hat combines with tendrils of hair and
ribbon into a strong but humorous silhouette, clearly defined in a
translucent space.

Moreover Manet's revelation of a confident, vital woman was

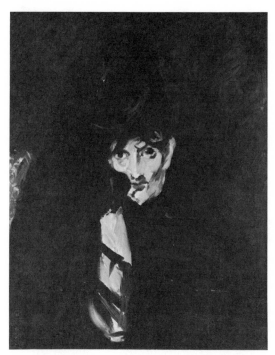

84. Edouard Manet, *Berthe Morisot in a Mourning Hat,* 1874.

not limited to one mood. The pictorial and emotional variety of his eleven portraits, painted in a six-year span, carves the many facets of a complex personality.[2] Manet could recognize, in his 1868–69 *The Balcony* (Fig. 44), Morisot's passionate intensity, perhaps her sexuality—Morisot herself wrote to her sister when the canvas was displayed, "it seems the epithet *femme fatale* has made the rounds among the curious"[3]—at the same time as he represented its containment. Morisot's huge eyes, her curt fan, and her neck locket smolder as she twists against the flat green barrier of the balcony. Only a year later Manet would paint her in a gentler, more ladylike guise, in his 1869–70 *Repose* (Fig. 83). Her expression furled like her skirt and fan, she reclines, reassuringly rounded, on a plump sofa, a picture for delectation like the painting depicted above her.

It was Morisot, as well, who provoked one of Manet's most turbulent paintings, *Berthe Morisot in a Mourning Hat* (Fig. 84). Heavy, slashing, flat brushstrokes record a distress comparable to Morisot's in her self-portrait, but as a grief projected outward, into the swirls of black around the arm, the weight of the face against the fist, rather than as inward consumption.

Together Manet's eleven images of Morisot constitute an exceptionally discerning and sensitive tribute. We might even, seeing with contemporary eyes, think Manet's pictures a truer portrait of Morisot's self than Morisot's own self-portrait. And we would not, in a way, be wrong.

Not only do Manet's images present us with the Morisot perceived by other contemporaries and reiterated by her professional attainments, but his images of Morisot were publicly available, while hers and her sister's remained private. Whereas Morisot's 1885 pastel self-portrait was not exhibited until 1961, several of Manet's portraits, including *The Balcony* and *Repose,* were made for the Salon, that most public of all exhibition places. Long before she was recognized as a producing artist, Morisot became notorious in artistic circles. Her image and reputation circulated among others on Manet's terms; she merely reported the result.

Paintings in the category of the self-portrait express an individual physiognomy and psyche, but only on the conditions their culture allows. A codification of self, the self-portrait obeys the parameters within which privacy may, in a given time and place, manifest itself publicly.[4] It functions as both an act of self-revelation and an act of professional advertisement (hence the great number of self-portraits with emblems of the trade). If the tension between the two imperatives can be great, the self-portrait seductively promises to release that tension, to reconcile or at least assemble disparate selves: inner and outer, private and professional.

In his portraits of Morisot, Manet took as his subject a person who experienced an acute conflict between personal and professional selves. It would be fair to suppose that Morisot's intellectual

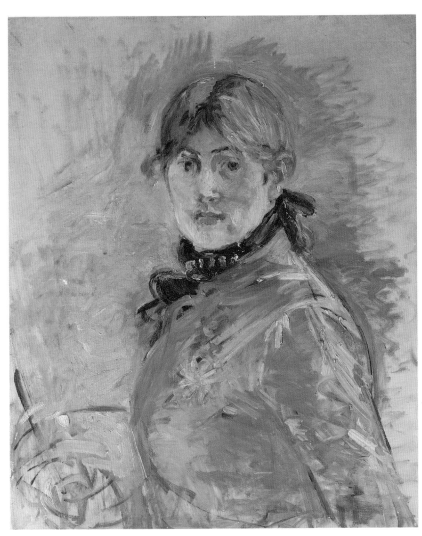

PLATE IX. Berthe Morisot, *Self-Portrait*, 1885.

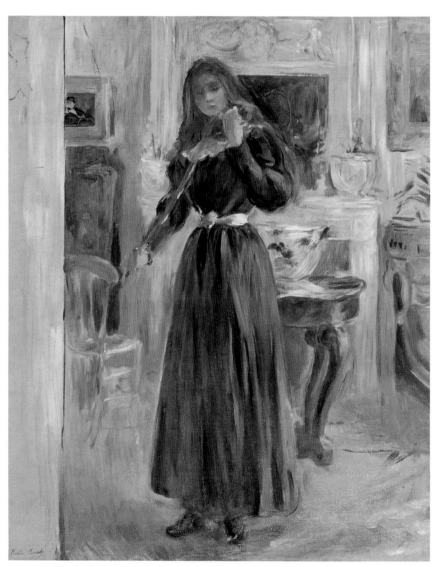

PLATE X. Berthe Morisot, *Julie Playing the Violin*, 1893.

acuity as well as her physical attraction kindled Manet's images of her. Manet, though, a man looking at a woman and making paintings of her, would not have to face her conflicts. He could choose to see Morisot not as a painter but as a feminine woman wielding a fan rather than a palette, as a woman who gave him visual pleasure.[5] In 1868, the year he met her, Manet wrote to Fantin-Latour: "I agree with you, the Misses Morisot are delightful. What a shame they aren't men; nonetheless they might, as women, serve the cause of painting by each marrying an Academician and sowing discord in the camp of those doddering old fellows."[6]

Morisot, however, could not avoid the conflict between femininity and high art. She had faced it before in so many of its manifestations, but after Julie's birth in 1878 she had to confront its strictest rule. No one believed a professional artist could be a good mother. A career in painting and maternity were supposed to be utterly irreconcilable. Who had dared break that rule? Not even Bonheur, not even Cassatt.

Pundits conceded that "womanly arts" like needlework and decorative crafts enhanced domestic life. Marius Vachon wrote in his book *Woman in Art:*

> In intimate family life, Art is a form of wealth. By the thousand marvelous, ingenious, picturesque and delicate things it inspires, by the refinement it brings to taste and elegance, the home receives the caressing and joyous features of all the works in which Woman has put a reflection of her soul and her heart.[7]

In 1882 the art critic Charles Bigot went so far as to praise the effect of a mother's amateur art on her children.

> I don't see that one is necessarily a less good housekeeper or raises one's children less well because one paints during spare moments rather than spins or runs a sewing machine. On the contrary, I see a very salutary symptom in the attraction that

art exerts on today's women, and certainly you can better admire what is beautiful when you try in turn to render it yourself. The mothers who are artists themselves will inspire nobler sentiments in their children.[8]

Motherhood and artistic creation, moreover, were united metaphorically. Each was spoken of as a way of giving birth, both were miraculous processes of production, each reproduced its author. Take, for example, Zola's list of possible titles for his 1886 *L'oeuvre*, a novel about an Impressionist painter. The list is long; I cite only about a third of it:

To make a child	The work [*l'oeuvre*]
To make a world	The work of the flesh
To make life	The blood of the work
	The human work
Creation. To create. Procreation	Immortality[9]

Yet the metaphoric bond between maternity and artistic genius had to be distended into mutual contradiction for gender roles to be maintained. Zola only lists disparate terms, and not even in a single sequence. As soon as terms are articulated into texts, the duties of wife and mother are diametrically opposed to the exercise of genius. The bond remains, for the dangers of women's artistic creativity are always posed in terms of a threat to their feminine role. Catherine Parr at the end of the century summarized previous decades' rhetoric in a chapter of her etiquette book called "The Woman Who Wants to Be an Artist without Remaining a Woman":

> Hardly had she laid hands on the sketch, hardly had she seen a still unformed statuette come from her brain, than she thought she had the right to be no longer either wife, or mother . . . Mistress of the house, she left everything around her in a state of negligence . . . Wife, she abandoned to chance the conservation of her beauty . . . Mother, she considered her son a nuisance.[10]

The more public the medium, the greater the menace. Hence the acute fear of the woman sculptor. Hawthorne in *The Marble Faun*

(1860) pits the dangerous sensuality of the marble sculptor, Miriam, against the redemptive purity of Hilda, copyist of the Old Masters. In novel after novel the cultural ban on women's artistic careers is given its ideological structure. Balzac in *Le chef-d'oeuvre inconnu* (1837), the Goncourts in *Manette Salomon* (1876), and Zola in *L'oeuvre* all represent a masculine genius sapped and perverted by women. While these texts assign artistic prowess to men, their narrative structure depends on a (destructively) binary relationship between masculine genius and feminine sexuality.

Should masculine genius occur in a woman's case, the narrative consequences must be either the end of her genius or the end of her life. Dinah Maria Mulock Craik's heroine Olive paints professionally only because she is deformed: "That sense of personal imperfection which she deemed excluded her from a woman's natural destiny, gave her a freedom of her own,"[11] but only temporarily, for a man—the man who is to be her husband—saves Olive from a fire which destroys her studio, her canvases, and her desire to paint. Then her deformity begins to disappear. In Edmond and Jules de Goncourt's *Renée Mauperin,* the heroine, "the *modern young lady* such as an artistic and boyish education . . . have made her" opens the plot by announcing to a man: "Hey! I paint in oil, I do; my family is appalled . . . I should only paint watercolor roses,"[12] and closes the story by dying, virginal, of a broken heart. In Kate Chopin's 1899 *The Awakening,* Edna Montpellier, whose discovery of her physical and emotional desires as well as her alienation from her husband and children parallels the increasing seriousness with which she paints, ends up drowning herself in the sea.

For Great Art to be made, women must conform to the social order. As wives and mothers women enable art; as wanton mistresses or even independent single women they prevent it. In any case a woman's autonomy must be sacrificed. More is at cultural stake in the denial of women's artistic careers than institutional elitism. The ideology revealed when novels describe male artists cannot be separated from the place in literature of female artists. Considered together they reveal not only that female genius is un-

imaginable but also that the price of male genius is women's sexual freedom. Men make art for culture. Women make babies for nature. Friedrich von Schlegel's *Lucinde,* in which a male writer meets a female painter, ends happily. They marry; she gives up painting; he writes his novel; she bears them a son.[13]

So Morisot could not feel the unity between private self and public role presumed by the painter's self-portrait. The conflicts her culture decreed between her maternity and masculine genius operated as an intrinsic part of gender itself as well as on the social surface. Her identity as a woman painter—according to what she was told it meant to be a painter—was corroded by its very constitution; no alloy could be forged from her professional and personal identities; no self could emerge whole to be portrayed. Manet's portraits of Morisot define her according to rules she could not ignore, and her participation in their creation implies she believed in those rules, if only partially or provisionally. Manet's portraits represent a woman as a man sees her, and as a woman identifies with a man's way of seeing: as a wholly feminine woman (who is not an artist), therefore as a woman whole in society's eyes. Morisot's 1885 pastel records another self, experienced within: a self disintegrating under ideological dictates, at once defined and undermined by the internalization of gender roles.

But Morisot could also see an alternative to her pastel self-portrait. For the pastel is less a single image than one aspect of a three-part self-image that Morisot worked on in 1885. While in her pastel she concedes the disjunctions between her personal and professional roles, at the same time, in her other two self-images, she makes those roles support each other. To represent herself as a painter Morisot had to redefine what it meant to be a painter. She had to believe in herself as a mother, and assert that maternity and painting could be synonymous rather than contradictory kinds of creativity. She had to picture a self that was not a self according to nineteenth-century individualism, but that was instead an identity at once independent and shared with her daughter, Julie.

Morisot matched her pastel self-portrait with a maternal self-image (Fig. 85). She shows herself in the two images with identical hairstyles and clothing. As in the pastel, Morisot flaunts her pictorial skill, pushing her medium to its mimetic limits, using minimal means to establish her subject. But the two pictures put a similar style to very different purposes. In the small fragile pastel Morisot denies having a body, while in the rather large and much more solid oil painting (72 by 91 centimeters) she fills space with her physical presence. The canvas shows through everywhere, but her brazenly casual style assuredly conveys its ample message. Stabilized by jut-

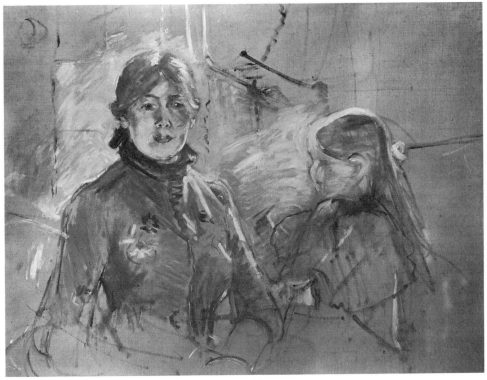

85. Berthe Morisot, *Self-Portrait with Julie Manet*, 1885.

ting elbows, the full forms of her arms and chest swell beneath a tightly fitted dress. Torso and head meet securely at the high neck-piece that joins the rounded, plastic, modeling of face and figure. Morisot dominates the picture, gazing calmly out and obliquely past us, her head placed in relief against a dramatically brushed background. Next to Morisot, the merest sketch, but present none-theless, is Julie.

Morisot overcomes the disparities between these two self im-ages in a third picture made at the same time. Morisot painted an-other self-portrait in 1885, one that accomplishes everything the pastel shrinks from (Pl. IX). Morisot, dressed in the same way once again, presents herself martially erect, gazing straight out at us, holding a palette. This could be the archetypal artist's self-portrait, were it not so closely paired to Morisot's maternal self-image.

The two images of Morisot alone belong to the same category of self-portrait. But the two oil paintings, one of Morisot alone and one with her child, are more fundamentally alike, in self-presentation as well as in medium. In both oil paintings, Morisot represents herself with the same vigor. Before the canvas of the maternal image darkened with age, the two oil pictures shared the same color composition as well as the same scale, style, and pose. Morisot worked each of these two pictures to exactly the same de-gree, noticeably unfinished by contemporary formal standards. She even left Julie in one picture and her palette in the other equally schematic in relation to each image of herself. We must assume that Morisot deemed these pictures finished enough for her purposes. They were left as reflections of each other, with one difference—the exchange of daughter for palette. It was a necessary exchange, for each guaranteed the other's validity. The equation of child and art enabled her to face outward with a confidence both physical and intellectual. As Morisot represented herself in 1885, the alternative to a double mother/artist identity can only be the pastel image of her own effacement.

The subject of a woman with her child was itself banal. Mori-sot's husband Eugène pictured Morisot with Julie in a watercolor he

86. Eugène Manet, *Berthe Morisot and Julie Manet,* 1885.

made while she was working on her self-portraits in 1885 (Fig. 86). Later, in 1894, Renoir represented Morisot the same way, with Julie (Fig. 99). In these images nothing distinguishes Morisot from other mothers. Before 1885 Morisot had several times produced this conventional mother and child image of herself. It had been common currency for several generations; Elisabeth Vigée-Lebrun, the late eighteenth century's most famous woman artist, had adopted the same maternal persona in some of her self-portraits.

Mothers were supposed to be seen with and reflected in their daughters. According to the tenets of a nineteenth-century pedagogy, it was a mother who best taught her daughter the lessons of femininity. "The daughter's soul borrows almost everything from her mother's soul. It's from her mother that she must learn to consider, to think," wrote the Baronne Staffe in *My Woman in the Family: The Daughter—the Wife—the Mother.*[14] Among the metaphors frequently used to advise the mother's indoctrination of her daughter was painting:

It's so easy for a mother to lead her daughter's thoughts where she will, and also to turn her imagination away from some

paintings by creating others for her. If the ardent and passion-
ate souls of girls need paintings and images, she will know
how to paint the ideal of a daughter, of a sister, of a wife, of a
mother, of a homemaker.[15]

Morisot appropriated these conventions and these metaphors
to reinterpret the mother-daughter relationship. Whereas other im-
ages of her, including her own earlier pictures of herself, all imagine
an exclusive, biological and emotional, bond between mother and
daughter, in 1885 Morisot tested the possibility of a triangular rela-
tionship between self, daughter, and image.

After 1885 she reaffirmed her dual identity in several drawings.
In one of them she shows Julie looking at her mother, who relays
her gaze by looking in the mirror. In another Julie stands behind her
mother's chair and looks over her mother's shoulder at the image
her mother is making while Morisot looks into a mirror. In yet an-
other drawing, dated 1887 (perhaps Morisot's favorite, since she
chose it from among the others to rework into a print), Julie and
Morisot lean their heads together to look at the image Morisot is
making (Fig. 87): Julie looks at the sketch pad, Morisot looks in the
mirror. We know that Julie treasured the memory of Morisot's atti-
tude: "What a delightful mother I had . . . how good she was; she
was at once an artist and a tender mother," Julie wrote.[16]

"Une ardente flamme maternelle, où se mit, en entier, la créa-
trice," wrote Mallarmé in his preface to the catalogue of Morisot's
posthumous 1896 exhibition.[17] As usual, Mallarmé's (untranslat-
able) syntax conveys more than one meaning. A linear translation
implies that Morisot threw her entire creative self into an ardent
maternal flame whose heat could destroy whatever it touched. But
Mallarmé also placed the syntactical juxtaposition of and analogy
between "en entier" "(in its entirety")" and "la créatrice" ("the cre-
ator") in equilibrium with "the ardent maternal flame"; he thereby
equated Morisot's imaginative integrity with maternal fire. A con-
suming passion burns all the more brightly as it threatens to extin-
guish itself.

87. Berthe Morisot, *Self-Portrait with Julie Manet*, 1887.

Morisot guarded her fires closely. The most audacious pictorial experiments of her later years were carried out in secrecy. Her 1885 proposal that maternity and painting be rethought in relation to each other remained unknown in her lifetime. Perhaps she had to withdraw from painting's public arena to question its assumptions. Just as all three of her 1885 self-images push at the limits of contemporary stylistic norms, so, as a group, they contradicted art's ideological dictates. They would have been difficult for a public to understand, let alone accept. For they were not merely private—rather, they questioned hierarchical distinctions between private and public that enforced women's relegation to the "private" domain of maternal nurture and denied them access to the "public" domain of culture.

The first of Morisot's 1885 self-images to appear publicly was the one that, isolated, best conformed to the category of self-portraiture: the oil self-portrait with a palette. Immediately after she

had painted it, without showing it to anyone, Morisot had rolled it up and stashed it in a closet.[18] Exhumed for the 1896 retrospective, it surprised even her closest friends. Using masculine terms, Mallarmé likened the embroidered flower on her dress to a military decoration, while Henri de Régnier concurred that Morisot looked "chevalresque" (chivalric).[19] Speaking in the feminine case, Morisot's daughter wrote that it revealed her as "la grande artiste qu'elle était."[20]

It was this 1885 self-portrait as an artist, which we can understand Morisot made in conjunction with a maternal self-image, that led to her greatest control over painting. For she reused this self-portrait to inaugurate a series of images that cite paintings in order to subsume and manipulate their meanings.

About a year after she had made the self-portrait she remade it within a fan-shaped painting called *Medallions, Fan* (Fig. 88). She reproduced her painting in watercolor as if it were a reproducible

88. Berthe Morisot, *Medallions, Fan,* 1886.

carte-de-visite photograph, cornered as if to be mounted in an album. As a painting that mimics another medium, her self-portrait is mirrored on the other side of the fan by an image of the child who has empowered her to play with her medium. The entire image, ornamented with cameos of the Bois de Boulogne and with floral garlands, resembles both an album page and the masthead of a women's magazine; the fan, of course, still carries its connotations of feminine communication. Having asserted the compatibility of feminine maternity with masculine painting, Morisot feels free to joke about the femininity of her art. She has attained that greatest privilege and most valuable asset, a sense of humor.

Besides citing her own self-portraiture, *Medallions, Fan* echoes her 1869 *Two Sisters on a Couch,* returning to its exploration of her self, or rather selves, as well as to its use of the fan. Once again we see Morisot's self-portrait on the right of a fan, and on the left a portrait of a woman with whom she identifies. Once again Morisot plays with the likeness and difference between art forms to confuse masculine with feminine means of expression and represent herself as both intellectual painter and nurturing woman. But this time the fan-painting is hers, the work she cites is hers, and the self-portrait is unmistakably hers. Between 1869 and 1886 Morisot had come into her own.

Chapter Nine

A Mother Pictures Her Daughter

One kind of maternal image appealed to many people in the late nineteenth century. Close embraces that physically bonded a mother with her children evoked a natural love. Designed to convey the most primal sensations, the most universal of experiences, images of maternity—especially of women with infants—became popular in every medium, including fine art, genre painting, prints, and portrait photographs. Herself the mother of a daughter, Morisot represented her feelings differently.

Morisot's paintings of her daughter, Julie Manet, constitute her most extensive pictorial project and her most innovative one. This project had been prefigured before Julie's birth by Morisot's twenty-four paintings of mothers and daughters, chiefly but not exclusively of her sisters, Edma and Yves, with their daughters, Jeanne, Blanche, Paule, and Jeannie (Figs. 16, 56; Pls. II, III, VI). Morisot's pictorial interest had its roots in the amateur artistic tradition and was reinforced by the conventions of feminine propriety prevalent in her adulthood. Even taking into account these traditions and conventions, as well as the biographical circumstances that presented her the chance to paint sisters and nieces much more often than brothers and nephews, Morisot's insistent return to the theme of mothers and daughters indicates how very much it fascinated her personally.

Her interest became a passion when she gave birth to her own daughter in 1878, at the age of thirty-seven. Thereafter Morisot made more pictures of Julie than of anything else, steadily produc-

ing between 125 and 150 portraits over the next sixteen years.[1] The devotion implied by the sheer extent of Morisot's work conforms to the prevailing ideal of maternal absorption in children, as does the complicity required of any comparably enduring partnership between an artist and a model. But in Morisot's images there is more to maternal bonding than the physical love between mother and baby. In her pictures the baby grows up. Almost immediately, Julie acquires a separate identity. She develops an intellectual and artistic life which echoes her mother's and yet is her own. Along the way, the mother also changes. By 1885 Morisot felt able to question her identity with self-portraits. Through her self-portraits she suggested new possibilities for reconciling maternity and art. In the work she did after 1885 she acted on those possibilities.

By the time Julie was born conventions for the representation of maternity had become so pervasive that they cut across the boundaries of medium and genre. As Louise d'Argencourt has shown with many well-chosen examples, the conservative painter William Bouguereau traded in exactly the same imagery of rapt adoration and idyllic sensuality as mass-produced prints, studio portrait photographs, and commercial postcard photographs.[2] Rather than dwelling either on an unusually successful painter or on the cheapest postcards, let us consider a picture somewhere in between, a triptych shown at the 1888 Salon (Fig. 89) and praised by the art critic for *L'Illustration,* that perennially popular family magazine. Today the painting and its author, one M. Humbert, have been forgotten, but when it was first exhibited it struck a resonant chord.

At the center of *Maternity* a young woman holds two children closely in her arms. A toddler presses his cheek against her throat and wraps his arm around her shoulder; an infant rests its head in the crook of her elbow and reaches to its sibling. Mother and children are united compositionally into one triangle. The mother's dress, posture, and rural setting indicate to the painting's (and *L'Illustration*'s) predominantly middle-class audience that this

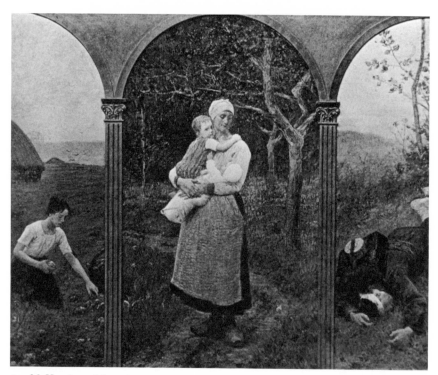

89. M. Humbert, *Maternity,* c. 1888.

mother belongs to the peasant class. Her image reassures them that their idea of maternity does not depend on class and is common to all women. Since, moreover, to urban eyes she, being a peasant, is close to the land and therefore to nature, her maternity must also be natural. The critic supports these conclusions by saying that the painting reconciles "realism" with "poetry," by claiming for the mother that "instinctively she has found one of those poses full of nobility in its naturalness."[3]

 Almost all Salon reviews in this period singled out images of maternity for special praise. No matter what the time, place, or situation of the subject, critics stressed the transcendent qualities of the good mother. About Boulanger's *Mother of the Gracchi,* for ex-

ample, a *L'Illustration* critic wrote in 1885: "But however appealing
these children might be . . . it's the happiness exuded by the young
mother that makes the whole painting; she truly walks . . . in a
starry dream, summing up all the joys and all the infatuations of
maternity."[4]

Such pictures and language imagine a bliss shared by the child
and the mother, who identifies herself with her child in a time be-
fore loss, anxiety, discipline, or hierarchy. Both nostalgic and uto-
pian, these maternal images attempt to substitute the memory of
infantile pleasures for the problems of adult society. The mother-
child relationship exists in a world apart, disconnected from the rest
of life. To grow up is to fall from grace and suffer the social destinies
that follow expulsion from maternal paradise. Humbert's *Maternity*
represents this in triptych form, with images on either side of the
central panel showing what comes after separation from the
mother. The class identity that had been subordinated to a classless
maternity reasserts itself. One of the children has become a peasant
like her mother; the other has become a simple soldier. Gender, too,
has marked them. The daughter labors anonymously for subsist-
ence, while her brother fights publicly for the nation. The poi-
gnancy of the image is supposed to reside in the contrast between
the innocent happiness of the children in their mother's arms and
the harsh realities that await them. Maternity ends in tragedy. In its
ideal state it therefore never ends. To avoid the possibility of a tragic
ending, it never changes. The mother must always be the same and
the children always babies.

Art historical precedent reinforced the sanctity of the late nine-
teenth-century mother-child image. Humbert's *Maternity* was lik-
ened by its *L'Illustration* critic to both Leonardo da Vinci's and Ra-
phael's images of the Virgin Mary.[5] Comparisons with specific Old
Masters, usually of the Italian Renaissance, or the more general epi-
thet "modern Madonna," endowed a contemporary image of mater-
nity with a prestigious and pious lineage. By the middle of the cen-
tury Catholic images of the Madonna and child had renewed their

currency. No single person was more responsible for this revival than Anna Jameson, England's first professional art historian.[6] She devoted the third volume of her *Sacred and Legendary Art* to *Legends of the Madonna,* first published in 1852 and reprinted many times on both sides of the Atlantic for decades afterward. Jameson wrote that images of the Madonna and child depicted "the glorified type of what is purest, loftiest, holiest in womanhood."[7] To illustrate her points she included dozens of engravings after masters such as Raphael, Giovanni Bellini, and Lorenzo Lotto (Fig. 90). Books like Jameson's, along with a middle-class predilection for cultural tourism and museums, made the iconography of the Renaissance Madonna widely available.

Obviously Madonnas came freighted with specific Catholic significance. But they were rapidly reinterpreted according to a new, vaguely Christian and decidedly middle-class family ideal. If Protestants rejected Catholic dogma, including the cult of the Virgin Mary, all Christians agreed on the Madonna's moral purity and exemplary motherhood. Images of Mary holding an unclothed infant Jesus reminded nineteenth-century viewers of her nurturing love for a baby son who was God but also human. *L'Illustration*'s art critic, for example, wrote of Pascal Adolphe Jean Dagnan-Bouveret's *Virgin,* shown in the 1885 Salon, that "the Virgin, mother of Christ, is for M. Dagnan only a symbol of the eternal maternity that sums itself up and synthesizes itself in her."[8]

Madonnas both old and new corroborated the latest trends in family organization: the autonomy of the nuclear family, a restriction in the number of children, and reinforcement of psychological bonds between family members, as well as of physical bonds between mothers and children, promoted for instance by arguments in favor of maternal breast-feeding rather than the previously common practice of wet-nursing.[9] Madonna images, after all, showed a mother tenderly embracing a single child, often to the breast that nursed him, and always implied a father—less Joseph, Mary's earthly husband, than God the Father.

56 Raphael.

the style of execution is somewhat hard and cold. In this, by Fra Bartolomeo (60), there is such a depth of maternal tenderness in the

57 Giau Bellini. 58 Squarcione.

90. Anna Jameson, *Legends of the Madonna*, 1852, p. 118.

Cassatt's pictures of mothers and babies participated in this modernization of the Madonna. Like Morisot, Cassatt dedicated her late career primarily to the representation of maternity. Because they were colleagues and peers, both of them committed to the same Impressionist ideas, a comparison of their pictures of mothers and children can help us see exactly which aspects of Morisot's project were uniquely hers.

Cassatt encouraged women to love their babies sensually. In picture after picture—her *Baby on His Mother's Arm, Sucking His Finger* (Fig. 91), for example—Cassatt showed mothers holding small children, boys and girls. Typically, her images centered on an embrace. Flesh presses against flesh—cheek to cheek, lips to hands, hands caressing feet, silken hair brushing against maternal throat. These contacts organize the image, establish its central axes and its compositional vectors, mapping the topography of sensual communion. Both Cassatt and Morisot had failed to represent the sensuality of the adult female nude, which remained for them an insoluble conflict between personal and professional imperatives. Here Cassatt looks instead at children's bodies and has found her erotic object. In many of her pictures the children are clothed, but in others they are naked or nearly naked. Clothed or not, Cassatt's children represent the physical pleasure women and children give each other. Besides conveying the pleasures of touch thematically, Cassatt provides viewers with the pleasures of sight. Her technical ability to create convincing illusions of volume and her preference for clear bright color contrasts give us a powerful visual impression of corporeality, even more tactile when she draws with velvet-toned and textured pastel. She places bodies far forward in her pictorial spaces and displays them generously from the most advantageous angle. Our gaze easily finds plenitude.

The difference between Cassatt's images of maternity and other modern Madonnas is that they do offer women this possibility of visual pleasure. Like conventional images of the female nude, Cassatt's images expose bodies and allow their enjoyment. But here

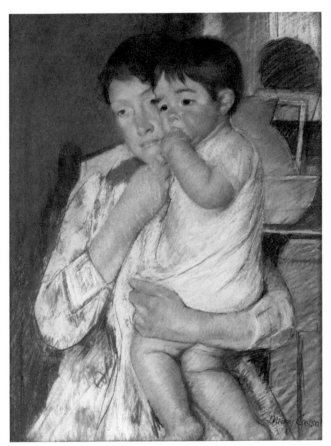

91. Mary Cassatt, *Baby on His Mother's Arm, Sucking His Finger,* 1889.

women's bodies are shielded from our gaze, encased in the constricting and concealing respectable clothing of the bourgeoisie. Here children's bodies are the objects of desire, and it is women who enjoy them—women spectators, but also the women within Cassatt's images. Cassatt's mothers and children are reciprocally absorbed in each other's physical satisfaction. The ideal of the modern Madonna enunciated in the average picture or critical review did not preclude such pleasure, and even sometimes hinted at it. But Cas-

92. Berthe Morisot, *Julie in Bed,* 1885.

satt's images are entirely devoted to pleasure, making no pretenses
to spiritual, allegorical, or historical significance. Her disinterest in
the child's sex—sometimes female, sometimes male, never empha-
sized—renders that pleasure generically maternal. Cassatt's moder-
nity makes it easy for a middle-class female audience to identify
with maternal ecstasy; the women she paints look like the women
for whom the images are made, and they live in the same kinds of
bourgeois domestic interiors.

Morisot's pictures of her child also have a sensuous quality to
them. One of her early portraits of Julie, for instance, concentrates
lovingly on the toddler's last moments in bed before falling asleep
(Fig. 92, which, based on the child's appearance, should be dated
about 1881 rather than 1885). Though just a pastel sketch, Julie's

93. Berthe Morisot, *Julie Dreaming,* 1894.

round face and chubby hands are caressingly modeled in pinks, set
by bright blue shadows into a pillow that plumply occupies almost
the entire pictorial surface. If anything, Morisot's style became in-
creasingly lush with time. Renoir's influence has been invoked to
explain the more careful draftsmanship, more richly blended colors,

and fuller volumes of Morisot's work in the late 1880s and 1890s. The physical confidence and pride Julie brought her mother might be equally important. Indeed, some of Morisot's most sensual works are her late portraits of Julie, none more so than the 1894 *Julie Dreaming* (Fig. 93). Pyramidally composed, the image is direct and frontal; Julie's face rises out of thick undulating hair, supported by one curvaceous arm, while the other rests solidly along the picture edge. Aquatic, sinuously mingled blues and greens unify the image, deepened occasionally by opaque browns. *Julie Dreaming* recalls pictures like Edvard Munch's sexual Madonna/Vampires, with their swaying silhouettes, long manes, and heavy-lidded gazes.

This sensuality surprises us, for we are not accustomed to seeing it so openly acknowledged in images of children well past babyhood and into adolescence. But for Morisot the sensuality of her maternal feelings was only one of the ways in which she felt close to her child. A physical bond informs all of Morisot's images of maternity, but although necessary it was not sufficient. Her representations of the mother-daughter relationship depended, ultimately, on imaginative and intellectual bonds.

Morisot wanted to represent a mother-daughter relationship as artistic as it was physical. Closeness and distance, identification and separation, had to be expressed simultaneously. Today, feminist psychologists assure us that all women face this challenge. A feminine identity, theorists Nancy Chodorow and Carol Gilligan explain, is formed primarily by the mother-daughter relationship. Women's sense of themselves emerges out of their identification with their mothers and their need to both grow apart from and remain attached to them. Rejecting the idea that an adult identity must be entirely autonomous, Chodorow and Gilligan argue for the development of an identity based positively on the mother-daughter relationship, independent yet shared. Ideally, a stable self would not be jeopardized by the permeable identity boundaries that allow adjustment to others' needs and that, for better or for worse, have characterized femininity.[10]

At the same time, feminist psychologists explain why the mother-daughter relationship has been perceived negatively, and why a feminine identity has been so debilitating for many daughters and mothers. Sigmund Freud and his followers described an early bonding between mother and child, which, just like popular images of maternity, was primitively physical, exclusive, and impossible to sustain happily. Chodorow writes, quoting first Freud and then Ruth Mack Brunswick:

> Freud, Ruth Mack Brunswick and Lampl-de Groot stress the intensity and ambivalence of the girl's early relationship to her mother. They also argue that any first love relation is "doomed to dissolution" just because of its ambivalence and intensity, and because of the restrictions and compulsions which the child must undergo to maintain it: "the mother-child relationship is doomed to extinction. Many factors militate against it, the most potent perhaps its primitive, archaic nature. Ambivalence and passivity characterize every primitive relation and ultimately destroy it."[11]

For Freudian psychoanalysts, this "pre-Oedipal" phase ends when the child identifies with the father and enters into the verbal, symbolic world of adults. According to a Freudian scenario, boys and girls must reject identification with their mother and become autonomous in order to mature. Yet daughters can never entirely disassociate themselves from the mothers they resemble biologically and therefore continue to identify with them; because the mother lacks power (signified for Freudians by the phallus), however, this identification succumbs to resentment, fear, passivity, or repression. Chodorow and other psychologists of the object-relations school recast this Freudian scenario in the social terms that dominated Morisot's time. They demonstrate that negative or even destructive mother-daughter relationships can be attributed to bourgeois family organization as much as to biological factors. They argue that daughters feel ambivalent about their mothers because of their mothers' social inferiority and powerlessness.

These reevaluations of the mother-daughter relationship have altered our understanding of nineteenth-century women's writing.[12] Women with literary or artistic ambitions faced an acute and specific version of the feminine identity problem. The models for their endeavors, the very pictorial and verbal languages they hoped to use in their work, manifestly belonged to men. To declare themselves authors, women had to identify with cultural father-figures. How could they articulate an identification with mothers who had been invisible and mute? Moreover, the anxiety they felt as daughters could only increase if they became mothers. Without a legacy to receive, women doubted whether they had one to give.

Maternity and mother-daughter relations preoccupied many creative women of the time besides Cassatt and Morisot. In the last decade or so much has been written on this topic, including the collection of short stories entitled *Between Mothers and Daughters;*[13] Susan Gubar's essay "The Birth of the Artist as Heroine"[14] and Sandra Gilbert's on Mary Shelley's *Frankenstein;*[15] Margaret Homans's analysis of women's novels, *Bearing the Word;*[16] and especially Gubar and Gilbert's magisterial *The Madwoman in the Attic.*[17] We are learning from these works that a nineteenth-century woman's sense of herself as a daughter shaped her writing both thematically and structurally. Not only do images or scenes of transition from one female generation to the next recur throughout women's texts, but those matrilineal moments occur in conjunction with references to language or at crucial narrative moments that reveal the imagination of the author to be inseparable from the identity of the daughter. The transmission of language both represents and is a transmission of wealth, just as a narrative identity both represents and is a social identity.[18]

Contrary to popular images of an idyllic maternity, many women writers represented relationships to mothers or mother-figures with diffidence if not with dread. According to Gilbert, Shelley's anxiety about her own illegitimate maternity and the legacy of her notorious mother, Mary Wollstonecraft, who died giving birth

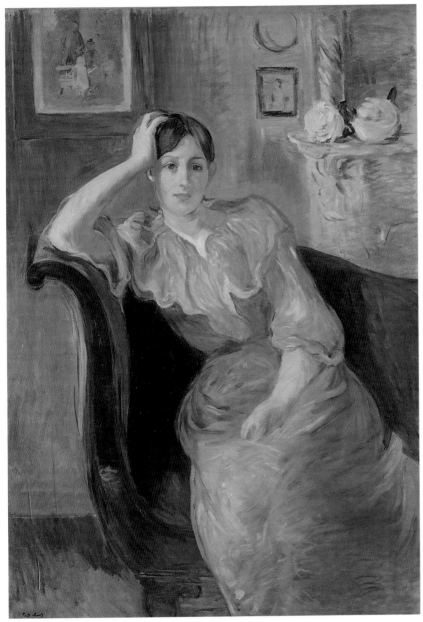

PLATE XI. Berthe Morisot, *Portrait of Jeanne Pontillon,* 1893.

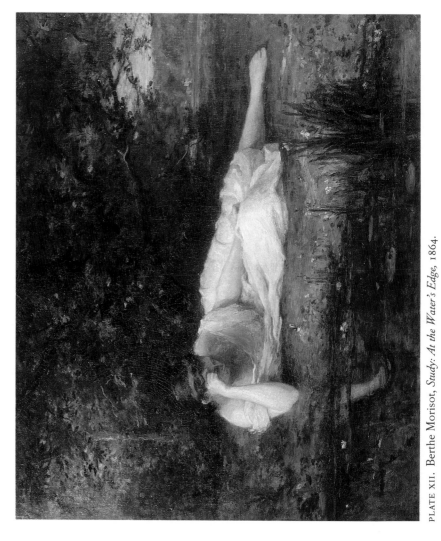

PLATE XII. Berthe Morisot, *Study: At the Water's Edge*, 1864.

to her, interacted with the literary model of Milton's *Paradise Lost* to produce *Frankenstein*, in which procreation is damned and reproduction monstrous. Homans shows how in Gaskell's novels and short stories, the masculine language women must obey—in the form of letters, wills, opinions, and laws—menaces the bonds between mothers and daughters and introduces incomprehension, betrayal, and even death. Both Shelley and Gaskell suppress mothers. Shelley casts her hero, Frankenstein, as a man and his artificial progeny as a monster, while, as Gilbert points out, the female figures in the book are rootless beggars and orphans. In Gaskell's works, Homans finds original mothers replaced by substitutes who alienate daughters from the values the mother represents. Marianne Hirsch, in her book *The Mother/Daughter Plot*, goes so far as to claim that in a fictional world of "monstrous mothers and motherless daughters," "the mothers, themselves motherless, can only perpetuate a cycle of abandonment."[19] Women writers, Homans observes, associated maternity with death, both because they had observed that women's artistic careers almost invariably ended, if not with marriage, then at the birth of children, and because so many women did in fact die in childbirth: "Within the conventions of fiction, childbirth puts an end to the mother's existence as an individual."[20]

Not all women's texts interpret maternity quite so negatively. As Beatrice Didier reads Sand's *Consuelo*, for instance, its epic plot of self-discovery and artistic fulfillment revolves around the return to the principles of a lost mother; Consuelo, moreover, is initiated into the possibilities of political enlightenment and sexual pleasure by a mother-figure, Wanda.[21] In many women writers' lives, including Sand's, textual and personal experience refract each other's plots. Elizabeth Barrett Browning's poetry became more politically overt and its author more self-assertive after she married Robert Browning and gave birth to her son Penn.[22]

In negative or positive modes, all these women's texts have in common what they also share with Morisot's portraits of Julie: a deep concern for lineage, or what Hirsch calls "genealogy."[23]

Whether (as in Shelley's novel) a parent's scientific experiments create a monster, or (as in Sand's novel) a mother turns her daughter into an apostle of sexual and political freedom, women authors dwell on the problems of transmission from one generation to the next; and women who are mothers, not unexpectedly, worry as much about what mothers can pass on to their children as what they have inherited from their own mothers. Loss, violence, and separation threaten the mother's gifts; death accompanies birth: both mother and father, Frankenstein is finally killed by his offspring; Consuelo must descend into a terrifying underworld in order to be reborn.

Women strive to construct legacies for future generations of characters within their fictions and of readers or viewers outside them. Their books and paintings bear the signs of their struggle. Where novels speak of texts, paintings depict pictures. Where Frankenstein's monstrous child pursues him with letters pleading for recognition and affection, Morisot's late portraits include other portraits in their backgrounds. Control over these reinscribed works of art affirms a woman's will to control the act of writing or painting. Sometimes the struggle is unsuccessful, but to engage in it at all is to fight for a legacy that can be handed down to daughters.

Morisot hardly seemed to struggle at all. Her integration of maternity and art appeared effortless to her daughter and to her contemporaries. Julie Manet recalled: "We were always together, Mother and I. Even though I had a nurse, Mother looked after me tenderly. She painted at home during the day and, when we went out, she took along notebooks to sketch me."[24] Those who knew Morisot described her maternal feelings as the force behind her artistic creativity. Louis Rouart wrote as early as 1908: "Besides, she never ceased making pictures of this child. It was as if the most assiduous and the most affectionate care could not suffice to satisfy her maternal passion which always sought new opportunities to express itself."[25]

Perhaps the most often-cited passage on Morisot's apparent merging of art and life is by Paul Valéry, her niece's husband.

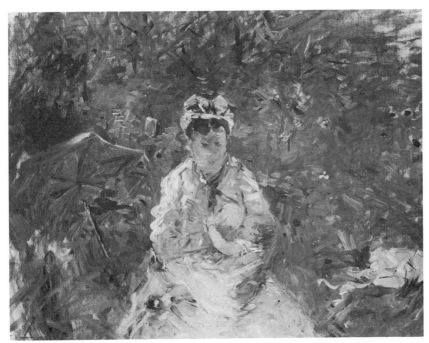

94. Berthe Morisot, *Wet Nurse and Baby,* 1880.

But Berthe Morisot's singularity consisted in ... living her painting and painting her life, as if this were for her a natural and necessary function, tied to her vital being, this exchange between observation and action, creative will and light ... As a girl, wife, and mother, her sketches and paintings follow her destiny and accompany it very closely.[26]

Yet Morisot's very first attempt to represent her child indicates the difficulties she had before arriving at the pictorial solutions that later seemed so natural. Morisot's earliest paintings of her daughter, notably *Wet Nurse and Baby* (Fig. 94), depict her with her wet nurse Angèle. A traditional image of maternity, a baby at a woman's breast, occupies the center of Morisot's picture. Morisot has resolved this center pictorially, constructing volumes and spatial relationships with blended and coherent colors. But around that cen-

ter, space splinters into colliding bars of flat color, fracturing into one of the most precarious paintings of Morisot's career.

As Linda Nochlin has shown, Morisot intrudes paid labor and class politics into her image of maternity.[27] The wet nurse, a member of the working-class, exchanged her milk for wages. She was only one of the most privileged among servants in middle-class households; Morisot makes sure we know she has hired Angèle by clearly representing her characteristic wet nurse's white cap with its long floating ribbons. Already Morisot refuses to conform to a bourgeois maternal ideal. Even in her daughter's infancy Morisot would not cast herself (or any other woman) as a modern Madonna. She not only declines the "natural" role of the nurturing mother for herself, but even goes out of her way to represent the class and economic situation that allows her to be another kind of mother. Morisot represents her maternal love as artistic attention rather than physical intimacy. The wet nurse's labor enables Morisot to carry out another kind of work, the work of painting. That work takes Julie as its beloved object, but from an intellectual distance.

Julie grows up independently in her mother's images. Though several times Morisot pictures Julie with her maid Pasie, her English governess Miss Reynolds, or her father, in these pictures Julie sits apart from her caretakers, actively engaged in her own story telling, sewing, or play. Not incidentally, the similarities among these pictures overthrow one of the most deeply entrenched assumptions about child care. In four pictures, among them *Eugène Manet and His Daughter in the Garden* (Fig. 95), Morisot quietly assumes a point of view that turns gender roles around. For in her version of parenting the child is a daughter, not a son, the caretaker is a father, not a mother, and the absent member of the nuclear family is a mother who is also the artist. A radically new relationship to her child produced by shared family responsibilities allowed Morisot the space, both literally and figuratively, to cultivate an artistic bond between mother and child.

Morisot maintains contact with her child even though she stays

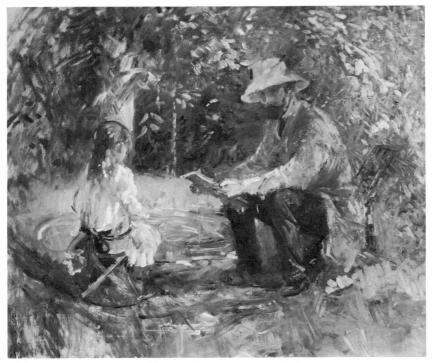

95. Berthe Morisot, *Eugène Manet and His Daughter in the Garden*, 1883.

out of the picture. Her portraits of Julie express a physical intimacy
with her child not only through their style but also through the
relationship they express between the model in the pictures and the
artist who makes the pictures—a spatially intimate relationship
sealed by an exchange of gazes. To have made the pastel of a small
Julie in bed (Fig. 92), the artist could only have been sitting on the
child's bed beside her, a presence Julie calmly accepts with complete
trust. In *Julie Dreaming* (Fig. 93), Julie seems to sit right in front of
the viewer, but still her gaze responds without constraint. She has
the familiar look of an adolescent daydreaming in front of a mirror.
Here her mother, and her mother's art, do mirror her, just as she is
her mother's mirror image.

Morisot's portraits record the process of Julie's growth from baby to adolescent, physically and intellectually. Morisot made painting a part of that process by using it as a teaching tool. Morisot and Eugène Manet educated their daughter themselves, sending her only very briefly to a local private school. Morisot taught Julie about the practice and the history of art. Julie took drawing and painting lessons from her mother along with her cousins Paule and Jeannie Gobillard, who were almost like daughters to Morisot, especially after their mother died in 1893 and they became orphans. During outings into the city Morisot introduced Julie to the Louvre, showed her prints in bookstalls, and explained sculpture in parks— together mother and child analyzed the color of shadows. The feminine amateur painting tradition encouraged many middle-class mothers to transmit artistic skills to their daughters and nieces, and for a mother to teach her girls history lessons was also not unusual. Morisot did what other mothers did, but the art she turned into pedagogy belonged to an order of cultural importance mothers rarely aspired to.

Morisot managed to maintain connections between an ordinary pedagogic project and extraordinary artistic ambitions. When someone gave Julie a set of children's color pencils, Morisot tried them herself. She adopted them and used them in her most personal and finished drawings, unabashed by their childish connotations. Similarly, Morisot recycled her paintings into children's illustrations. Around 1883 she started an alphabet-book project, whose title page announced: "Alphabet de Bibi" (Julie's nickname). Each page was to include two letters and two pictures illustrating the letters. Letters "C" and "D" reuse Morisot's 1883 oil painting *Lady in a Rowboat,* letters "L" and "M" her 1881 *Peasant Woman Hanging Laundry.* In 1883, as well, some of Morisot's watercolors did double duty, picturing, for instance, her daughter, her niece Jeannie (called Nini), and her nephew Marcel, but also teaching them how to write. The watercolor captions read: "The Chair The Bouquet" "Bibi and Nini Lunch with Marcel."

96. Jeannie Gobillard, Julie Manet, Berthe Morisot, untitled document, 1884.

An untitled document (Fig. 96) summarizes Morisot's approach to art and teaching in the early 1880s precisely because it cannot be classified or conveniently catalogued. Is it a work of art or a schoolroom exercise? Mistakes and even improper attitudes have been corrected. Along the straight and dotted lines a child laboriously scrawls: "Bibi has a doll that doesn't have a pretty dress, she loves it a lot." Someone has altered this phrase by crossing out the "n't" to make the statement positive. Around the writing exercise Morisot has drawn little sketches of dolls, of Julie and Jeannie with their dolls, and of their cousin Marcel. She oversees the chil-

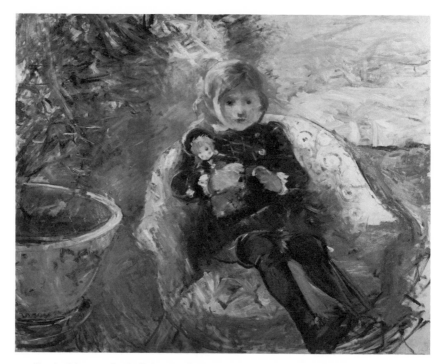

97. Berthe Morisot, *Little Girl with a Doll,* 1884.

dren's education, teaches them to write, and at the same time pre-
pares one of her major canvases of this period with her sketches,
her 1884 *Little Girl with a Doll* (Fig. 97).

Morisot's culture taught girls femininity with dolls. The com-
tesse de Ségur opened her book *Les petites filles modèles* with Camille
and Madeleine, the quintessential good girls of nineteenth-century
France, tending their beautiful dolls and organizing the dolls' im-
peccable domestic apparatus. Camille and Madeleine rehearse their
exemplary feminine roles by enacting in miniature their doll-like
future. Dolls teach them to nurture and empathize, to tend babies,
orchestrate wardrobes, and manage households. According to Jean-
nie Gobillard's niece, *Little Girl with a Doll* numbered among Julie

Manet's favorite paintings, so much so that she hung it above her bed.[28] The picture's casually bold brushwork and succinct, elegant construction certainly merit formal admiration, but its image of a "petite fille modèle" was easy to admire as well.

Nicole Savy, in her exhibition "Les Petites Filles Modernes" and its catalogue, has shown that in the last third of the nineteenth century girls acquired an image of their own. She points to the publication of three tremendously popular books each about a little girl's adventures: the comtesse de Ségur's *Les malheurs de Sophie* (1859), Victor Hugo's *Les misérables,* with its heroine Cosette (1862), and Lewis Carroll's *Alice in Wonderland* (1865). By the 1880s, according to Savy, the female child had become a current subject in literature, painting, prints, advertising, the law, and toys. In December 1880 the "loi Camille Sée" promised all girls a public education for the first time. It was also around 1880 that dolls began to be consistently designed to look like girls rather than women.[29]

Sophie, Cosette, and Alice have endured in our imaginations because their adventures take them beyond the realm of the doll that circumscribed most nineteenth-century girls' options. If Morisot did often represent Julie holding dolls, especially when Julie was a little girl, she too insisted on more for her daughter. From her child's earliest days, and increasingly as she matured, Morisot preferred to picture Julie concentrating on her own inner life: staring out of windows, playing with watering cans or boats, splashing in fountains, later reading (in four paintings), and above all, playing music (in sixteen paintings, including Figs. 98 and 104 and Pl. X).

Images of Julie playing the violin and Jeannie Gobillard playing the piano occupied a special place in Morisot's endeavors. They endowed Julie and Jeannie with an art of their own, one that echoed Morisot's yet was theirs to share. Of all her images except *The Cherry Tree* (Fig. 1), Morisot worked longest and most carefully on *The Piano* (Fig. 98). In preparation for the final 1888 pastel version, she made no fewer than four oil sketches, one pastel, and at least seven drawings, some of them quite large and elaborate. Jeannie sits

98. Berthe Morisot, *The Piano*, 1888.

in perfect profile on the right, her arms reaching straight across to the piano keys on the left. She looks at the sheet of music opposite her. Julie, seated behind Jeannie on the piano bench, faces us and looks at us, that is, at her mother making the picture. The two girls' gazes, one at an artist and the other at art, or one at a mother and the other at music, are the perpendicular versions of each other—two identically direct gazes that intersect over the piano keys.

Renoir picked up on the significance of this image in his later portrait of Morisot with Julie (Fig. 99). He cites *The Piano*'s composition almost exactly. Once again Julie looks straight out at us, seated behind a figure in profile, this time Morisot. Renoir might well have been interested in the 1888 painting because he had worked on pictures of girls at pianos in 1889 and again in 1892; but, as Morisot's close friend, he seems to have understood something

99. Pierre-Auguste Renoir, *Portrait of Berthe Morisot and Julie Manet,* 1894.

personal about the particular way she had interpreted the theme. He puts Morisot in the place—literally—she had given to her daughter's artistic companion. The complicity depicted in Morisot's image in the perpendicular gazes is given a more straightforward but less suggestively intellectual form in Renoir's double portrait of mother and daughter.

Morisot renewed herself in her paintings of her daughter. In this respect they resemble the late Impressionist projects of her closest professional friends, Renoir, Monet, and Degas. Each of them embarked, in the late 1880s, on groups of paintings of a few preferred subjects. In different ways, each of these four Impressionists both compensated for their advancing age and consolidated their professional reputations. Renoir returned to the monumental

classical nude that affirmed his allegiance to painting's *grande tradition* as well as his delight in the pleasures of the flesh. Monet began his series of poplars, haystacks, cathedrals, fields, and especially waterlily ponds that he had built on his Giverny estate. He concentrated on the landscape rather than on the human figure but with an appreciation of nature's gifts similar to Renoir's. Degas's late subjects seems artificial in comparison, in the most rigorously experimental way; he seemed to withdraw from nature altogether into a studio, pushing his images of nudes and dancers toward abstraction. But like Renoir and Monet, Degas treated his subjects biomorphically, letting images evolve cyclically out of each other, nourishing new images with earlier versions of the same themes, freeing line and color from descriptive discipline and allowing them their own autonomy.

After Julie's birth Morisot began the work that had started in the late 1860s all over again. In her earliest surviving paintings the women are young, the mothers expecting. A decade passes, the babies are born, grow up, and then the mothers disappear. In the late 1870s Jeannie and Julie are born, the girls are babies once more, and the process of growth begins again. After one portrait of her mother in 1868–69, and apart from her 1885 self-portraits, Morisot never represented women older than about forty.

In her late paintings Morisot turned to a new generation of women. Her reproduction of herself in her daughter reproduced itself throughout her work. She became increasingly absorbed by the representation of girls Julie's age, of her nieces and also of hired models. In a few cases, notably *The Cherry Tree,* Morisot interchanged Julie and hired models. As Julie's appearance multiplied in Morisot's painting, so did the issues she evoked. The majority of Morisot's late works, therefore, could be called a Julie series, regardless of whether Julie actually posed for them. Even more than the other late Impressionist series, these pictures constitute a cycle. Because she was a mother in a society that valorized maternity more than any other woman's role, Morisot had a more immediately

personal sense of her changing place in a lifecycle than her male
colleagues Renoir, Monet, and Degas. They could imagine life rep-
licating itself abstractly or symbolically in voluptuous bodies, gar-
dens, or the repetitions of artifice, while she felt her life continuing
in female children.

In the most literal sense, Morisot hoarded artistic wealth for
her child to inherit. When she bought several major canvases by
Edouard Manet at his posthumous studio sale in 1883, she worried
about whether Julie would mind if her mother had traded some of
the money she would inherit for paintings but then decided hope-
fully that her daughter might share her own estimation of Manet's
value. Morisot planned to add what she created to Julie's inheri-
tance. When, for instance, she withdrew *The Cherry Tree* from the
market, she did so with the express intent of bequeathing it to Julie:
"You'll see that after my death you'll be very happy to have it."[30] In
fact, she left hundreds of works to Julie, who responded to her
mother's legacy with a lifetime of curatorial devotion and filial
pride.

Morisot also took stock of what she could bequeath to Julie in
a more conceptual way. Once before, in 1869, she had used an im-
age within an image to make a statement about her identification
with another woman and to counteract their separation through an
affirmation of an enduringly eloquent professional identity. The re-
production of Degas's fan within *Two Sisters on a Couch* (Pl. IV) had
marked the artistic allegiance that compensated for the uncontroll-
able loss of her sister Edma. Later in life, as she dealt with the in-
evitable process of separation from an adolescent daughter, she re-
peatedly used the same device. To leave her child in good standing,
Morisot settled all her accounts, biographical and professional.

As early as 1868 Morisot had begun to play on issues of sight
with images of mirrors and windows within her paintings. Particu-
larly in her toilette pictures of the middle 1870s, she had allowed
her images to address overtly what Neil Hertz, rethinking Freud,
has called the figuration of figuration itself.[31] As Hertz puts it, "the

irreducible figurativeness of one's language is indistinguishable from the ungrounded and apparently inexplicable notion of the [repetition] compulsion itself."[32] The acknowledgment of repetition in the form of its figuration within a text, and by extension within a painting, would therefore signal an author's recognition—conscious or unconscious—of the act of representation. Hertz has proposed the replication of an image within itself as one of the forms this recognition can take.

> There is no term in English for what French critics call a *mise en abyme*—a casting into the abyss—but the effect itself is familiar enough: an illusion of infinite regress can be created by a writer or painter by incorporating within his own work a work that duplicates in miniature the larger structure, setting up an apparently unending metonymic series. The *mise en abyme* simulates wildly uncontrollable repetition.[33]

Once alerted to the general significance of the *mise en abyme,* it becomes necessary to ask what forms it takes in a particular author's work and in what contexts. All authors, arguably, share an acute concern with representation. But which aspects of representation nag an individual's consciousness, and why? In Morisot's case, the forms her *mises en abyme* took changed over the course of her career. In the 1870s, in her toilette pictures, as well as in her 1891 *At the Psyché* (Pl. VIII), when she attempted to imagine the erotic sight of women's bodies from a woman's point of view, the mirrors and windows within her images remained blank. But in *Two Sisters on a Couch,* and again in her late Julie series, *mises en abyme* opened up the possibility of declaring her own artistic status, matching her talents against men's, and reinterpreting men's images of her. The representation of her relationships, first to her sister and then to her daughter, gave her the artistic confidence not only to make paintings but to remake paintings.[34]

In all three of the paintings in which she represented women making art, as well as in the one finished drawing she did on the

100. Berthe Morisot, *Paule Gobillard Drawing,* 1886.

subject, Morisot included an extra sign of artistic creation. Morisot
had no students or disciples other than the daughter and two Gob-
illard nieces who figure in these images, the most assiduous being
Paule, pictured by herself in two of the paintings (including Fig.
100). In each of her four images of her students, though they were
produced over a five-year period, Morisot placed the same statuette.
It reminds us of the art that is being learned in the foreground, and
its female form reminds us that women are doing the learning. Yet
because it is a sculpture it contrasts with the drawing or painting

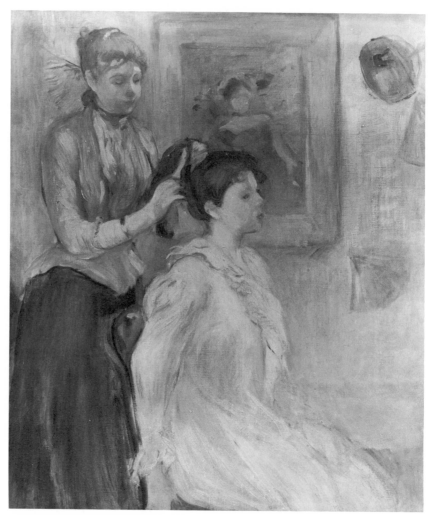

101. Berthe Morisot, *The Coiffure*, 1894.

102. Berthe Morisot, *The Black Bodice*, 1878.

Paule, Jeannie, and Julie do, just as its neoclassical nudity and whiteness differentiate the artistic past it symbolizes from the kind of modern art Morisot teaches her students.

Only once, in 1894, did Morisot reproduce a painting of her own within another work: in *The Coiffure* (Fig. 101). Behind two models who resemble Julie and Jeannie in age and appearance (one dark, the other fair), hangs a miniature version of Morisot's 1878 *The Black Bodice* (Fig. 102). Partners in preparation for a public appearance, these two young women are placed in front of an image

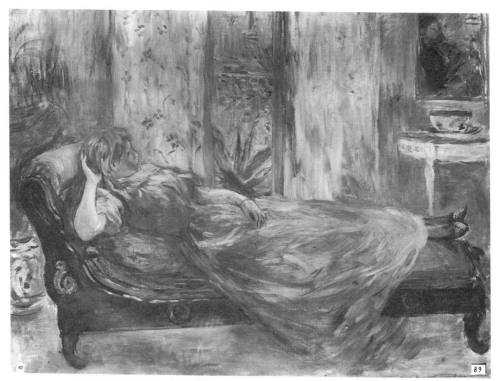

103. Berthe Morisot, *On the Chaise Longue*, 1893.

of a young woman on display at a ball. Morisot seems to have been less interested in restating her own past production than in redoing other people's images. In her 1893 *On the Chaise Longue* (Fig. 103), she signals the direction of this late preoccupation by repeating an earlier image with a twist. *On the Chaise Longue* takes up again a subject Morisot had treated in the 1870s, notably in her 1874 *Portrait of Marie Hubbard* (Fig. 59). This time, however, the subject gazes at an image of Julie playing the violin, rather than at the artist. The internal image cannot be matched with any catalogued Morisot painting. Is it a lost painting, or an image reflected in a mirror? In

104. Berthe Morisot, *Violin Practice*, 1893.

either case, the image has been framed as if it were a painting, a painting of Julie engaged in her own art.

Morisot did put Julie playing the violin at the center of her 1893 *Violin Practice* (Fig. 104), one of several paintings with allusions to Manet, who had been dead a decade by this time. Morisot revered his art, which had played so great a part in the formation of Impressionism, and which hung so prominently on her apartment walls. Her inclusion of his 1880 *Portrait of Isabelle Lemonnier* (Fig. 105) in *Violin Practice* pays tribute to him but also records her current ownership of the painting and, perhaps, mourns him in order to be able to bury him and move on. Morisot included the image of a print by Manet—*Woman in Spanish Costume*—in the rack beside

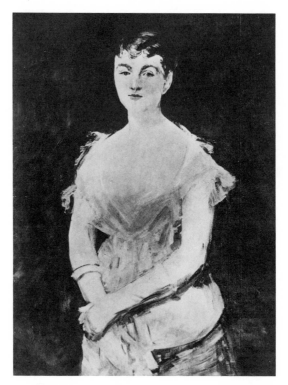

105. Edouard Manet, *Portrait of Isabelle Lemonnier,* 1880.

the figure of her niece Alice Gamby in an 1890 portrait (Fig. 106) clearly enough for her daughter to take note of it,[35] though the image is extremely difficult for an uninformed observer to decipher. Here Manet has been tucked away almost out of sight. The same statuette that guards over Morisot's students at work presides over this niece and her print-rack as well.

A painting by Manet also appears in the upper left corner of Morisot's 1893 *Julie Playing the Violin* (Pl. X). As Charles Stuckey has noted, Morisot balances Manet's portrait of herself, his 1873 *Berthe Morisot Reclining* (Fig. 107), on the left with Degas's 1874

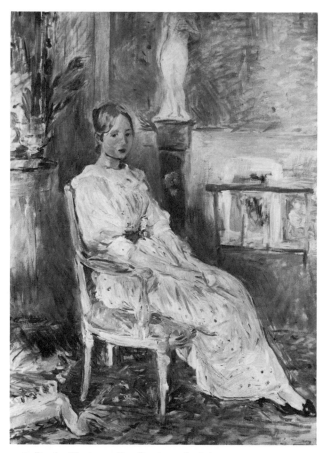

106. Berthe Morisot, *Alice Gamby in the Salon,* 1890.

portrait of Eugène Manet (Fig. 108) in the upper right corner. She has, figuratively, given the child in the center of the image a family tree: mother on one side, father on the other.[36] Morisot, however, represents only a sliver of her husband's portrait; no one but the most knowledgeable viewer could identify him. He is passing out of the picture while she remains behind her child, perhaps a refer-

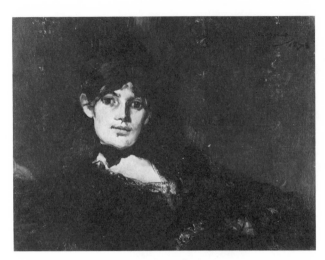

107. Edouard Manet, *Berthe Morisot Reclining,* 1873.

ence to Eugène Manet's death in 1892. Each of the miniature paint-
ings within *Julie Playing the Violin,* therefore, commemorates one of
the two dead Manet brothers. And in a way, both of them com-
memorate another past, Morisot's own two pasts, professional and
personal. Edouard Manet's portrait of her recalls the time she was
as much a man's model as a painter; Eugène Manet's portrait recalls
the time she was a man's wife.

Having seen Manet's painting reproduced this way, we can at
last recognize one of the vague images in Morisot's 1891 *At the
Psyché* (Pl. VIII). It is once again *Berthe Morisot Reclining,* seen re-
versed in a mirror. If the noticeably center-parted hairstyle, the pale
areas of face and tilted throat, and the dark, almost horizontal areas
of bodice were insufficient to make this connection, the proportions
of the frame that Morisot placed around the image, the same frame
we see in *Julie Playing the Violin,* settles any uncertainty.

In *At the Psyché* we see an unusually intricate example of the
"wildly uncontrollable repetition" Hertz describes. Morisot repeats
her image in a mirror that itself contains another mirrored replica.

108. Edgar Degas, *Portrait of Eugène Manet*, 1874.

Morisot's self-representation here takes its most elusive form, in the spectral reflection of the artist who includes herself in her painting as the reversed trace of another person's portrait of her. This image of herself is uncanny, in Freud's sense of the word, as defined in his essay "The Uncanny."[37] Hertz brilliantly drew general conclusions about representation from this essay, but if we go back upstream, we find that Freud's more psychologically specific understanding of the uncanny applies eerily well to this particular Morisot image. Freud suggests that the uncanny comes from the fear we feel at the resurgence of our former selves, the dread we have, to put it simply, of the ghosts from our past. In fables, legends, and European literature alike, Freud proposes, the uncanny is expressed by twins, doubles, or mirror images.

Which past? What ghost? Whose double? As Morisot tries to imagine a woman's body seen from a masculine point of view, she sees her own double in the mirror, the ghost of her past as a man's model. *At the Psyché* initially appears to be the image of a nude model, seen twice, once as an ostensibly real figure, and again as a

mirror image. But the mirror image itself has a reflection in it, Manet's portrait. Morisot has flattened the hairstyle and blurred the features of this portrait so that it resembles the face of the nude seen in the psyché. The frame of Manet's portrait, moreover, leads to the head of the mirror nude just as the mirror's frame leads to the head of the real nude. As Morisot represents them, the three images of women—real, mirrored, and twice-mirrored, are all alike. This is the visual equivalent of Mary Coleridge's 1882 poem *The Other Side of the Mirror:*

> Shade of a shadow in the glass,
> O set the crystal surface free!
> Pass—as the fairer visions pass—
> Nor ever more return, to be
> The ghost of a distracted hour,
> That heard me whisper, "I am she!"[38]

The female nude is juxtaposed with Manet's image of her, and thus juxtaposed, Morisot can bring neither into focus. Both are visions of a female self seen with masculine eyes, and neither can be resolved in Morisot's image. She cannot overcome their paired force. Only in an image diametrically opposed to the nude, passive object of masculine vision, only in an image of her daughter playing music, participating actively in culture, does Manet's portrait escape the mirror's reversal, if not its spectral meaning. Morisot's uncanny identification with this image by Manet was repeated in her posthumous exhibition when her family and closest friends decided to use it as the frontispiece of the catalogue. They too felt it could mirror her. In her life she tried to subsume this portrait in her art. After her death Manet's image once again introduced her work.

In the same year she painted *Julie Playing the Violin,* Morisot also painted *Portrait of Jeanne Pontillon* (Pl. XI). In the portrait of her own child she left her daughter a parental genealogy, one in which the mother figures at least as fully as the father. In her portrait of a niece she left another pair of precedents. In the upper left corner of Jeanne Pontillon's portrait appears a different commemorative im-

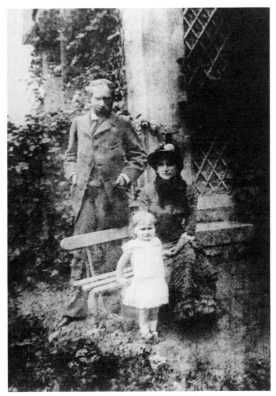

109. Eugène Manet, Julie Manet, and Berthe Morisot in the garden at Bougival, 1883–84.

age of Morisot's marital life. The image indistinctly reproduces the only known picture of Morisot with both Julie and Eugène Manet, a photograph taken of the family in the halcyon summer days of 1883 or 1884 at Bougival (Fig. 109). Only in this spectral way did Morisot ever represent herself in the traditional role of the wife.

Morisot has matched this traditional image of her family life with an image of her career by placing a picture of another niece, Alice Gamby, made in about 1890 (Fig. 110, a variant), in the opposite corner. In this picture within a picture Morisot redoubles the

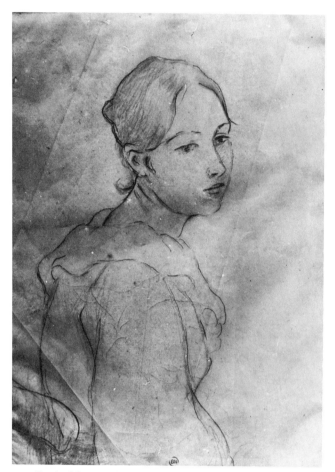

110. Berthe Morisot, *Portrait of Alice Gamby,* c. 1890.

signs of artfulness. She makes art imitate art by repeating the fore-
ground figure's orange dress in what we presume from surviving
variants was a black and white drawing, and also by turning the two
figures, "real" and "represented," toward each other. The drawing
she chose to reuse had already been reused: it was one of two illus-
trations accompanying the only monographic article on Morisot's
art published in her lifetime, Théodore de Wyzéwa's (Fig. 111).

Mᵐᵉ Berthe Morizot

Les femmes peintres ne manquent pas dans l'histoire de l'art : mais ce qui y manque tout à fait, c'est proprement la peinture de femme, une peinture exprimant l'aspect particulier que doivent offrir les choses à des yeux et à un esprit féminins. Il n'est pas douteux, pourtant, que cet aspect est très particulier, qu'il est en outre délicieux, à condition qu'on le prenne pour ce qu'il est, et qu'il aurait pleinement le droit d'être traduit sous une forme artistique. On peut bien soutenir que les femmes n'ont pas une façon à elles de penser ou de sentir, et qu'ainsi la littérature ou la musique ne sont point de leur fait ; mais à coup sûr elles savent voir, et ce qu'elles voient est tout différent de ce que nous voyons, et l'art qu'elles mettent dans leurs gestes, dans leurs toilettes, dans la décoration de ce qui les entoure, suffit à donner l'idée de l'instinctif génie plastique qui réside en chacune d'elles. Le malheur est qu'elles ne savent point reconnaître ce génie, le comprendre, l'apprécier et le cultiver autant qu'il conviendrait.

Quelques-unes cependant, jadis, ont essayé de faire une peinture féminine. Les pastels de la Rosalba Carriera et les portraits de Mᵐᵉ Vigée-Lebrun, qui n'ont d'ailleurs, ni les uns ni les autres, aucune des qualités d'une œuvre d'art, expression, dessin ou couleur n'en sont pas moins imprégnés d'un charme spécial, assez fort pour les empêcher d'être perdus dans la foule des non-valeurs de la peinture. C'est qu'ils traduisent, malgré tout, une vision du monde que nous sentons très distincte de la nôtre, plus légère, plus flottante, plus douce, telle, à peu près, qu'elle doit exister dans les yeux d'une femme.

Cette vision artistique, ni la Rosalba, ni Mᵐᵉ Vigée-Lebrun n'ont su, malheureusement, la traduire avec art : du moins

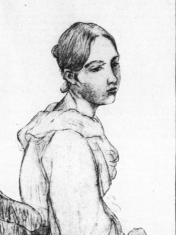

D'après un dessin inédit de Mᵐᵉ Berthe Morizot

elles ont eu le mérite de la respecter et de ne point la tenir pour indigne d'être traduite. La plupart des autres femmes peintres, au contraire, paraissent n'avoir eu que du mépris pour leur vision de femmes : elles ont tout fait pour l'effacer de leurs yeux, et leurs œuvres ont toujours l'air d'avoir été peintes par elles, on dirait toujours que ce sont leurs maris qui se sont chargés d'en voir les sujets. Plusieurs sont même parvenues à s'assimiler très heureusement nos habitudes de vision : elles savent à merveille tous les secrets du dessin et de la couleur ; et on serait tenté de les considérer comme des artistes, n'était une fâcheuse impression d'artifice et de mensonge qu'on éprouve toujours devant leur peinture. Quelque chose y sonne faux, quoi qu'elles fassent. On sent qu'il ne leur est pas naturel de voir le monde tel qu'elles le peignent, et qu'elles ont mis leur très habile main au service des yeux d'autrui. N'est-ce pas une impression analogue que nous font éprouver ces œuvres cependant si parfaites des peintres japonais contem-

porains, qui ont cru devoir accommoder leur vision aux lois, pour eux toutes nouvelles, de notre perspective occidentale ?

D'avoir consenti à regarder les choses avec ses propres yeux, c'est le premier mérite de Mᵐᵉ Berthe Morizot. Chacune de ses œuvres nous offre le même charme indéfinissable que nous offrent, avec leurs défauts, les portraits de la Rosalba et de Mᵐᵉ Vigée-Lebrun. On y découvre un monde qui n'est pas celui que nous voyons ; et de même que les portraits de la Rosalba et ceux de Mᵐᵉ Vigée-Lebrun, les œuvres de Mᵐᵉ Berthe Morizot laissent apercevoir du premier coup une originale vision toute féminine.

Mais Mᵐᵉ Morizot ne s'est point contentée de voir avec des yeux de femme les choses qu'elle peignait ; elle a su encore adapter à sa vision personnelle les plus parfaits moyens qui seyaient à la rendre ; de sorte qu'elle a créé un art très homogène, très complet, constitué de toutes les qualités qui doivent constituer un art, et, de plus, absolument exquis. Oui, les œuvres de Mᵐᵉ Morizot sont, dans leur genre particulier, la perfection même ; rien n'y détonne, rien n'y manque de ce qui peut revêtir de la plus noble valeur artistique les délicates sensations d'une femme. La peinture contemporaine compte bien un ou deux maîtres dont l'art est d'une beauté plus haute, ou pousse plus avant l'expression de la vie ; mais, pour être d'un degré inférieur, l'art de Mᵐᵉ Morizot est le seul qui réalise son idéal avec une harmonieuse plénitude.

✳

L'excellence de cet art provient, je crois, en partie du bienheureux hasard qui, naguère, a donné Édouard Manet pour professeur à madame Morizot, et l'a ainsi d'emblée rattachée au mouvement impressionniste. Et je crois en vérité que la méthode impressionniste était spécialement prédestinée à former le talent de Mᵐᵉ Morizot : c'était, par essence, la méthode qui convenait pour amener enfin l'avènement d'une peinture féminine. Tout, dans l'impressionnisme, semblait tendre à cette fin. L'usage exclusif des tons clairs s'accordait avec ces caractères de légèreté, de fraîche clarté, d'élégance un peu facile, qui constituent les traits essentiels de la vision d'une femme. Et bien davantage encore que le procédé, c'était le principe de l'impressionnisme qui devait contribuer à en faire une méthode d'art féminin. C'est en effet le propre de la femme de ne point s'occuper des rapports intimes des choses, d'apercevoir l'univers comme une gracieuse et mobile surface infiniment nuancée, et de laisser se succéder en soi, comme dans un théâtre de féerie, un adorable cortège de passagères impressions. Seule une femme avait le droit de pratiquer dans sa rigueur le système impressionniste : elle seule pouvait limiter son effort à traduire

111. Berthe Morisot, after a drawing of Alice Gamby, 1890.

This portrait within a portrait of Alice Gamby thus cited a very important public acknowledgment of Morisot's artistic reputation. It balanced Morisot's one representation of her family identity with an emblem of her professional success.

An endless mirror game? Not quite. Morisot places all her replicas in the background of a new generation of women. The female nudes, whether sculptures or paintings, the mirrors, the repetitions of Manet's and Degas's images, the references to her own careers as mother, wife, model, and painter, all of these have been controlled. They may be the ghosts that will always haunt her painting, but she has reduced their dimensions, securely framed them, and subordinated them spatially. Morisot leaves her daughter, and us, with a promise; our mothers may not have been able to vanquish the past, but thanks to their efforts one day we will be able to put the past behind us.

Chapter Ten

Conclusion

... ce Narcisse féminin. Un seul symbole conviendrait encore ici: l'image d'une plante dans la haute lumière du midi où elle jette son ombre verticalement, où, cachée dans cette ombre, elle la regarde comme le plus tendre reflet de son propre être—s'ombrageant en elle: pour que le grand brasier ne la consume pas avant son temps.

Lou Andréas-Salomé, "Du type féminin," 1914

At the start of her career Morisot depicted a Narcissus. One of her very few surviving early paintings, this 1864 *Study: At the Water's Edge* (Pl. XII) has always been called a study, and the woman looking into a pond has been assumed to be a nymph in Corot's manner. But very clearly this woman is gazing at her own reflection in the water; her position is not unlike Nicolas Poussin's famous Narcissus in *Echo and Narcissus,* a painting hanging in the Louvre where Morisot was copying at the time.

A critic, Louis de Gonzague Privat, wrote of Morisot's painting and a landscape of Edma's, both on display at the 1865 Salon: "Courage! mesdemoiselles, you are following a path that leads far, and you seem to me to be decided to walk along it with confidence and faith. I sincerely congratulate you for it."[1] Privat, here at least, foretold the future. Morisot's Narcissus did herald the work to come: pictures of women made in her own image. And she was on a path, undertaken with confidence and faith, that would lead her far.

The myth of Narcissus has been used to allegorize the darker

side of painting ever since Ovid told his famous version of it.[2] In its filial relationship to Corot, as well as in its repetition of the Narcissus theme, Morisot's *Study* stands for her antecedents in the history of painting. It pays her tribute to the masters who came before her and to the central intellectual issue of their common endeavor. At the same time, it marks her difference within painting's history. For Morisot's Narcissus is a woman. The main actor in the myth of representation has been changed. A woman has acceded to the possibilities both powerful and frightening of self-representation.

The Narcissus myth, in its masculine version, warns that to dwell on one's own image leads to folly and self-annihilation. Fixated by his reflection in a pool, Narcissus cannot distinguish between himself and his image, between the real and unreal; because he cannot escape from his illusions, he wastes away, caught in the deceptive bliss of self-absorption. Although Morisot dedicated her art almost entirely to representations of herself or women like herself, this project, far from paralyzing her, gave her a creatively critical distance not only from her own personal background but also from her social condition.

Artistically, Morisot refracted reflections of herself and her environment, rendering her world in a new light. In her paintings material immediacy plays against illusions skillfully wrought. She translates her subjects into disjunctures between passages or planes with paint dashed onto canvas, left as it hit the surface, in great swathes, stabs, and short tense flickers, colors jostling, unblended tones in prismatic multiplicity, placed suddenly, oddly, unexpectedly: images of things seized quickly by the eye and mind. But then again, artist and subject face each other with the calm reserve of mutual discretion; color and space, however disparate or scattered, usually hold together; a slowly evident optical logic balances their mimetic inconsistency. If Morisot's subjects seem so rapidly conceived, it is because they have long been assessed, experienced, esteemed. And if they seem to bear the weight of intimacy lightly, it is because their author leaves them as she finds them, forgoing the

imposition of any one point of view, any one controlling device or narrative.

Morisot's achievement, however, exceeded the artistic. To study women's self-representation in the nineteenth century we must take a critical distance from painting. Without ignoring or underestimating the accomplishment of any individual artist, or the formal integrity of any particular work of art, we must ask under what historical conditions such accomplishment or integrity was achieved and include among those conditions class, race, and gender. These conditions force creativity into historically specific forms. No one artistic form should be taken for granted, nor its expressive opportunities be thought self-evident, not even the nineteenth-century novel or painting, both so apparently dedicated to reflections of reality. Painting, with all its esthetic, economic, institutional, and logistic conditions allowed, but also structured and limited, expression. Painting constituted identities as much as it reflected them, and in nineteenth-century Europe it did much more to limit than to allow women's self-expression.

Once we consider painting both critically and historically, we can see more clearly how many forms of expression coexisted or even overlapped with it. If we think of painting as one among many kinds of images—albeit an extremely privileged and privileging kind of image—then we become aware of women's active and diverse participation in a feminine visual culture. In addition to the small but increasing numbers of women who produced "fine art" paintings, sculpture, or photography, women made albums, amateur paintings, and all sorts of decorative and functional domestic objects. Moreover, women expressed themselves indirectly through domestic genre prints, studio portrait photographs, religious imagery, and fashion plates.[3] Women were engaged with these sorts of images as producers as well as consumers, for feminine creativity found outlets in the circulation, purchasing, and collecting of images, regardless of the low opinion in which those indirect sorts of creativity were held.

This visual culture did not necessarily express a female esthetic or sensibility nor reveal some truth about female experience, but it did provide the elements out of which in a particular time and place women could fashion the visual aspects of a social identity. Caught in the rhythms of cultural, economic, and technological change, women's pictures expressed a femininity necessarily provisional and arbitrary yet nonetheless lived as experience. However fragmentary, fragile, marginal, or ephemeral, women's pictures gave them a visual sense of self.

A feminine sense of self should not be confused with artistic authorship. In fact, the two identities conflicted with each other. The historicization of painting, far from eliciting a new roster of women authors, enables us to understand why women, despite the existence of a feminine visual culture, virtually never became "great artists." A reluctance to acknowledge the historical realities of art only perpetuates the premises on which those realities rest.

We still cling to the assumption that only crafted, individually signed, professional, exhibitable, marketable artworks carry real or worthwhile visual messages. We still base our studies on a definition of "art" that makes women's modes of visual creativity at best marginal, more often invisible. By concentrating on what art does include we have neglected what it does not include. Unwilling to confront art's negative or disempowering cultural functions, we have only begun to address the ways in which art denies women's identities. Although we have analyzed how men construed feminine identities within the parameters of high art,[4] as well as how artistic institutions refused women, we have not yet asked how or why nineteenth-century high art precluded the possibility of a feminine identity representing itself.

This book could be considered one way of answering the question Linda Nochlin posed back in 1971, in the very title of her landmark essay "Why Have There Been No Great Women Artists?"[5] and my method essentially derives from her suggestion that we cease questing for genius on masculine terms and begin to confront

the social and sexual factors that so powerfully affect women's artistic careers. I owe also a great debt to Griselda Pollock's recent "Spaces of Modernity," which clearly demonstrates how thoroughly sexual difference sets paintings by both Morisot and Mary Cassatt apart from the work of their male Impressionist colleagues.[6] Art historians like Nochlin and Pollock encouraged me to question the limits of our field, and to go beyond issues of formal quality or art historical significance and instead consider the problems of Morisot's work as issues of feminine identity.

Middle-class women's privileges make these problems all the more subtle and therefore tenaciously resistant to analysis. Many women like Morisot had every social, economic, and personal advantage on their side, and made good use of their assets. Women were allowed to become painters under special circumstances, and a select few, like Rosa Bonheur, basked in public acclaim during Morisot's formative years. Nor did the subject of femininity seem to be banned from the fine arts, at least from the 1860s onward. Genre scenes of middle-class women and their daily lives attracted audiences both academic and commercial.

But from whose point of view were powerful representations of femininity overwhelmingly imagined? Art critics, professors, theorists, dealers, administrators, and historians, as well as artists themselves, overtly and explicitly stratified visual expression hierarchically. To professional studio painting went the highest status and the greatest power, whereas the forms of feminine visual culture enjoyed so little prestige that we can barely recognize them as art at all. Foucault has made a crucial theoretical distinction between what he calls the *visible* and the *énonçable*.[7] We can think of women in the nineteenth century as what was "visible" and femininity as what was "expressible." Each depends on the other; femininity would have no meaning without women, yet women in the nineteenth century could only be understood or even understand themselves through their gender. Men controlled the means of defining how women experienced that femininity. In the most basic sense,

art helped make femininity intelligible and knowable[8] to women as well as to men. How could women not believe in the images of femininity that constituted the only culturally credible visualizations of their experience? While during the entire nineteenth century women made many pictures of themselves, they could almost never represent themselves in any viable or valuable way without replicating or reinforcing prevailing ideals.

Women's experience of femininity obstructed or diminished the probabilities of their artistic emergence.[9] Morisot defied cultural odds and forced open an artistic breach for herself and thus for other women. She did become a painter despite being a woman and despite a lifelong commitment to the representation of femininity. Her work cannot be securely placed on either side of a dividing line between painting and feminine visual culture. Morisot's paintings blur art's boundaries between public and private, masculine and feminine, marginal and dominant.

It would be inaccurate to say that Morisot elevated feminine imagery to a higher status, since to be recognized as a painter she altered her ways of making and exhibiting pictures very significantly. It would be equally inaccurate, however, to say that Morisot could have acted as a painter without a tradition of feminine picture making not only to launch her but to sustain her. Morisot adjusted her life and work in ways that enabled her to attain some of the fame, influence, and artistic freedom usually unavailable to women without entirely sacrificing the security of a shared feminine identity. To achieve this balance, Morisot had to be logically inconsistent, retaining and conceding at the same time, conforming as much as innovating.

Faith, not logic, promised self-representation. Morisot had to believe that women could imagine themselves. Her Narcissus was just a beginning.

Notes

Unless otherwise noted, all translations from the French are my own. Quotations of Morisot's unpublished letters and notebooks are taken from manuscripts in private collections. Quotations of her published letters and notebooks are from Denis Rouart's 1950 *Correspondance de Berthe Morisot* or from Philippe Huisman's 1962 *Morisot: Charmes*. My translations of her published and unpublished writings © 1990, 1991 by Rouart Frères.

1. Introduction

1. To cite a quite recent example: Tim Hilton asked, in his review of a Morisot exhibition, "Does the sympathetic show . . . really convince us that she is—as the title of the catalogue essay puts it—'a great impressionist'?" *Guardian Weekly* (November 25, 1990), p. 27.
2. Although the eight group exhibitions held between 1874 and 1886 in which Morisot and her colleagues participated had several different names, I have called them all Impressionist exhibitions for the sake of easy recognition.

2. Impressionism in the Feminine Case

1. This kind of account, combined with a formalist assessment, was essentially the project of the catalogue accompanying a major exhibition of Morisot's paintings: Charles Stuckey, William Scott, and Suzanne Lindsay, *Berthe Morisot: Impressionist* (New York: Hudson Hills, 1987).
2. For further information about this and all subsequent biographical material, see Anne Higonnet, *Berthe Morisot: A Biography* (New York: Harper and Row, 1990).
3. Morisot's mother, Cornélie Thomas, Mme. Tiburce Morisot, wrote Edma in 1867 that Oudinot had come to their studio to pick up canvases for an unidentified exhibition in Versailles. *Correspondance de Berthe Morisot,* ed. Denis Rouart (Paris: Quatre-Chemins Editart, 1950), p. 15; hereafter cited as *Correspondance*).
4. *Correspondance,* p. 16.

5. *Explication des ouvrages de peinture, sculpture, architecture, gravure et lithographie des artistes vivants* (Bordeaux: Société des Amis des Arts de Bordeaux, 1867), nos. 414, 415, 416, 417. Thanks to Daniel J. Sherman for this reference.

6. On Cadart and other dealers in Impressionist paintings, see Anne Distel, *Collectionneurs impressionnistes* (Paris: Réunion des Musées Nationaux, 1989).

7. *Correspondance,* p. 16.

8. Ibid., pp. 17–18.

9. In 1882, for instance, Eugène Manet wrote Morisot that Portier had sold a pastel for 300 francs. *Correspondance,* p. 112.

10. *Berthe Morisot,* exh. cat. (Paris: Durand-Ruel, 1896).

11. Monique Angoulvent, *Berthe Morisot* (Paris: Morancé, 1933), p. 39.

12. *Correspondance,* p. 90.

13. Ibid., p. 92.

14. Ibid., p. 89.

15. Berthe Morisot to an unnamed dealer, between 1882 and 1884, cited in *Autographes,* sales cat. (Paris: G. Morssen, 1975), n.p.

16. *Correspondance,* p. 16.

17. Ibid., p. 38.

18. Manuscript, private collection.

19. Manuscript, private collection.

20. Emile Cardon, "L'exposition des révoltés," *La Presse,* 39 (April 29, 1874): 3.

21. Ernest d'Hervilly, "L'exposition du boulevard des Capucines," *Le Rappel,* no. 1512 (April 17, 1874): 2.

22. Marc de Montifaud, "Salon de 1877," *L'Artiste,* 48, no. 1 (May 1, 1877): 340.

23. Higonnet, *Berthe Morisot,* pp. 179–180.

24. *Correspondance,* p. 158.

25. Stéphane Mallarmé, [1896] *Oeuvres complètes* (Paris: Gallimard, 1961), p. 533.

26. Cassatt's work is described in Chapter 7. Puvis finished his version, a part of a mural called *Inter Artes et Naturam,* for the Rouen municipal fine arts museum, by 1890. The Puvis and Cassatt figures resemble each other quite closely.

27. *Correspondance,* p. 161.

28. Angoulvent, *Berthe Morisot,* p. 90.

29. *Berthe Morisot,* exh. cat. (Paris: Galerie Hopkins-Thomas, 1987), n.p., cat. entry 41.

30. *Correspondance,* p. 172.

31. Ibid., p. 156.

32. Manuscript, private collection.

33. Théodore Duret, *Histoire des peintres impressionnistes* (Paris: Floury, 1906), pp. 165–167.

34. Angoulvent, *Berthe Morisot,* p. 112.

35. Jean-Paul Bouillon, "Sociétés d'artistes et institutions officielles dans la seconde moitié du XIXe siècle," *Romantisme,* no. 54 (1986): 88–113.

36. Camille Pissarro, *Lettres à Lucien,* ed. Lucien Pissarro and John Rewald (Paris: Albin Michel, 1950), p. 371, n. 6.

37. Manuscript, private collection.

38. Higonnet, *Berthe Morisot,* p. 88.

39. Angoulvent, *Berthe Morisot,* p. 39.

40. *Correspondance,* p. 90.

41. Manuscript, private collection.

42. *Cent ans d'impressionnisme, 1874–1974: Hommage à Paul Durand-Ruel* (Paris: Durand-Ruel, 1974), n.p.

43. Stuckey, Scott, and Lindsay, *Berthe Morisot,* p. 180.

44. Durand-Ruel Livres du Stock, Durand-Ruel Brouillard.

45. Durand-Ruel records for 1896.

46. Notebook, c. 1888, in *Berthe Morisot,* exh. cat. (Vevey: Musée Jenisch, 1961), p. 54.

47. *Correspondance,* p. 92.

48. Ibid., pp. 103–110.

49. For example, she hung portraits of Julie in her own bedroom. Rosamond Bernier, "Dans la lumière impressionniste," interview with Julie Manet, *L'Oeil,* no. 53 (May 1959): 42.

50. Stuckey, Scott, and Lindsay, *Berthe Morisot,* pp. 184–185.

51. Arsène Alexandre, "L'oeuvre de Mme Berthe Morisot," *Le Figaro* (March 6, 1896), p. 5.

52. Louise Chandler Moulton, "Paris and Pictures," in *Lazy Tours* (London, New York, and Melbourne: Ward, Lock, and Co., 1896), p. 175.

53. *Exposition des arts de la femme,* exh. cat. (Paris: Warmont, 1892).

54. Charles Bigot, "Beaux Arts," *La Revue Politique et Littéraire* (March 4, 1882), pp. 280–282.

55. Ernest Hoschedé, "Les femmes artistes," *L'Art de la Mode,* 2 (April 1881): 55–59.

56. Consuelo, "Chronique parisienne," *La Grande Dame,* 3, no. 28 (April 1895): 108.

57. Théodore de Wyzéwa, "Mme Berthe Morizot," *L'Art dans les Deux Mondes,* no. 19 (March 28, 1891): 224.

58. Pissarro, *Lettres à Lucien,* p. 371.

59. André Mellerio, "L'art moderne: Berthe Morisot (Madame Eugène Manet). Exposition de son oeuvre, chez Durand-Ruel," *La Revue Artistique,* 2 (April 1896): 78.

60. André Mellerio, *L'exposition de 1900 et l'impressionnisme* (Paris: Floury, 1900), p. 6.

61. Louis Rouart, *Berthe Morisot* (Paris: Plon, 1941), p. 46.

62. Private archives.

63. On collectors of Impressionism, see Distel, *Collectioneurs impressionnistes.*

64. Wildenstein exhibition catalogue archives.

65. Paul Jamot, "La *dame aux éventails* de Manet et le *Berceau* de Berthe Morisot," *Bulletin des Musées de France,* 2, no. 8 (August 1930): 158.

66. Morisot files, Documentation du Musée d'Orsay.

67. Arts Club of Chicago, *Berthe Morisot,* exh. cat. (Chicago: 1943).

68. Ordrupgaardsamlingen archives, incomplete before 1918.

69. Brooklyn Museum archives.

70. Stéphane Mallarmé, "The Impressionists and Edouard Manet," *Art Monthly Review,* 1, no. 9 (September 1876), in *The New Painting: Impressionism, 1874–1886,* exh. cat. (San Francisco: Fine Arts Museums, 1986), p. 33.

71. Stéphane Mallarmé, "Berthe Morisot," in *Berthe Morisot,* exh. cat. (Paris: Durand-Ruel, 1896), p. 16, reprinted in Mallarmé, *Oeuvres complètes,* p. 537. On Mallarmé's art criticism, see Lloyd Austin, "Mallarmé critique d'art," in *The Artist and the Writer in France: Essays in Honour of Jean Seznec,* ed. Francis Haskell, Anthony Levi, and Robert Shackleton (Oxford: Clarendon Press, 1974), pp. 153–162.

72. Félix Fénéon, "VIIIe exposition impressionniste," *La Vogue* (June 7 and 15, 1886), in *Fénéon: Oeuvres* (Paris: Gallimard, 1948), p. 77.

73. Gustave Geffroy, preface, *Exposition de tableaux pastels et dessins par Berthe Morisot,* exh. cat. (Paris: Boussod Valadon, 1892), in Geffroy, *La vie artistique,* 3d ser. (Paris: Dentu, 1892–1895), p. 267.

74. Julie Manet, *Journal* (Paris: Klincksieck, 1979), p. 93. This edition of Julie Manet's journal is the most complete.

75. Madeleine Benoust, *Quelques femmes peintres* (Paris: Stock, 1936), p. 26.

76. Théodore Duret, *Les peintres impressionnistes* (Paris: Heymann et Perois, 1878), p. 29.

77. Anonymous, review of the 1886 Impressionist exhibition, *The Bat* (May 25, 1886), in *Impressionists in England: The Critical Reception,* ed. Kate Flint (London: Routledge and Kegan Paul, 1984), p. 70.

78. De Wyzéwa, "Mme Berthe Morizot," p. 223. What follows the passage cited is worth recording in order to understand the logic by which other women painters were judged less feminine than Morisot.

　　　"Cette vision artistique, ni la Rosalba, ni Mme Vigée-Lebrun n'ont su, malheureusement, la traduire avec art: du moins elles ont eu le mérite de la

respecter et de ne point la tenir pour indigne d'être traduite. La plupart des autres femmes peintres, au contraire, paraissent n'avoir eu que du mépris pour leur vision de femmes: elles ont tout fait pour l'effacer de leurs yeux, et si leurs oeuvres ont toujours l'air d'avoir été peintes par elles, on dirait toujours que ce sont leurs maris qui se sont chargés d'en voir les sujets … Plusieurs sont même parvenues à s'assimiler très heureusement nos habitudes de vision: elles savent à merveille tous les secrets du dessin et de la couleur; et on serait tenté de les considérer commes des artistes, n'était-ce une facheuse impression d'artifice et de mensonge qu'on éprouve toujours devant leur peinture. Quelque chose y sonne faux, quoi qu'elles fassent. On sent qu'il ne leur est pas naturel de voir le monde tel qu'elles le peignent, et qu'elles ont mis leur très habile main au service des yeux d'autrui."

79. Joris Karl Huysmans, appendix, *L'art moderne* (Paris: Charpentier, 1883), p. 288.

80. "Ici, que s'évanouissent, dispersant une caresse radieuse, idyllique, fine, poudroyante, diaprée, comme en ma mémoire, les tableaux, reste leur armature, maint superbe dessin, pas de moindre instruction, pour attester une science dans la volontaire griffe, couleurs à part … la Critique, attendrie pour quelque chose de moins péremptoire que l'entourage et d'élyséennement savoureux: erreur, une acuité interdisant ce bouquet, déconcertait la bienveillance. Attendu, il importe, que la fascination dont on aimerait profiter, superficiellement et à travers de la présomption, ne s'opère qu'à des conditions intègres et même pour le passant hostiles; comme regret. Toute maîtrise jette le froid: ou la poudre fragile du coloris se défend par une vitre, divination pour certains." Mallarmé, "Berthe Morisot" [1896], pp. 13, 10, in *Oeuvres complètes,* pp. 536, 535.

3. Amateur Pictures

1. For other approaches to what critics meant by Morisot's femininity, see Kathleen Adler and Tamar Garb's introduction to *Berthe Morisot: The Correspondence with Family and Friends,* ed. Denis Rouart, tr. Betty Hubbard (Ithaca: Cornell University Press, 1987); Anne Higonnet, "Writing the Gender of the Image: Art Criticism in Late Nineteenth-Century France," *Genders,* no. 6 (Fall 1989): 60–73; Leila Kinney, "Morisot," *Art Journal* (Fall 1988): 236–241; Suzanne Lindsay, "Berthe Morisot and the Poets: The Visual Language of Women," *Helicon Nine,* no. 19 (Summer 1988): 8–17.

2. The only essay on the subject is Anne Higonnet, "Secluded Vision: Images of Feminine Experience in Nineteenth-Century Europe," *Radical History Re-*

view, no. 38 (Spring 1987): 16–36. In writing this article, I was influenced by Carroll Smith-Rosenberg, "The Female World of Love and Ritual: Relations between Women in Nineteenth-Century America," *Signs,* 1, no. 1 (Autumn 1975): 1–29; and Carol Gilligan, *In a Different Voice* (Cambridge: Harvard University Press, 1982).

3. English and American collections and publishers preserve more amateur work. See J. P. M. Brenan, Anthony Huxley, and Brenda Moon, *A Vision of Eden: The Life and Work of Marianne North* (New York: Holt, Rinehart and Winston, 1980); Betty Bright-Low and Jacqueline Hinsley, *Sophie du Pont, A Young Lady in America: Sketches, Diaries, and Letters, 1823–1833* (New York: Harry N. Abrams, 1987); Stefan Buczacki, *Creating a Victorian Flower Garden: Original Flower Paintings by Alice Drummond-Hay* (New York: Weidenfeld and Nicolson, 1988); Caroline Davidson, *Women's Worlds: The Art and Life of Mary Ellen Best, 1809–1891* (New York: Crown, 1985); Mariamna Davydoff, *Memoirs of a Russian Lady: Drawings and Tales of Life before the Revolution* (London and New York: Abrams, 1986); Robert Fairley, ed., *Jemima: The Paintings and Memoirs of a Victorian Lady* (North Pomfret, Vt.: Trafalgar Square Publishing, 1989); Flora Fraser, ed., *Maud: The Diaries of Maud Berkeley,* intro. Elizabeth Longford (London: Secker and Warburg, 1985); Marina Warner, *Queen Victoria's Sketchbooks* (New York: Crown Publishers, 1979).

4. A great deal of work has been done on the theme of the artist in nineteenth-century literature. Although these discussions of that theme do not set out to cover amateur art, they sometimes include it indirectly. One pertinent theme they trace is the professional male artist contrasted to the amateur female artist; another is the female artist's accession to professional status and the difficulties she encounters along the way. See Maurice Beebe, *Ivory Towers and Sacred Founts: The Artist as Hero in Fiction from Goethe to Joyce* (New York: New York University Press, 1964); R. P. Blackmur, "The Artist as Hero," in *The Hero in Literature,* ed. Victor Brombert, (Greenwich, Conn.: Fawcett Publications, 1969), pp. 233–238; Van Wyck Brooks, "The Hero as Artist," *Sketches in Criticism* (New York: E. P. Dutton, 1932), pp. 93–99; Theodore Robert Bowie, *The Painter in French Fiction: A Critical Essay* (Chapel Hill: University of North Carolina Press, 1950); Sister Mary Joanna Fink, "The Concept of the Artist and Creative Genius in American Naturalistic Fiction" (Ph.D. diss., University of Notre Dame, 1965); Gerald Jay Goldberg, "The Artist-Novel in Transition," *English Fiction in Transition,* 4, no. 3 (1961): 12–27; Bo Jeffares, *The Artist in Nineteenth-Century Fiction* (Gerrard's Cross: Colin Smythe, 1979); Maurice Z. Shroder, *Icarus: The Image of the Artist in French Romanticism,* Harvard Studies in Romance Languages, vol. 27 (Cambridge:

Harvard University Press, 1961); Susan Siefert, *The Dilemma of the Talented Heroine* (St. Alban's, Vt.: Eden Press, 1977); Grace Stewart, *A New Mythos: The Novel of the Artist as Heroine, 1877–1977* (St. Alban's: Eden Press, 1979); James M. Wells, "The Artist in the English Novel, 1850–1919," *Philological Studies,* 4 (September 1943): 77–80.

5. Manuscript, private collection.

6. On the English case, see Michael Clarke, *The Tempting Prospect: A Social History of English Watercolours* (London: British Museum Publications, 1981). "The genteel nature of drawing as a leisure activity rapidly led to it becoming largely the prerogative of female pupils" (p. 97); "It is generally true that amateurs belonged to the aristocratic and land-owning classes, and the majority were young ladies for whom an ability to draw was viewed as a social achievement and improved the prospects of marriage" (p. 104). His evidence for this includes such sources as contemporary advertisements, a wide variety of biographical material, and statements by male artists such as David Cox, who in 1812 ascribed the ascendance of watercolors to "the cultivation of the study of drawing in watercolours, by the enlightened ladies of our time" (p. 97). See also his chapters "Drawing Masters," pp. 90–102, and "Amateurs," pp. 103–122.

7. John Stuart Mill, *The Subjection of Women* (London: Longmans, Green and Co., 1909 [1869]), p. 100.

8. See Edgar Munhall, *Ingres and the Comtesse d'Haussonville* (New York: Frick Collection, 1985).

9. Caroline Brame, *Le journal intime de Caroline B,* ed. Michelle Perrot and Georges Ribeill (Paris: Montalba, 1985).

10. Geneviève Bréton, *Journal, 1867–1871* (Paris: Ramsay, 1985).

11. Bright-Low and Hinsley, *Sophie du Pont,* p. 189.

12. Ibid., p. 191.

13. Private archives.

14. Hippolyte Auger, *La femme du monde et la femme artiste,* 2 vols. (Paris: Ambroise Dupont, 1837), I, 211–212.

15. Mme. la Baronne Aloïse de Carlowitz, *Le pair de France, ou, Le divorce* (Paris: Charles Lachapelle, 1835), pp. 64–65.

16. Mme. B. Monborne, *Une victime* (Paris: Mouillefarine, 1834), p. 104.

17. Ibid., pp. 126–127.

18. George Sand, *Histoire de ma vie* (Paris: Stock, 1985 [1855]), pp. 271–273.

19. Jean Tulard, *Nouvelle histoire de Paris: Le Consulat et l'Empire, 1800–1815* (Paris: Hachette, 1970), n.p.

20. Ibid., n.p.

21. This evocative name designates a common type of mirror. About six feet high, it could be tilted within its heavy frame and was used in dressing rooms. A psyché appears in several of Morisot's paintings.

22. The common idea that amateur women were mainly flower and fruit painters is a myth. Some women specialized professionally in botanical illustration. A few amateurs also specialized in flower painting. But these tend to be the exceptions that prove the rule. Often their work sprang from private motivations and could be used, even outside family circles, to recreate home-like situations. Marianne North (1830–1890), for instance, an eminent amateur botanical painter, took up flower painting to console herself after the death of her father, whose constant companion she had been; when she donated her paintings to Kew Gardens, she requested they be assembled into an environment she would design as a refuge for visitors to the gardens, complete with a live-in caretaker couple to serve tea and light refreshments. Brenan, Huxley, and Moon, *A Vision of Eden.*

The case of Scottish artist Jemima Wedderburn Blackburn shows how, in the generation just preceding Morisot's, an amateur iconography persisted despite professional experience and specialization. Before, during, and after her career as a professional animal and ornithological illustrator, Blackburn produced a large body of typical amateur work. See Fairlie, *Jemima.* Blackburn's case indicates a mid-nineteenth-century transitional strategy in which women painted in an amateur mode but became professionals in minor art forms.

A peer of Morisot's, Marie Quiveron Bracquemond, was told by Ingres to stick to genre and flower painting. She retorted: "I wish to work at painting, not to paint flowers, but to express the feelings that art inspires in me." Cited in Jean-Paul Bouillon and Elizabeth Kane, "Marie Bracquemond," *Woman's Art Journal,* 5 (Fall 1984/Winter 1985): 22.

23. Charlotte Yeldham, *Women Artists in France and England,* vol. 1 (New York: Garland, 1984), p. 205.

24. Daniel Stern [Marie de Flavigny, comtesse d'Agoult], *Nélida* (Paris: Calmann-Lévy, 1987 [1846]), pp. 72–73.

25. Ibid., pp. 75–76.

26. Sand, *Histoire de ma vie,* pp. 272–273.

27. Charles Baudelaire, "Salon de 1859, IX: Le paysage," in *Oeuvres complètes* (Paris: Gallimard, 1961). For other critical reactions to Hugo's drawings, see Pierre Georgel, *Dessins de Victor Hugo,* exh. cat. (Rouen: Musée Victor Hugo Villequier, 1971; Paris: Maison de Victor Hugo, 1972). See also Pierre Georgel, "'Le bonhomme est charmant . . .': Victor Hugo et les dessins de ses enfants," *Gazette des Beaux-Arts* (January–February 1988), pp. 55–62.

28. In many women's albums or scrapbooks swatches of favorite dresses or of dresses worn on special occasions are similarly used as memory devices.

29. On the origins and definitions of "album" in the Romantic period, see Ségolène Le Men, "Quelques définitions romantiques de l'album," *Art et Metiers du Livre* (January 1987), pp. 40–47.

 While amateur sketching seems to have developed fastest in England, some evidence suggests that albums containing material other than pictures originated in Germany. In 1832 Henry Monnier recounted the origin and intention of the album: "L'origine des albums remonte à une époque fort reculée, les premiers furent composés en Allemagne. Sur le point d'entreprendre un voyage de longue durée, il était d'usage d'envoyer un livre à ses amis, qui devaient recevoir des dessins, des vers, ou de la musique; on y ajoutaient encore des lettres de famille . . . C'était en quelque sorte un livre de coeur, dans lequel se trouvaient rassemblés toutes les affections les plus chères, toutes les amitiés." "La manie des albums," in *Paris ou le livre des cent-et-un,* vol. 5 (Paris: Ladvocat, 1832), pp. 199–200. Victor-Joseph de Jouy proposes either a German or a Russian source. See L'Hermite de la Chaussée d'Antin [Victor-Joseph de Jouy], "Des albums," and "Recherches sur l'album et le chiffonier sentimentale," in *Observations sur les moeurs et usages parisiens au commencement du XIXe siècle,* vol. 1 (Paris: Pillet, 1811), p. 145.

30. De Jouy, *Observations,* p. 149. There are surviving instances of albums by men; the examples I know of do not fit the feminine pattern of size, subject matter, or intention. One telling example is Léon Méhédin's album, preserved in the Bibliothèque Municipale de Rouen. It measures 120 by 60 centimeters and makes an autobiographical case for Méhédin's recognition, in the form of medals or career advancement, by the French state for his contributions to the glory of Napoleon III's regime. The album's contents are all designed to demonstrate the public significance of Méhédin's achievements. See Claire Bustaret, "Autobiographie photographique de Léon Méhédin," *La Recherche Photographique,* no. 1 (October 1986): 7–18.

31. Francis Guichardet, "Les albums," in *Le prisme* (Paris: Curmer, 1841), pp. 51–55.

32. See Pierre Georgel, "L'album de Léopoldine Hugo," *Revue des Sociétés Savantes de Haute-Normandie,* no. 45 (1967): 7–92; Pierre Georgel, *Léopoldine Hugo: Une jeune fille romantique* exh. cat. (Paris: Ville de Paris, Maison de Victor Hugo, 1968.)

 At least one seventeenth-century Dutch precedent survives: the scrapbook of Gesina Ter Borch. See Alison Kettering, "Ter Borch's Studio Estate," *Apollo,* 117, no. 256 (June 1983): 443–451. Gesina, the daughter in a family of professional artists, began assembling a scrapbook in 1660 that contained

newspaper clippings and drawings by various members of her family, including her own watercolors. Of the images by Gesina's hand, Kettering writes: "Gesina preferred to work with a minimum of line on a miniature scale, creating brightly colored figures engaged in some mundane and characteristic activity, or simply posing in an exotic or particularly fetching contemporary costume . . . sources there must have been: tiles, catchpenny prints, engraved series of trades and costumes, song-book illustrations and any number of other examples from popular literature and art. Gesina nearly always depended for a starting-point on two-dimensional models . . . Gesina's notion of art coincided not so much with that of her brothers as with the artistic proclivities of many female amateurs of the time" (p. 446).

33. Emmeline Raymond, "Gronderie conjugale," *La Mode Illustrée,* 12, no. 27 (July 2, 1871): 214.

34. Ibid., p. 215.

35. Sophie du Pont to Henry du Pont, January 12, 1831, in Bright-Low and Hinsley, *Sophie du Pont,* p. 66.

4. Heiress to the Amateur Tradition

1. *Correspondance,* p. 17.

2. Ibid., p. 87.

3. Edmond de Goncourt, *La maison d'un artiste* (Paris: Charpentier, 1881).

4. Griselda Pollock, "Modernity and the Spaces of Femininity," in *Vision and Difference: Femininity, Feminism, and the Histories of Art* (London and New York: Routledge, 1988), p. 62.

5. Having located the house and garden Morisot lived in at this time, I was able to check that the view from the family garden over to the Invalides corresponded to Morisot's image.

6. Violette, *L'art de la toilette chez la femme, bréviaire de la vie élégante* (Paris: Dentu, 1885), pp. 132–133.

7. Julie Manet, *Journal,* p. 33.

8. Caroline Brame (1847–1892), Morisot's exact contemporary and a very average young lady, provides a striking comparison in these respects. Michelle Perrot notes synthetically of Brame's world: "Relations familiales et fréquentations mondaines définissent l'espace de Caroline. Paris, Lille, quelques châteaux plus ou moins campagnards forment les pôles majeurs de déplacements que le chemin de fer ont rendus faciles et réguliers. Deux excursions à l'étranger, en Italie et en Belgique, à Rome et Florence, Bruxelles et Anvers et leurs musées, ouvrent à peine cette aire structurée par les ré-

seaux personnels" (Brame, *Journal,* p. 175). Like Morisot (in Musée Jenisch, *Berthe Morisot,* pp. 48–49), Brame found in Rubens the highest expression of sentiment (p. 106).

9. J. Lobet, *Le nouveau bois de Boulogne et ses alentours* (Paris: Hachette, 1856), pp. 18 and 21.

10. Mary Osborne, *Guide au bois de Boulogne* (Paris: Ghio, 1878), pp. 2–3.

11. Paule Gobillard's unpublished memoirs, private archives.

12. Mme. Emmeline Raymond, *Le secret des parisiennes,* 3d ed. (Paris: Firmin-Didot, 1885), p. 82.

13. Ibid., p. 82.

14. Liselotte, "Comment nous devons orner notre intérieur," *Petit Echo de la Mode,* 23, no. 3 (January 1901): 22.

15. Théodore de Wyzéwa, "Quelques figures de femmes peintres," in *Peintres de jadis et d'aujourd'hui* (Paris: 1903), p. 182.

16. De Wyzéwa, "Mme Berthe Morizot," pp. 223–224.

17. Opinion on Cassatt's adherence to a socially specific vision was more nuanced, but one critic at least firmly identified the feminine significance of her subject matter: "Miss Cassatt nous a montré la femme dans ses vraies fonctions sociales, maîtresse de son intérieur, adonnée aux soins de la maternité." See André Mellerio, preface, *Miss Cassatt,* exh. cat. (Paris: Durand-Ruel, 1893).

18. *Correspondance,* p. 38.

19. *La Mode Illustrée* (February 6, 1870), pp. 44–45.

20. *La Mode Illustrée* (January 9, 1870), pp. 12–13.

21. One reason *déshabillés* appear so little in costume histories is that they were made not by the *couturières* and *couturiers* who dominated clothing-related media but by the more modest *lingères. Déshabillés,* do however, show up prominently in clothing budgets, for example: "La Lingère. Paris 19 août 1869./ 1 costume batiste écrue. 250 f." *Comptes d'un budget parisien—Toilette et mobilier d'une élégante de 1869* (Paris: 1870), p. 21. Note the sum—at a time when working women earned an average of about three francs a day.

22. Violette, *L'art de la toilette,* p. 94.

23. Ibid., p. 94.

24. Bréton, *Journal,* p. 69.

25. Adeline Daumard notes that in wealthy bourgeois homes, following eighteenth-century architectural innovations, the bedroom could function as a fully furnished subsidiary living room for individuals within the family. See *Le parisien chez lui,* exh. cat. (Paris: Musée Carnavalet, 1976).

26. Bernier, "Dans la lumière impressionniste," p. 42.

27. Though they presented femininity as a natural quality, some bourgeois writers nonetheless claimed that their class had perfected nature: "La bourgeoise est peut-être la femme épouse et mère par excellence . . . car c'est elle qui . . . a su prendre chez la femme du peuple le courage et la sensibilité, et chez la grande dame le savoir vivre et les bonnes manières." E. Boursin, *Le livre des femmes au dix-neuvième siècle,* 5th ed. (Paris: Rome, 1865), p. 259. Anne Martin-Fugier in her *La place des bonnes: La domesticité féminine en 1900* shows that magazines geared toward a servant audience proposed a bourgeois definition of femininity despite the impossibility of its attainment: "Se lit ici l'uniformisation des mentalités dans la société autour des valeurs bourgeoises" (Paris: Grasset, 1979, p. 296). As is often the case in this kind of logic, which ascribes the fulfillment of an ideal to a particular social class, the argument could be extended to maintain that bourgeois women, therefore, were the most moral: "C'est parmi elles que l'on rencontre le plus de moralité." Marie Sincère, *La femme au XIXe siècle,* (Paris: Amyot, 1858), p. 90. Inevitably, conservatives ceaselessly lamented the demise of femininity and called on women and feminine art to revive the past: "C'est la femme, l'ange gardien du foyer, l'éducatrice de l'enfant, qui peut le plus faire pour nous rendre le culte de la maison et de l'art familier qu'avaient nos pères." Emile Cardon, *L'art au foyer domestique* (Paris: Renouard, 1884), pp. 94-95.

28. *In the Dining Room, Avenue d'Eylau* (1880); *In the Dining Room* (1886); *The Little Servant* (1886).

29. On the issue of class in Morisot's images of wet nurses, see Linda Nochlin, "Morisot's Wet Nurse: The Construction of Work and Leisure in Impressionist Painting," in Nochlin, *Women, Art and Power and Other Essays* (New York: Harper and Row, 1988), pp. 37-56.

30. Oliphant's *Autobiography* quoted in Elaine Showalter, *A Literature of Their Own* (Princeton: Princeton University Press, 1977), p. 135.

31. Private archives.

32. An exception to this would be the 1893 *Portrait of Jeanne Pontillon,* which was painted in Morisot's bedroom.

Morisot adds a personal twist to the feminine concealment of menial tasks or situations by her reluctance to identify with the theme of needlework. Contemporaries deemed needlework the activity which united women of all classes. See Rozsika Parker, *The Subversive Stitch* (London: Women's Press, 1984). Nathaniel Hawthorne, trying in 1860 to convey the essential femininity of his sculptor-heroine, Miriam, wrote: The slender thread of silk or cotton keeps them united with the small, familiar, gentle interests of life . . . A vast deal of sympathy runs along this electric line, stretching from the

throne to the wicker chair of the humblest seamstress, and keeping high and low in a species of communion with their kindred beings (*The Marble Faun,* New York, Crowell, 1902 [1860], p. 32). But Morisot seems to have agreed with Marie Bashkirtseff, who wrote in her diary: "Je ne comprends pas les femmes qui passent leurs loisirs à tricoter ou à broder les mains occupées et la tête oisive" (August 8, 1884, in Marie Bashkirtseff, *Journal,* Paris: Mazarine, 1980 [1887], p. 144). Morisot's rare depiction of an apparently middle-class woman, *Woman Sewing* (1879), is most definitely catalogued as being of a professional model, the 1883 *Young Woman Sewing in a Garden* may be of a professional model also, while the later *Sewing* (1889), showing Julie and her cousin Alice Gamby sewing together, almost replicates the 1882 *The Balcony,* one of a group of pictures depicting Julie's maid Pasie sewing.

33. Private archives.

34. Degas quotes in unpublished family memoirs, private archives.

35. The simplest way of verifying this is to project the size of Morisot's pictures into contemporary representations of various interiors. Pictures as big as Manet's *Olympia,* let alone Couture's *Romans of the Decadence,* could only hang in professional painting studios or in public buildings. They were just too big. Pictures of interiors show that in upper- and middle-class homes, the biggest pictures, and the Old Master pictures, hung in a picture gallery if the home had one, or in the *grand salon;* large pictures of stately subjects (i.e. religious, historical, and mythological) and large family portraits hung in the dining room. Medium-sized pictures hung in the family living room. Masculine images of military scenes, hunting, and light public entertainment hung in the masculine library, office, or smoking room. Small pictures hung in the parlor, the boudoir, and perhaps the bedroom. Most fashionable for bedrooms were eighteenth-century prints.

36. Camille Mauclair, *The French Impressionists (1860–1900)* (London: Duckworth and Co; New York: E. P. Dutton), pp. 144–146.

37. Hoschedé, "Les femmes artistes," p. 55. Morisot to her sister Edma in 1869 about Edouard Manet: "Il me parle de finir et j'avoue que je ne comprends pas ce que je puis faire" (*Correspondance,* p. 35). Jacques Emile Blanche remembering Marguerite Carré's description of sitting: "Elle ne devait pas être si contente de son ouvrage, puisqu'elle barbouillait et l'effaçait après la séance" (*Propos de peintre,* Paris: Emile-Paul, 1921, p. 77), and his own encounter with Morisot: "Elle efface tout ce qu'elle fait, en ce moment; la peinture à l'huile est trop difficile!" (p. 80). The critic Pierre Berthelot in 1929, for instance: "Plus d'une toile n'a pas été mené à la perfection" ("Expositions—Berthe Morizot: Bernheim Jeune," *Beaux-Arts,* 7, no. 6, June 15, 1929: p. 17).

38. Bashkirtseff, *Journal,* p. 304.

39. Florence Nightingale, *Cassandra* (Old Westbury, N.Y.: Feminist Press, 1979), pp. 43–44.

40. Pollock extends this argument to all the women Impressionists' subjects: "I have previously argued that engagement with the Impressionist group was attractive to some women precisely because subjects dealing with domestic social life hitherto relegated as mere genre painting were legitimized as central topics of the painting practices. On closer examination it is much more significant how little of typical impressionist iconography actually appears in the works made by artists who are women" (*Vision and Difference,* p. 56).

41. "They worked hard to present their writing as an extension of their feminine role, an activity that did not detract from their womanhood, but in some sense augmented it. This generation would not have wanted an office or even 'a room of one's own'; it was essential that the writing be carried out in the home, and that it be only one among the numerous and interruptible household tasks of the true woman." Showalter, *A Literature of Their Own,* p. 85.

42. From Mrs. Oliphant's *Autobiography,* pp. 23–24, quoted in Showalter, *A Literature of Their Own,* p. 85.

43. Gwen John to Mrs. Sampson, 1911, in Cecily Langdale and David Fraser Jenkins, *Gwen John: An Interior Life* (New York: Rizzoli, 1985), p. 12.

44. Paule Bayle, "Eva Gonzalès," *La Renaissance,* 15, no. 6 (June 1932): 111.

45. Katherine Cassatt (senior) to Katherine Cassatt (junior), April 15, 1881, in Mary Cassatt, *Cassatt and Her Circle: Selected Letters,* ed. Nancy Mowll Mathews (New York: Abbeville Press, 1984), p. 159.

46. See Suzanne Lindsay, *Mary Cassatt and Philadelphia.* exh. cat. (Philadelphia: Philadelphia Museum of Art, 1985), pp. 46–48.

47. Manet, *Journal,* p. 84.

48. Ibid., p. 93.

5. Feminine Visual Culture

1. Manuscript, private collection.

2. Sophie du Pont, diary, February 1838, quoted in Low and Hinsley, *Sophie du Pont,* p. 18.

3. Bigot, "Beaux Arts," pp. 280–281.

4. See Elizabeth Ann McCauley, *A. A. E. Disdéri and the Carte-de-Visite* (New Haven: Yale University Press, 1985).

5. See Beatrice Farwell, *French Popular Lithographic Imagery, 1815–1870,* vol. 1 (Chicago and London: Chicago University Press, 1981); Jeff Rosen, "The

Political Economy of Graphic Art Production during the July Monarchy," *Art Journal,* 48, no. 1 (Spring 1989): 40–45.

6. Farwell, *French Popular Lithographic Imagery,* I, 1.

7. Rosen, "The Political Economy of Graphic Art Production," p. 42.

8. Cynthia Leslie White, *Women's Magazines, 1693–1968* (London: Michael Joseph, 1970).

9. See Raymond Gaudriault, *La Gravure de Mode Féminine en France* (Paris: Editions d'Amateur, 1983). Initially fashion plates represented collections of costumes from foreign lands, which were then joined by collections of European, chiefly French, aristocratic fashions. Often sold as separate images, these early fashion plates were also included in almanacs, then during the eighteenth century more frequently in general-interest periodicals, and finally in specialized women's magazines, of which the most eminent at the end of the century was La Mésangère's *Journal des Dames et des Modes.*

10. Gaudriault, *La Gravure de Mode,* p. 64.

11. Honoré de Balzac, "Gavarni," *La Mode, Revue des Modes, Galerie de Moeurs, Album des Salons,* 2d ser., 1 (1830): 20–21.

12. For more on fashion illustration and on the Colin sisters, see Vyvyan Holland, *Hand-Coloured Fashion Plates, 1770–1899* (London: Batsford, 1955); Valerie Steele, *Paris Fashion: A Cultural History* (New York and Oxford: Oxford University Press, 1988).

13. See Gaudriault, *La Gravure de Mode.*

14. Françoise Tétart-Vittu and Piedade Da Silveira, *Dessins de Mode: Jules David 1808–1892 et Son Temps,* exh cat. (Paris: Mairie du VIe arrondissement, 1987), pp. 9–11.

15. Abigail Solomon-Godeau, "The Legs of the Countess," *October,* no. 39 (Winter 1986): 83. See also Rachel Bowlby, *Just Looking: Consumer Culture in Dreiser, Gissing, and Zola* (New York and London: Methuen, 1985), chap. 2, "Commerce and Femininity," pp. 18–34.

16. Solomon-Godeau, "The Legs of the Countess," p. 108.

17. Memoirs of Maurice Leloir, manuscript, private collection.

18. Holland, *Hand-Coloured Fashion Plates,* p. 160.

19. Steele, *Paris Fashion,* pp. 102–111.

20. See Nicolas Green, "Circuits of Production, Circuits of Consumption: The Case of Mid-Nineteenth-Century French Art Dealing," *Art Journal,* 48, no. 1 (Spring 1989): 40–45; Nicolas Green, "Dealing in Temperaments: Economic Transformation of the Artistic Field in France during the Second Half of the Nineteenth Century," *Art History,* no. 10 (1987): 59–78; Cynthia A. White and Harrison C. White, *Canvases and Careers: Institutional Changes in the French*

Painting World (New York: 1965); Linda Whitely, "Art et commerce d'art en France avant l'époque impressionniste," *Romantisme,* no. 4 (1983): 65–75.

21. Philippe Huisman, *Charmes* (Lausanne: International Art Book, 1962), p. 56.

22. Musée Jenisch, *Berthe Morisot,* p. 55.

23. Geneviève Viallefond, *Le peintre Léon Riesener, 1808–1878: Sa vie, son oeuvre, avec des extraits d'un manuscrit inédit de l'artiste—"De David à Berthe Morisot"* (Paris: Editions Albert Morancé, 1955), p. 29.

24. Ibid., pp. 47–54.

25. Ibid., p. 64.

26. Ibid., p. 67.

27. 1885–1886 notebook, in Musée Jenisch, *Berthe Morisot,* pp. 48–49.

28. *Correspondance,* p. 88.

29. See Paul Duro, "The 'Demoiselles à Copier' in the Second Empire," *Woman's Art Journal,* 7, no. 1 (Spring/Summer 1986): 1–7; Theodore Reff, "Copyists in the Louvre, 1850–1870," *Art Bulletin,* 46, no. 4 (December 1964): 552–559.

30. Musée Jenisch, *Berthe Morisot,* pp. 46–53.

31. Manuscript, private collection.

32. Thomas Crow, "Modernism and Mass Culture in the Visual Arts," in *Modernism and Modernity: The Vancouver Conference Papers,* ed. Benjamin Buchloh, Serge Guilbaut, and David Slotkin (Halifax: Press of the Nova Scotia College of Art and Design, 1983), p. 215.

33. See Robert L. Herbert, *Impressionism: Art, Leisure, and Parisian Society* (New Haven: Yale University Press, 1988); Joel Isaacson, "Impressionism and Journalistic Illustration," *Arts,* no. 56 (June 1982): 95–115.

34. Mark Roskill, "Early Impressionism and the Fashion Print," *Burlington Magazine,* no. 112 (1970): 391ff.

35. Tétart-Vittu and Da Silveira, *Dessins de mode,* p. xx.

36. Herbert, *Impressionism,* pp. 33–57.

37. Cited with no reference in Angoulvent, *Berthe Morisot,* p. 36.

38. Notebook, c. 1888, private collection.

39. Documentation du Musée d'Orsay (which contains the former holdings of the Jeu de Paume), "Morisot" files.

6. Painting Women

1. Eva Gonzalès and Marie Quiveron Braquemond also joined the Impressionist circle, and some of their individual pictures of contemporary women resemble some of Cassatt's and Morisot's. But their careers were, unfortu-

nately, too brief and too tentative to be compared fairly with the work of women or men whose styles, subject matter, and artistic attitudes had much longer to evolve. On Gonzalès and Braquemond see Tamar Garb, *Women Impressionists* (Oxford: Phaidon Press, 1986).

2. From the series *Balivernes Parisiennes,* 24 lithographs, published in *Le Charivari,* 1846.

3. See Jean Boggs, Douglas Druick, Henri Loyrette, Michael Pantazzi, and Gary Tinterow, *Degas,* exh. cat. (New York and Ottawa: Metropolitan Museum of Art and National Gallery of Canada, 1988), pp. 130–132.

4. Louis Enault, "L'éventail," *La Grande Dame,* 2, no. 22 (October 1894): 336.

5. Octave Uzanne, *L'éventail* (Paris: Quantin, 1882), p. 11.

6. Ibid., pp. 10–11. The relevant paragraph reads: "Est-il bijou plus coquet que cet Eventail, hochet plus charmant, ornement plus expressif, dans les mains d'une reine de l'esprit telle que vous? Lorsque vous maniez le vôtre dans les coquetteries des réceptions intimes, il devient tour à tour l'interprète de vos sentiments cachés, la baguette magique des surprises féeriques, l'arme défensive des entreprises amoureuses, le paravent des pudeurs soudaines, le sceptre, en un mot, de votre troublante beauté."

7. Ibid., p. 11.

8. Boursin, *Le livre des femmes,* p. 311.

9. Uzanne, *L'éventail,* p. 11.

10. Higonnet, *Berthe Morisot,* p. 159.

11. See Boggs et al., *Degas,* p. 440.

12. See ibid., pp. 318–324, 440.

13. Degas also made a picture, c. 1882, in which Cassatt is chiefly characterized as the wearer of a hat: his *At the Milliner's.* Cassatt may, in addition, have modeled the figure though not the face for another of Degas's milliner pictures, but the identification is uncertain. See Boggs et al., *Degas,* pp. 395–397.

14. Nancy Mowll Mathews and Barbara Stern Shapiro, *Mary Cassatt: The Color Prints,* exh. cat. (New York: Harry N. Abrams, 1989), p. 61.

15. Some scholars have identified the images as tarot cards. See Boggs et al., *Degas,* pp. 442–443. Not only, however, are the images clearly black and white, whereas tarot cards would have been colored, but their format and their proportion of border to image correspond exactly with the ubiquitous *carte-de-visite.*

16. See Boggs et al., *Degas,* pp. 442–443.

17. Juxtaposition: the placement of the masculine side next to the feminine center next to the natural side. Axial alignment: the hands holding flowers one

above the other or the hand holding the flower next to the hand wearing a wedding ring. Visual metaphor: the woman is like an image of nature. Visual metonymy: one view of nature stands for nature as a whole. Visual assonance: one flower is like another flower because they are both pink; one view of nature is like another because they are the same shape. Visual alliteration: A flower in a vase echoes a flower in a hand.

18. The most recent and thorough example is Nancy Mowll Mathews, *Mary Cassatt* (New York: Abrams, 1987).

19. On this painting, see Pollock, *Vision and Difference,* pp. 75–76, and Herbert, *Impressionism,* pp. 99–100.

20. Matthew Rohn, "Berthe Morisot's Two Sisters on a Couch," *Berkshire Review,* no. 21 (Fall 1986): 80–90.

21. Theodore Reff, "Degas and the Literature of His Time," *Burlington Magazine,* 112 (1970): 579; Marc Gerstein, "Impressionist and Post-Impressionist Fans" (Ph.D. diss., Harvard University, 1978), pp. xlii, 5–6, 58; Marc Gerstein, "Degas's Fans," *Art Bulletin,* 44, no. 1 (March 1982): 105–106.

22. John T. Paoletti, "Comments on Rohn," *Berkshire Review,* no. 21 (Fall 1986): 91–94.

23. Huisman, *Charmes,* p. 36.

24. Ibid., p. 38.

25. "L'art c'est le faux!" Ibid.

26. Ibid.

27. Ibid., p. 58.

28. Ibid., p. 56.

29. Pollock writes: "A remarkable feature in the spatial arrangements in paintings by Morisot is the juxtaposition on a single canvas of two spatial systems—or at least of two compartments of space often obviously boundaried by some device such as a balustrade, balcony, veranda or embankment whose presence is underscored by facture . . . What Morisot's balustrades demarcate is not the boundary between public and private but between the spaces of masculinity and of femininity inscribed at the level of both what spaces are open to men and women and what relation a man or a woman has to that space and its occupants" (*Vision and Difference,* p. 62).

30. Emile Zola, *Au bonheur des dames* (Paris: Gallimard, 1980 [1883]), p. 97.

31. Violette, *L'art de la toilette,* p. 239.

32. Boursin, *Le livre des femmes,* p. 315.

33. Baronne Staffe, *Ma femme dans la famille* (Paris: Flammarion, n.d.), p. 5.

34. Violette, *L'art de la toilette,* p. 247.

35. Jacques Emile Blanche, "La grande dame de Passy," *Propos de peintre* (Paris: Emile-Paul, 1921), pp. 77–78.

36. Violette, *L'art de la toilette,* p. 261.

37. Camille Lemonnier, *Propos d'art* (1870), in *Les peintres de la vie* (Paris: Savine, 1888), p. 121.

38. Victor Fournel, *Ce qu'on voit dans les rues de Paris* (Paris: Adolphe Delahays, 1858), p. 387.

7. Mirrored Bodies

1. Vicomte de Bournon-Ginestoux, *Les jeunes femmes, ou, les séductions de la nature et de l'art* (Paris: Blanchard, 1856), pp. 109–110.

2. Comtesse de Gencé, *Le cabinet de toilette d'une honnête femme* (Paris: Pancier, n.d.), pp. 48–49.

3. On the corset and nineteenth-century eroticism, see Valerie Steele, *Fashion and Eroticism* (New York and Oxford: Oxford University Press, 1985), chap. 9.

4. Carla Gottlieb, in her "Picasso's 'Girl before a Mirror'," *Journal of Aesthetics and Art Criticism,* 24, no. 4 (Summer 1966): 509–518, writes of Morisot's *At the Pysché* and the use of mirrors to indicate double meanings: "It is fascinating to compare Picasso's picture in that respect with Berthe Morisot's rendering of a girl who views herself in a similar mirror, from which the painting is called *Devant la psyché* [Gottleib uses a variation on the catalogue raisonné's title]. Living in a world of positivist values, the nineteenth-century artist does not play with the double meaning of the term" (p. 510).

5. William Scott (Stuckey, Scott, and Lindsay, *Berthe Morisot,* pp. 196–197) has recently noted: "Although a close study of Morisot's palette has shown that she used a variety of colors . . . the most significant for Morisot was white. Many of her best works can be described as orchestrations of white tones."

6. Linda Nochlin, "Morisot's Wet Nurse: The Construction of Work and Leisure in Impressionist Painting," in *Women, Art and Power and Other Essays* (New York: Harper and Row, 1988), pp. 50–51.

7. *Correspondance,* p. 128.

8. On the prevalence of this understanding of the nude, see Beatrice Farwell, *Manet and the Nude: A Study in Iconography in the Second Empire* (New York and London: Garland, 1981), esp. chap. 2, "The Nude from Ingres to Courbet."

9. T. J. Clark, *The Painting of Modern Life: Paris in the Art of Manet and His Followers* (London: Thames and Hudson, 1984), p. 132.

10. Carol Armstrong, "Edgar Degas and the Representation of the Female Body," in *The Female Body in Western Culture,* ed. Susan Suleiman (Cambridge: Harvard University Press, 1986), p. 223; Carol Duncan, "Virility and Domination in Early Twentieth-Century Vanguard Painting," in *Feminism and Art History: Questioning the Litany,* ed. Norma Broude and Mary D. Garrard (New York: Harper and Row, 1982), pp. 293–313.

11. See Clark, *The Painting of Modern Life,* pp. 119–131.

12. Even Suzanne Valadon, the exception to every art historical social rule, conformed to this gender rule. Not her lower-class origins, her experience as a model, or her unconventional lifestyle distanced her from art's assumptions sufficiently to paint male nudes. See Rosemary Betterton, "How Do Women Look? The Nude in the Work of Suzanne Valadon," *Feminist Review,* no. 19 (Spring 1985): 3–24; Rozsika Parker and Griselda Pollock, *Old Mistresses* (New York: Pantheon, 1981), pp. 114–133.

13. Peter Gay, *The Bourgeois Experience: Victoria to Freud,* vol. 1, *Education of the Senses* (New York and Oxford: Oxford University Press, 1984).

14. *Correspondance,* p. 156.

15. Bréton, *Journal,* p. 75.

16. Notebook, c. 1890–91, private collection.

17. Manuscript, private collection. Eunice Lipton has suggested that Boucher's images of the female nude have special appeal to women's sexuality. See Eunice Lipton, "Women, Pleasure and Painting (e.g., Boucher)," *Genders,* no. 7 (Spring 1990): 69–86.

18. Edma Morisot Pontillon recognized the connection between her sister Berthe's copies after men's nudes and her own supreme attempt at the genre in her choice of images to copy. According to Morisot's early biographer, Angoulvent (counseled by Morisot's daughter, Julie), Edma copied five of Morisot's paintings from the 1890s in pastel; of these five, two were copies after Boucher and one was *At the Psyche* (Angoulvent, *Berthe Morisot,* p. 27).

19. Jenijoy LaBelle, *Herself Beheld: The Literature of the Looking Glass* (Ithaca and New York: Cornell University Press, 1988).

20. Raymond, *Le secret des parisiennes,* p. 132.

21. Alphonse Karr, *Les femmes* (Paris: Michel Lévy, 1853), p. 64.

22. Comtesse de Gencé, *Le cabinet de toilette,* pp. 49–50.

23. Jean Dolent, *Le livre d'art des femmes* (Paris: A. Lemerre, 1887), p. 189.

24. On Cassatt's prints, see Nancy Mowll Mathews and Barbara Stern Shapiro, *Mary Cassatt: The Color Prints,* exh. cat. (Boston: Museum of Fine Arts, 1989). The authors discuss Morisot's and Cassatt's collaboration on p. 36.

25. Eugène Manet wrote to Morisot in 1882: "J'ai rencontré hier à l'exposition

Mlle Cassatt qui me semble vouloir entretenir des relations plus intimes. Elle a demandé de faire le portrait de Bibi et le vôtre. Je lui ai dit volontiers à charge de réciprocité" (*Correspondance,* p. 111). Unfortunately these projects were not carried out. Janine Bailly-Herzberg suspects it was Cassatt who initiated Morisot into the techniques of etching, which Morisot practiced briefly around 1888 and 1889. "Les estampes de Berthe Morisot," *Gazette des Beaux-Arts,* 6th ser., no. 93 (May-June 1979): 215–226. Nancy Mowll Mathews has published Cassatt's four extant letters to Morisot and dates them from 1879 to 1890. Mary Cassatt, *Cassatt and Her Circle: Selected Letters,* ed. Nancy Mowll Mathews (New York: Abbeville Press, 1984), pp. 149, 150, 214, 216.

26. See Alicia Faxon, "Painter and Patron: Collaboration of Mary Cassatt and Louisine Havemeyer," *Woman's Art Journal,* no. 2 (Fall 1982/Winter 1983): 15–20; Frances Weitzenhoffer, *The Havemeyers: Impressionism Comes to America* (New York: Harry N. Abrams, 1986).

27. *Correspondance,* p. 169.

28. Cassatt, *Selected Letters,* p. 229.

29. Ibid., p. 149.

30. Bernier, "Dans la lumière impressionniste," p. 41.

31. Cassatt, *Selected Letters,* p. 335.

32. Mary Brunton, *Self-Control* (London: Bruce, 1844 [1811]), p. 58.

33. On the theoretical possibilities of this strategy, see Mary Ann Doane, "Film and the Masquerade: Theorising the Female Spectator," *Screen,* no. 23 (1982): 74–87. As she concludes: "The effectivity of masquerade lies precisely in its potential to manufacture distance from the image, to generate a problematic within which the image is manipulable, producible, and readable by a woman" (p. 87).

34. See Stuckey, Scott, and Lindsay, *Berthe Morisot,* pp. 212-213.

35. On Cassatt and Japanese prints, see Mathews and Shapiro, *Mary Cassatt: The Color Prints,* pp. 62–67.

36. Cassatt, *Selected Letters,* p. 214.

37. My thanks to Anne de Coursey Clapp for this comparison.

38. Michel Melot, "Questions au Japonisme," in *Japonisme in Art: An International Symposium,* ed. Yamada Chisaburo (Tokyo: Committee for the Year 2001, 1980), pp. 239–260.

39. Notebook, c. 1890–91, private collection, partly published, in slightly variant form, in Musée Jenisch, *Berthe Morisot,* p. 55. In light of Morisot's reference to *Romeo and Juliet* in the context of women's role playing, one wonders whether she knew Gavarni's lithograph on the same theme (Fig. 40), given

that she had copied from her father's collection of Gavarni prints in her youth.

40. My thanks to Miranda Marvin for this comparison.

8. An Image of One's Own

1. Louis Marin suggests in his comparative analysis of Poussin's self-portraits: "Chercher d'abord, dans ce qui est vu, et non dans un dictionnaire ou un code des symboles, des significations qui ne sont pas immédiatement d'ordre iconographique: celles que présentent les figures en elles-mêmes et leur *collocatio,* dans le tableau et d'un tableau à l'autre; le dispositif sémantique de la figure du peintre et ses effets de sens. Variations." "Variations sur un portrait absent: Les autoportraits de Poussin," *Corps Ecrits,* 5, *L'autoportrait* (1983), p. 95.

2. *The Balcony* (1868–69); *Berthe Morisot with a Muff* (1868–69); *Berthe Morisot in Profile* (1869); *Repose* (1869–70); *Berthe Morisot Veiled* (1872); *Berthe Morisot with a Pink Shoe* (1872); *Berthe Morisot with a Fan* (1872); *Berthe Morisot with a Bouquet of Violets* (1872, of which Manet also made a lithograph in two states); *Berthe Morisot Reclining* (1873); *Berthe Morisot Seen in Three-Quarters* (1874, an oil and a watercolor); *Berthe Morisot with a Mourning Hat* (1874).

3. *Correspondance,* p. 27.

4. Daniel Arasse writes: "Car si l'autoportrait est bien le 'portrait, par lui-même, d'un artiste' *(Grand Larousse encyclopédique),* si l'autoportrait est donc bien, d'une manière très générale, cette image fantasmatique où se recouvrirait exactement le sujet et son moi, si, effectivement et indubitablement, tout autoportrait implique, annonce et résout l'étrangeté de ce reflet où moi est un autre qui suis lui, si finalement l'autoportrait suppose bien cette intimité extrême pourtant donnée en public, prostituée sur le devant de son canevas, cette prostitution ne se fait pas hors de certaines règles, d'un code, d'une situation historiquement précisée, hors des conditions en un mot où il était possible, loisible et pensable de se peindre à tel moment et pour tel public et de s'en faire reconnaître.

 "L'autoportrait à une histoire. On y saisit l'instance sociale de l'autre déjà là, ce regard étranger qui travaille, dès l'entrée, l'image-de-soi et en structure l'apparence." "'La prudence' de Titien, ou l'autoportrait glissé à la rive de la figure," *Corps Ecrit,* 5, *L'autoportrait* (1983), p. 112.

5. Manet's portraits of Morisot might seem to be emotional or even sexual tributes, emphasizing as they do the feminine accoutrements of flirtation, especially given the *Bouquet of Violets* (Fig. 46), which unites the fan, the *"billet"*

inscribed "A Mlle Berthe," and the bouquet of violets, then considered a to-
ken of love. "Bouquet d'amour, bouquet d'un sou, qui se donne en cachette
et qui se fane dans un corsage," (Boursin, *Le livre des femmes*, p. 316). "La
violette est de toutes les fleurs la plus populaire et, à coup sûr, la plus intér-
essante. Elle signifie: modestie, vertu, amour discret" (Edouard Dangin, "La
Marchande de violettes," *Le Moniteur de la Mode*, no. 48, November 1872:
568). In an age when the most normal form of masculine appreciation of a
woman was flirtation, it would be more appropriate, I think, to see Manet's
portraits as transpositions in painting and in flirtatious symbols of an admi-
ration he did not know how to express otherwise.

We do know that both Manet and Morisot cherished these portraits all
their lives, as did Morisot's daughter, without any qualms about the compat-
ibility of the portraits with Manet's and Morisot's respective marital attach-
ments. *The Balcony* hung next to *Olympia* in Manet's studio until his death.
Manet, 1832–1883, exh. cat. (Paris: Réunion des Musées Nationaux, 1983),
p. 307. *Berthe Morisot with a Mourning Hat* was given to Dr. de Bellio as thanks
for his care of Manet during his last illness and eventually passed into De-
gas's collection. Manet's estate inventory listed seven Morisot portraits. *The
Balcony* was sold at Manet's estate sale to Caillebotte; *Berthe Morisot with a
Muff, Berthe Morisot in Profile, Berthe Morisot Veiled*, and *Berthe Morisot with a
Pink Shoe* were also sold at the estate sale. So it would seem that it was at
Manet's death that Morisot took possession of *Berthe Morisot Reclining* and
Berthe Morisot Seen in Three-Quarters. She tried to buy back *Repose* at the 1894
auction of Duret's collection, unsuccessfully, but did manage to acquire
Berthe Morisot with a Bouquet of Violets, using Durand-Ruel as her intermedi-
ary. Her daughter Julie later bought *Berthe Morisot in Profile*.

6. From Etienne Moreau-Nélaton, *Manet raconté par lui-même*, vol. 1 (Paris: H.
 Laurens, 1926), p. 103.

7. Marius Vachon, *La femme dans l'art, peinture, sculpture* (Paris: Rouan, 1893),
 p. 608.

8. Bigot, "Beaux Arts," pp. 280–281.

9. From Bibliothèque Nationale, Département des Manuscrits, Nouvelles Ac-
 quisitions Françaises, 10316, ff. 317–318, in Emile Zola, *L'oeuvre*, dossier
 (Paris: Garnier-Flammarion, 1974), p.425.

10. Catherine Parr, *L'usage et le bon ton de nos jours* (Paris: Rueff, 1892), pp.
 259–263.

11. Dinah Maria Mulock Craik, *Olive* (New York: Harper, 1857).

12. Edmond and Jules de Goncourt, *Renée Mauperin* (Paris: Fayard, 1875 [1864]),
 pp. 7, 10.

13. Friedrich von Schlegel, *Lucinde* (Berlin: Heinrich Frolich, 1799).
14. Baronne Staffe, *Ma femme dans la famille: La fille—L'épouse—La mère* (Paris: Flammarion, n.d.), p. 339.
15. Boursin, *Le livre des femmes,* p. 41.
16. Manet, *Journal,* p. 71.
17. Mallarmé, "Berthe Morisot," in *Oeuvres complètes,* p. 535.
18. Manet, *Journal,* p. 88.
19. Ibid.
20. Ibid.

9. A Mother Pictures Her Daughter

1. In about twenty-five pictures the sitter cannot be securely identified but is probably Julie.
2. Louise d'Argencourt, *William Bouguereau,* exh. cat. (Montreal: Museum of Fine Arts, 1984).
3. Gabriel Séailles, "Salon de 1888," *L'Illustration* (April 28, 1888), n.p.
4. "Salon de 1885," *L'Illustration,* no. 2200 (April 25, 1885): 274.
5. Séailles, "Salon de 1888," n.p.
6. See Adèle M. Holcomb, "Anna Jameson: The First Professional English Art Historian," *Art History,* 6, no. 2 (June 1983): 171–187.
7. Anna Jameson, *Legends of the Madonna, As Represented in the Fine Arts: Forming the Third Series of Sacred and Legendary Art,* 2d ed. (London: Longman, Brown, Green, Longman and Roberts, 1857), p. 58.
8. "Salon de 1885," p. 270.
9. For a summary of these issues, see *A History of Private Life,* vol. 4, *From the Fires of the Revolution to the Great War,* ed. Michelle Perrot, trans. Arthur Goldhammer (Cambridge: Harvard University Press, 1990).
10. See Nancy Chodorow, *The Reproduction of Mothering: Psychoanalysis and the Sociology of Gender* (Berkeley: University of California Press, 1978); and Carol Gilligan, *In a Different Voice* (Cambridge: Harvard University Press, 1982).
11. Nancy Chodorow, "Mothering, Object-Relations, and the Female Oedipal Configuration," *Feminist Studies,* 4, no. 1 (February 1978): 146.
12. For recapitulations of these issues and for bibliographies, see Jessica Benjamin, "A Desire of One's Own: Psychoanalytic Feminism and Intersubjective Space," in *Feminist Studies: Critical Studies,* ed. Theresa de Lauretis (Bloomington: Indiana University Press, 1986), pp. 78–101; Marianne Hirsch, "Mothers and Daughters," *Signs,* 7, no. 1 (1981): 200–222.

13. *Between Mothers and Daughters: Stories across a Generation,* ed. Susan Koppelman (Old Westbury, N.Y.: Feminist Press, 1985).

14. Susan Gubar, "The Birth of the Artist as Heroine: (Re)production, the Kunstlerroman Tradition, and the Fiction of Katherine Mansfield," in *The Representation of Women in Fiction,* ed. Carolyn Heilbrun and Margaret R. Higonnet, Selected Papers from the English Institute, 1981, New Series, no. 7 (Baltimore and London: Johns Hopkins University Press, 1983), pp. 19–59.

15. Sandra Gilbert, "Horror's Twin: Mary Shelley's Monstrous Eve," *Feminist Studies,* 4, no. 2 (June 1978): 48–73.

16. Margaret Homans, *Bearing the Word* (Chicago: Chicago University Press, 1986).

17. Sandra Gilbert and Susan Gubar, *The Madwoman in the Attic: The Woman Writer and the Nineteenth-Century Literary Imagination* (New Haven: Yale University Press, 1979).

18. On this theme in eighteenth- and early nineteenth-century novels, see April Alliston, *Epistles to the Ladies* (Ph.D. diss., Yale University, May 1988).

19. Marianne Hirsch, *The Mother/Daughter Plot: Narrative, Psychoanalysis, Feminism* (Bloomington and Indianapolis: Indiana University Press, 1989), p. 48.

20. Homans, *Bearing the Word,* pp. 88–89.

21. Beatrice Didier, *L'écriture-femme* (Paris: Presses Universitaires de France, 1981).

22. Margaret Forster. *Elizabeth Barrett Browning: A Biography* (London: Chatto and Windus, 1988).

23. Hirsch, *The Mother/Daughter Plot,* p. 43. Peter Brooks has shown that men's plots also share this concern; see his *Reading for the Plot: Design and Intention in Narrative* (New York: Alfred A. Knopf, 1984). In men's works, however, maternity and female genealogy are obviously not the issues, and men worry more about the deviations of inheritance and the uses to which they put their legacies than about whether they have a right to any inheritance at all.

24. [Julie Manet Rouart], "All the Great Ones Painted Us: Renoir, Degas, Manet, and Mother," *Life,* 54, no. 19 (May 10, 1963): 53.

25. Louis Rouart, "Berthe Morisot," *Art et Décoration* (May 1908), p. 171.

26. Paul Valéry, "Au sujet de Berthe Morisot," in *Berthe Morisot,* exh. cat. (Paris: Musée de l'Orangerie, 1941), pp. v-vi.

27. Linda Nochlin, "Morisot's Wet Nurse: The Construction of Work and Leisure in Impressionist Painting," in *Women, Art and Power and Other Essays* (New York: Harper and Row, 1988), pp. 37–56.

28. Conversation with Agathe Rouart-Valéry.

29. Nicole Savy, *Les petites filles modernes,* Dossiers du Musée d'Orsay, no. 33 (Paris: Editions de la Réunion des Musées Nationaux, 1989).

30. Julie Manet, *Journal,* p. 84.

31. Neil Hertz, "Freud and the Sandman," in *The End of the Line* (New York: Columbia University Press, 1985), pp. 97–121.

32. Ibid., p. 121.

33. Ibid., p. 112.

34. On the idea that maternity induces a diffuse specular economy, see Julia Kristeva, "Héréthique de l'amour," *Tel Quel,* no. 74 (Winter 1977): 30–49, and another version of the same essay, retitled "Stabat Mater," in *Histoires d'amour* (Paris: Denoël, 1983), pp. 295–327.

35. Private archives.

36. Stuckey, Scott, and Lindsay, *Berthe Morisot,* p. 166.

37. Sigmund Freud, "The Uncanny," in *Standard Edition of the Complete Psychological Works,* ed. James Strachey, trans. Alix Strachey, vol. 14 (London: Hogarth, 1954), pp. 122–161. Freud wrote that the most uncanny thing of all was the sight of a woman's genitals. If we reread Freud's anatomical images as textual tropes, we could understand him to mean that the most uncanny thing of all is the representation of a woman's sexuality. Morisot's image would seem to concur.

38. Mary Elizabeth Coleridge, "The Other Side of a Mirror" (1822), *Poems* (London: Elkin Mathews, 1908), pp. 8–9.

10. Conclusion

1. Louis de Gonzague Privat, *Place aux jeunes! Causeries critiques sur le Salon de 1865* (Paris: Cournol, 1865) p. 147.

2. See Hubert Damisch, "D'un Narcisse l'autre," in *Narcisse,* special issue of *Nouvelle Revue de Psychanalyse,* 13 (Spring 1976): 109–146.

3. Lisa Tickner argues in her article "Feminism, Art History, and Sexual Difference," *Genders,* no. 3 (Fall 1988): 92–128, "Women have never become an identified audience for art in the way that they have for the novel and film: there is no 'women's genre' in painting to match the vigor and massive popularity of Hollywood melodrama or 'the serious woman's novel'" (p. 104). She herself, however, devotes most of her article to criticizing categories like "art" and "painting," and she has been among the first to apply such a methodology in her book *The Spectacle of Women: Imagery of the Suffrage Campaign, 1907–1914* (Chicago: Chicago University Press, 1988). In fact all nineteenth-century literary forms designed for female audiences have pictorial counterparts, direct forebears of the twentieth-century "Woman's Film."

4. See, for instance, Lynda Nead on Victorian images of women's sexuality: *Myths of Sexuality* (London: Blackwell, 1988).

5. Linda Nochlin, "Why Have There Been No Great Women Artists?" [1971], reprinted in *Women, Art and Power and Other Essays* (New York: Harper and Row, 1988), pp. 145–178.

6. Pollock, *Vision and Difference,* pp. 50–90.

7. See Michel Foucault, *The Archaeology of Knowledge* [1969], trans. A. Sheridan Smith (London: Tavistock, 1972). While the basic concepts and terms are Foucault's, the most suggestive application of them to visual forms of expression for me has been David Rodowick's "Reading the Figural," written in 1989 and forthcoming in *Camera Obscura,* 1991; I am grateful to him for letting me learn from it.

8. "The visible is . . . intimately linked to the expressible in that it enables énoncés which in turn 'underwrite' conditions of visibility. Visibility is not strictly equivalent to sight; rather, it refers to what can be rendered as intelligible and therefore knowable in a society." Rodowick, "Reading the Figural," manuscript, p. 10.

9. Rodowick, "Reading the Figural," manuscript, p. 8.

List of Illustrations

The titles of Morisot's paintings have been translated directly from the French titles in Morisot's catalogue raisonné by Bataille and Wildenstein. An exception has been made in the case of portraits where the sitter's name can be completed. I have also adopted most of Bataille and Wildenstein's dates.

Bibliothèque Historique de la Ville
de Paris

38. *Le Moniteur de la Mode,* fig. 142, June
 1871, p. 102
 Engraving, 19.5 × 17 cm
 Bibliothèque Historique de la Ville
 de Paris

39. Detail of Fig. 38.

40. Gavarni
 Balivernes Parisiennes, ". . . et combien
 . . ."
 Le Charivari, 1846, 15th ser., vol. 2
 Lithograph
 Bibliothèque Historique de la Ville
 de Paris

41. Gavarni
 Balivernes Parisiennes, "A portée de
 lorgnon"
 Le Charivari, August 14, 1846, 15th
 ser., vol. 2
 Lithograph
 Bibliothèque Historique de la Ville
 de Paris

42. Edgar Degas
 Portrait of the Painter James Tissot, 1868
 Oil on canvas, 151.4 × 112.1 cm
 The Metropolitan Museum of Art,
 New York
 Rogers Fund, 1939 (39.161)

43. Edouard Manet
 Portrait of Eva Gonzalès, 1870
 Oil on canvas, 200 × 135 cm
 National Gallery, London

44. Edouard Manet
 The Balcony, 1868–69

Oil on canvas, 169 × 123 cm
Musée d'Orsay, Paris
Photograph: Réunion des Musées
Nationaux, Paris

45. Edouard Manet
 Berthe Morisot with a Bouquet of Violets,
 1872
 Oil on canvas, 55 × 38 cm
 Private collection
 Photograph: Giraudon, Paris

46. Edouard Manet
 Bouquet of Violets, 1872
 Oil on canvas, 22 × 27 cm
 Private collection
 Photograph: Giraudon, Paris

47. Edgar Degas
 *Mary Cassatt at the Louvre: The Paint-
 ings Gallery,* 1879–80
 Etching, soft-ground etching, aqua-
 tint, and drypoint on ivory wove
 Japanese tissue, sixteenth state,
 30.5 × 12.6 cm
 The Art Institute of Chicago
 Photograph © 1991, The Art Insti-
 tute of Chicago; All Rights Re-
 served

48. Mary Cassatt
 Self-Portrait, 1878
 Gouache on paper, 23.5 × 17.5 in.
 The Metropolitan Museum of Art,
 New York
 Bequest of Edith H. Proskauer, 1975
 (1975.319.1)

49. Marcellin Desboutin
 Portrait of Berthe Morisot, 1876
 Drypoint, 26.3 × 17.6 cm

Oil on canvas, 81 × 65 cm
Private collection
Photograph: Durand-Ruel, Paris and
 New York

100. Berthe Morisot
Paule Gobillard Drawing, 1886
Pastel on paper, 73 × 60 cm
Private collection
Photograph: Bernheim-Jeune, Paris

101. Berthe Morisot
The Coiffure, 1894
Oil on canvas, 55 × 46 cm
Museo Nacional de Bellas Artes,
 Buenos Aires

102. Berthe Morisot
The Black Bodice, 1878
Oil on canvas, 73 × 65 cm
National Gallery of Ireland, Dublin

103. Berthe Morisot
On the Chaise Longue, 1893
Oil on canvas, 55 × 73 cm
Private collection
Photograph: Bernheim-Jeune, Paris

104. Berthe Morisot
Violin Practice, 1893
Oil on canvas, 41 × 33 cm
Private collection

105. Edouard Manet
Portrait of Isabelle Lemonnier, 1880
Oil on canvas, 101 × 81 cm
Private collection
Photograph: Harvard University Art
 Museums

106. Berthe Morisot
Alice Gamby in the Salon, 1890

Oil on canvas, 68 × 51 cm
Private collection
Photograph: Bernheim-Jeune, Paris

107. Edouard Manet
Berthe Morisot Reclining, 1873
Oil on canvas, 26 × 34 cm
Private collection
Photograph: André Held

108. Edgar Degas
Portrait of Eugène Manet, 1874
Oil on canvas, 81 × 65 cm
Private collection

109. Eugène Manet, Julie Manet, and
 Berthe Morisot in the garden at
 Bougival, 1883–84
Photograph
Private collection

110. Berthe Morisot
Portrait of Alice Gamby, c. 1890
Pencil on paper, dimensions un-
 known
Present location unknown
Photograph: Bibliothèque Nationale,
 Paris

111. Berthe Morisot
After a drawing of Alice Gamby,
 1890
L'Art dans les Deux Mondes, 19 (March
 28, 1891): 223
Photograph: Bibliothèque Nationale,
 Paris

Plate I. Berthe Morisot
Interior, 1872
Oil on canvas, 60 × 73 cm
Private collection
Photograph: Galerie Schmit, Paris

Plate XII. Berthe Morisot
Study: At the Water's Edge, 1864
Oil on canvas, 60 × 73 cm
Mr. and Mrs. Fred Schoneman
Photograph: Northeast Color
Research, Inc., Somerville,
Massachusetts; courtesy of
Mount Holyoke College Art
Museum, South Hadley,
Massachusetts

Acknowledgments

This project required a lot more than an author to become a book. It needed people and institutions who gave of their time, knowledge, and resources. They made my work possible, and I am deeply grateful to them.

The Lurcy Foundation, the Helena Rubinstein Foundation, the Florence Gould Foundation's Tocqueville Fellowship, the Social Science Research Council, and a Wellesley College dissertation expenses grant supported me financially.

Curators and museums allowed me to study paintings and archives: Françoise Cachin at the Musée d'Orsay in Paris; Jean Coquelet at the Musée d'Ixelles in Brussels; Charles Stuckey, Suzanne Lindsay, Nancy Iacomini, and Florence Coman at the National Gallery of Art in Washington, D.C.; Richard Brettel and Gloria Groom at the Art Institute of Chicago; Valerie Foradas, Mary Kuzniar, and Timothy Lennon at the Los Angeles County Museum of Art; Ruth Berson at the Museums of Fine Arts in San Francisco; Diane Lesko and Michael Milkovich at the St. Petersburg Museum of Fine Arts; Helen B. Mules at the Metropolitan Museum of Art in New York; Ann Dumas and Sarah Faunce at the Brooklyn Museum; the staff of the Nasjonalgalliert, Oslo; Pontus Grate at the Nationalmuseum in Stockholm; the staff of the Ny Carlsberg Glyptotek in Copenhagen; the staff of the Ordrupgaardsamlingen in Copenhagen; Wendy Watson and especially Teri Edelstein at the Mt. Holyoke College Art Museum in South Hadley.

The staffs of the Bibliothèque Nationale, the Bibliothèque Marguerite Durand, the Bibliothèque Doucet, the Bibliothèque Historique de la Ville de Paris, the Bibliothèque de l'Arsenal, the Musée de la Mode de la Ville de Paris, the Musée Nationale de la Mode, and Anne Roquebert at the Documentation du Musée d'Orsay in Paris, as well the staffs of Harvard University's Widener Library and Fogg Art Library in Cambridge gave me access to their collections.

Dealers and archivists in galleries and art foundations shared their paintings, documents, and photographs: the Galerie Schmit, the Galerie

Bernheim-Jeune, France Daguet at the Fondation Durand-Ruel, Marie-Christine Mofus and Daniel Wildenstein at the Fondation Wildenstein.

I am grateful for the advice, support, and suggestions of mentors, colleagues, collectors, readers, and friends: Jean Adhémar, Jean-Christophe Agnew, Chittima Amornpichetkul, Janine Bailly-Herzberg, Pierre Bernard, Zette de Bodard, Rosalind de Boland Roberts, Caroline Chotard-Lioret, Judith Coffin, William Coles, the Danon family, Daphne Doublet-Vaudoyer, Juliet Faithfull, Michel Fleury, Mme. Giraud de l'Ain, Beverley Gordey, Othenin d'Haussonville, Ethel R. R. Higonnet, Philip J. Higonnet, Elisabeth Higonnet-Dugua, Elizabeth Honig, Cecily Horton, Sally Horton, Nicole Leloir, Francis Ley, Denise de Lima, Donald Marcus, John Merriman, Jacqueline Paysant, Madeleine Rebérioux, Marguerite Riottot-Olagnier, Eugène Rossignol, Claude Schkolnyk-Glangeaud, Pierre Sieur, Valerie Steele, Lisa Tickner, Jean Tulard, everyone in the Wellesley Art Department, and especially Martha Zuber.

Those who read portions of the manuscript know how much I owe to their astute comments: Katherine Auspitz, Margaret Carroll, Margaret Cohen, Peter Gay, John Geanakoplos, Margaret Higonnet, Cat Nilan, Philip Nord, Daniel J. Sherman, Lisa Tierston, and Cécile Whiting. Deborah Cohen, James D. Herbert, Patrice L. R. Higonnet, and Janet Marin King heroically read entire drafts and each contributed immeasurably to the final product, as did Celeste Brusati, Anne Hanson, and Michelle Perrot, my dissertation readers.

Berthe Morisot's descendants Agathe Rouart-Valéry, Yves Rouart, Clément Rouart, Julien Rouart, and especially Jean-Dominique Rey and Mme. Denis Rouart, graciously allowed me to study their collections and to learn from their experience. They made my work a personal pleasure.

Most of all, I want to thank my teacher Robert L. Herbert for his wisdom, scholarship, and generosity.

Index

Page numbers in italics indicate black-and-white illustrations. The index includes authors cited in the notes.